EARTHLY VISIONS

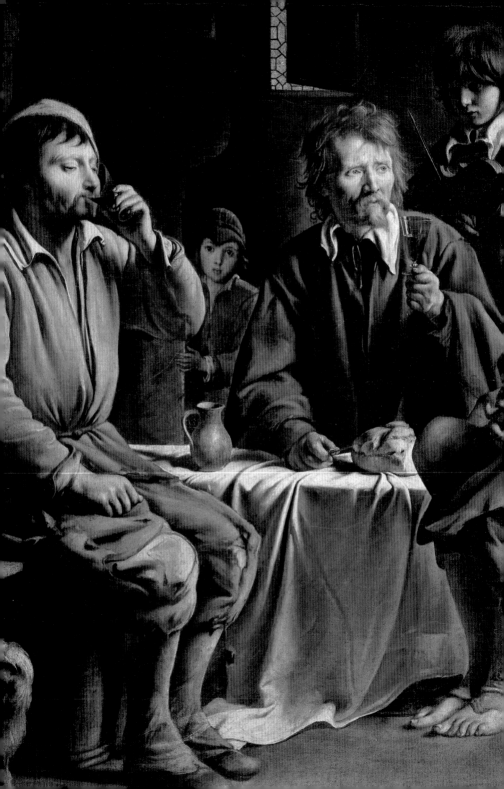

EARTHLY VISIONS

Theology and the Challenges of Art

T. J. GORRINGE

Yale University Press
New Haven and London

FOR CAROL
IN MEMORIAM

Printed in China

Library of Congress Cataloging-in-Publication Data
Gorringe, Timothy.
Earthly visions : theology and the challenges of art / Timothy Gorringe.
p. cm.
Includes bibliographical references and index.
ISBN 978-0-300-16280-6 (cl : alk. paper)
1. Christianity and art. 2. Theology. 3. Secularism. 4. Art,
European–Themes, motives. I. Title. II. Title: Theology and the challenge
of art.
BR115.A8G665 2011
246–dc22

2011005524

A catalogue record for this book is available from The British Library

Frontispiece: Louis Le Nain, *Peasant Meal*, detail, 1642, Musée du Louvre, Paris.
Photo © RMN / Gérard Blot

CONTENTS

ACKNOWLEDGEMENTS

I have first to record my debt to the students of the *Theology, Art and Politics* class at the University of Exeter from 1999 to the present. They have consistently worked far harder than could reasonably have been expected and their energy, enthusiasm and insight have been an inspiration. Magdalen, Hugo, Mai and Iona Gorringe have been similarly energetic and rigorous companions to art galleries and exhibitions over the years: it is a particular joy to learn from one's children (and in Mai's case, from a daughter-in-law who is also a professional art historian). Alfy Gathorne-Hardy helped me in obtaining some of the more recherché material. Among my colleagues Mark Wynn shares virtually identical interests, and conversations with him are always illuminating. Gill Westcott shared in this book from very near its inception and has consistently helped by putting searching questions to received wisdom. My deepest debt, however, is to Carol, who introduced me to art in the first place, and who always had a more profound and understanding eye. This is her book.

I have also to thank the British Academy for a grant towards the cost of the pictures, and Gillian Malpass for sticking with the project.

Tim Gorringe
Trinity 2010

Facing page: detail of fig. 36

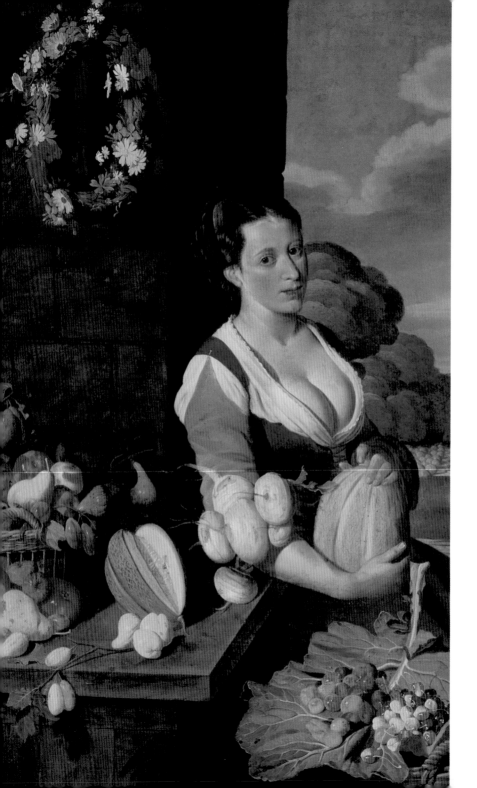

1

SECULAR PARABLES

A young woman clad in mustard-coloured sleeves and a blue bodice sits by a stone window, looking out on to a tree-lined valley and a river (fig. 1). Her face is fine and rather pensive. The melon she holds is a deliberate echo of her breasts, as is the cut melon on the table to her right – almost an early seventeenth-century version of the Page Three girl![1] This portrait is not intended to be salacious, however: doubtless she is a real girl, but she is also Ceres, the goddess of plenty. The table on which her elbow rests is heaped with the finest turnips, figs, pears, peaches and quinces. By her knees is a wicker basket with peas, beans and cherries. To the far side of the window cabbages, marrows, grapes, onions and squashes are piled up.[2] In Shakespeare's *The Tempest*, which the artist may very likely have seen, Ceres blesses the union of Ferdinand and Miranda thus:

> Earth's increase, foison plenty,
> Barns and garners never empty;
> Vines with clust'ring bunches growing,
> Plants with goodly burden bowing;
> Spring come to you at the farthest,
> In the very end of harvest!
> Scarcity and want shall shun you,
> Ceres' blessing so is on you.[3]

Facing page: detail of fig. 1

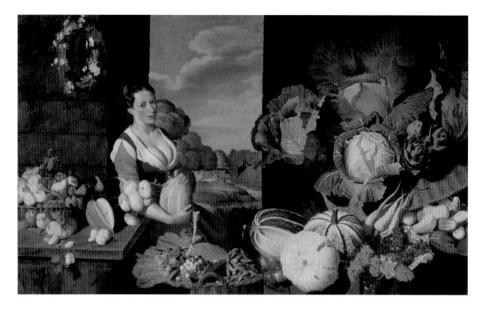

1 Nathaniel Bacon, *Cookmaid with Vegetables*, *c.*1620–5, Tate Britain, London

This abundance is what we see here represented. The tone of the picture is radiantly optimistic and affirmative, emphasised by the dominance of yellows and greens. 'Desire is creative', writes David Hart, 'when it is directed not only toward a particular *quid*, but toward a certain radiance, a certain ordination and ordonnance of all things, a certain rhythm that places all things in peaceful sequences of donation and redonation; desire creates in finding proportions of peace. This is the secret of true art, which both speaks and receives the world in one integral movement of generosity and gratitude.'[4] We have not only that 'certain radiance' in this picture, but also the proportions of peace, which the artist introduces by the use of the golden section so beloved of the Renaissance, in the downward line of the window and the horizontal line of the window shelf. The golden section, the relation of three-eighths to five-eighths, was believed to have mystical significance, and spoke of the harmony of all things and the human ability to intuit that.

The artist also alludes to another favourite Renaissance *topos*, the relation of nature and nurture, in placing a garland of wild flowers above the girl's head, to the left of the view to the cultivated garden and overlooking the fantastic cultivated harvest. With their marigolds these recall the 'flowr's of middle summer' of Perdita's speech in *The Winter's Tale*. This is art, both the painter's art and the gardener's, augmenting nature and celebrating it. In Polixenes' words: 'This is an art which does mend nature, change it rather; but the art itself is nature.'[5] On the artist's tombstone were carved the words: 'Nature alone taught him through his experiments with the brush to conquer Nature by Art.'[6]

This extraordinary picture, one of a series of ten of which only two seem to have survived, was painted around 1620 by the nephew of Francis Bacon, a nobleman, amateur artist and passionate gardener. 'God Almighty', wrote his uncle, 'first planted a garden'. To produce abundance such as this, in a world where general famines occurred every decade, was to tiptoe back into Eden. Of course Bacon himself did not have to gain his food by the sweat of his brow: others sweated for him. Nevertheless there is nothing utilitarian about this gardening. 'Indeed', wrote his uncle, 'it is the purest of human pleasures. It is the greatest refreshment to the spirits of man; without which, buildings and palaces are but gross handyworks: and a man shall ever see that when ages grow to civility and elegancy, men come to build stately sooner than to garden finely.'[7] The younger Bacon paints this refreshment and pleasure. In doing so he is drawing on a minor but still important tradition of painting which had been perfected by Pieter Aertsen and Joachim Beuckelaer in Flanders.

Beuckelaer is considered by some the greatest of this group and his set of *The Four Elements*, in the National Gallery in London, together with Bacon's picture, serve to introduce us to the theme of secular parables.[8] The idea of the four elements belonged to an older cosmology which was beginning to be replaced, but was still current in the sixteenth century and was usually related to the four humours, or types of temperament. When Beuckelaer was painting it was already being reflected on theologically. For example, the ceiling of the Prelate's Gallery in the Archbishop's Palace in Seville has a painting of the four elements as well as the four seasons and

a kitchen scene which makes the point that the natural world is created for human beings by a loving God.[9] In Italy, at the end of the sixteenth century, Cardinal Borromeo, Archbishop of Milan, collected landscape and still life paintings specifically because they displayed the love of God in creation. His spirituality has been described as a form of 'Christian optimism'.[10] Beuckelaer is part of this tradition: he shows no interest either in the ancient idea of the four elements according to which everything was the product of love or strife, or in the four humours. Rather, as with Bacon, we have a celebration of creation. What differentiates him from contemporaries like Jan Bruegel, who painted the same theme, is that all the produce is here set out for sale or is being prepared for consumption: Beuckelaer paints not an imaginary world but the world that citizens of his day might encounter, as if the Garden of Eden was realised here and now. *Earth* and *Water* were painted in 1569, the first set in the country, the second in the town; *Air* and *Fire* were painted in 1570, again divided between town and country (figs 2–5). All four have biblical scenes in the background. In each picture we have rather serious girls, who in two cases engage us directly, just as in Bacon's picture, reminding us that in Shakespeare's comedies it is almost always a young woman who is the main source of the action and, in the later plays, the bringer of redemption as well. Apart from the common theme of produce the four pictures are also related by devices such as the use of mussel shells in both *Fire* and *Water*, by the wonderfully rendered baskets, by the street scenes in *Air* and *Water*, and above all by the foreground figures.[11] Gentry are absent: what we have are well-attired servants depicted with immense dignity – a theme we shall return to in Chapter 3.[12] Compared with Bacon, Beuckelaer appears to have a much more pastel palette, but this seems to be because his blue pigments have faded, giving paintings that might otherwise be summery a rather cool autumnal tone.

A fish market, obviously enough, is how Beuckelaer chooses to represent *Water*. Four sellers of fish, three women and one man, stand or sit behind their baskets and stalls: two of them look directly out at the viewer. Two customers, women with veils, stand in the background. All the figures are painted with tremendous seriousness. There is a profusion of fish –

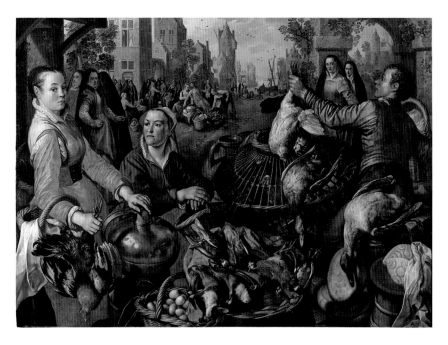

2 Joachim Beuckelaer, *Air* from *The Four Elements*, 1570,
National Gallery, London

twelve varieties have been identified. Their mottled silver contrasts with
the warmth of the clothes worn by two of the sellers. A ray fish, the theme
of one of Chardin's most famous pictures, is on display. An Antwerp street
filled with people runs up steeply to the left while, through an arch, there
is what is taken to be a tiny account of John 21, the risen Christ appear-
ing to the disciples by the Sea of Galilee and sharing with them a break-
fast of fish. Compositionally the picture is held together by the hands of
the sellers, particularly the two in the foreground; these form a triangle
through which the other figures are seen, which is in turn mirrored by the
triangle of the arch.

In *Earth* we are present at a vegetable stall: two women, in red and
green, sit or stand behind baskets and a wheelbarrow piled high with vege-

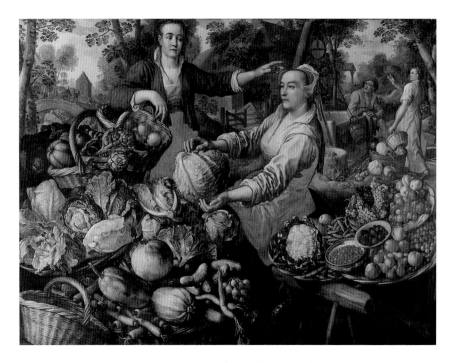

3 Joachim Beuckelaer, *Earth* from *The Four Elements*, 1569,
National Gallery, London

tables – marrows, carrots, cucumbers, radishes, cabbages, artichokes, peas, raspberries, apples and pears among others. As with *Water* the arms of these two women (it is not clear whether they are buyers or sellers or perhaps one of each) hold the two sides of the picture together, the standing figure extending her left hand to the other, almost in a gesture of blessing, and the seated figure, with complementary yellow sleeves, extending her hands in the other direction to hold a gigantic cabbage. As with Bacon's picture, the produce on sale is heaped up, 'pressed down, spilling over'. A man and a woman stand at a well in the middle distance, inevitably recalling Rebekah and Abraham's servant, while in the far background, crossing a bridge, the Holy Family are shown fleeing into Egypt,

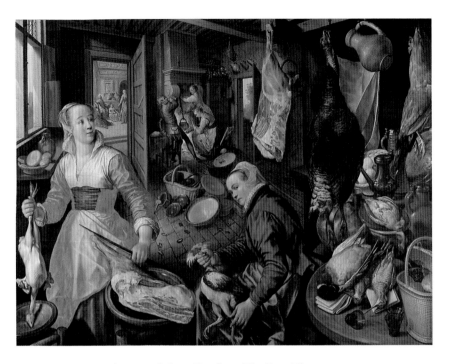

4 Joachim Beuckelaer, *Fire* from *The Four Elements*, 1570,
National Gallery, London

though in truth this could be any couple on a journey. Compared with
Bacon the tone is more sombre, but the message is the same.

How was the artist to represent *Fire*? He takes us to a kitchen where
meat is being prepared. Light pours in through a window to the left and
on the window-sill are loaves and wine, perhaps eucharistic symbols. In
the foreground two women are preparing poultry – caught in action. The
seated figure turns and regards the viewer, somewhat severely. To her right
are tables laden with poultry and game, a basket of lemons, linen napkins,
a basket of rolls, glass tumblers. The flame-coloured feathers of the
hanging cock highlight the scarlet bodice of the seated girl. A starched
white cloth is hanging up, presumably to lay a table. At the far end of the

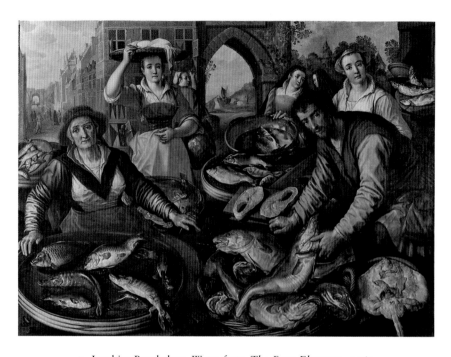

5 Joachim Beuckelaer, *Water* from *The Four Elements*, 1569,
National Gallery, London

room a man and a woman stand by a bright fire on which food is being cooked. The man is drinking, while another girl has one hand extended to the fire and with the other shields her face. To the side of the fire a door opens on to a garden. Beuckelaer has had problems with the perspective and the floor tilts crazily between the foreground and background figures. Through an open door, this time unambiguously, we see Christ talking with Mary. 'Christ in the house of Martha and Mary' was an ancient *topos* which, from the time of Augustine, had been about contrasting the active life and the contemplative life, and it is possible that we are supposed to read a moral meaning into this scene.[13]

Air takes us back to the market, this time for fowls and other feathered birds. We have the same uncertainty about whether the foreground figures

are buyers or sellers as in *Earth*: only the young man in his scarlet doublet is clearly a seller. A huge array of produce is on sale – mainly fowls, but also eggs, rabbits and cheeses. Once again the arms of the figures are important compositionally, leading us from the sides to the centre of the picture where, in the background, is a depiction of what is presumed to be the Prodigal Son wasting his substance on harlots. In the foreground a girl looking straight at us holds a cockerel by its legs, and rests her left hand on a copper pot whose lustre gives warmth to an otherwise rather tonally dull picture. Her left hand firmly covering the mouth of her pot could be a symbol for virginity.[14] Another woman in a red jacket rests her hands on a basket. A man to the right in crimson satin holds a duck. Other birds are still alive in wicker cages. Behind the sellers is a busy street which gives out to a seaport.

What all of these paintings have in common is, first, an emphasis on abundance, and second a certain seriousness or even severity of tone. Why depict these themes in this profoundly materialist way, in a way which, in each case, refers to the sustenance of life? Why ignore the much more familiar reference to the humours, or to love and strife? One reason may be that the pictures form a pointed contrast to the reality of life in Flanders under the rule of the Duke of Alba, where a series of poor harvests meant real hardship for most people.[15] The pictures in that case call up an alternative world of peace and plenty. As with Bacon, the central figures all belong 'below stairs', but they are never patronised; on the contrary they have an almost Stoic nobility. All of the Beuckelaer pictures have a gospel scene in the background, and it is usually suggested that this implies a critique of the worldliness in the foreground. Given the dignity of the central figures, however, it is hard to believe this, and it seems much more plausible to discern in these pictures, as in the Archbishop's Palace, a reference to a theology of creation, and therefore a linking of creation and redemption, Old Testament and New, and possibly also an endorsement of the theology of work which had been newly re-emphasised by Luther. Forty years after Beuckelaer, in Bacon's picture, the gospel reference has disappeared entirely. Why? What is going on?

THE MEANING OF SECULARISATION

In illustrations of work and play, of love and war, of ethical and philo-
sophical allegories, on the reverse or in the margins of sacred pictures, and
especially in the Herbals used for medieval medicine, secular art is to be
found throughout the Middle Ages.[16] Beginning in the fourteenth century,
however, the pace of secular painting picks up.[17] In Europe throughout the
Middle Ages religious painting is undeniably the cultural dominant but it
is slowly displaced until, in the twentieth century, the proportion of secular
to sacred art which obtained in the fifteenth century is exactly reversed.
The change from Beuckelaer to Bacon could be read as part of the narra-
tive of secularisation. First, the overtly biblical elements are forced into the
background, while secular aspects are given priority, and then the biblical
are simply omitted. Alternatively, as I shall argue, what we have here is
a new and much more interesting change in theological direction. The
playing out of this change, its theological significance, and what it implies
about what Christians can learn from 'secular' art, is the theme of this book.

Secularisation continues in the growing scepticism about the claims of
religion which finds its most acute voices in Voltaire and Hume in the
eighteenth century, and which has its sociological correlate in the decline
of churchgoing throughout Europe and Scandinavia two centuries later.
Burckhardt was inclined to read the Renaissance in that way, as a revolu-
tion in which humanism came to displace theology. From God being the
centre, so the story went, human beings became the centre.[18] A change can
be discerned in which the spectator becomes the centre of the composition
through the use of three-dimensional perspective and other illusionist
strategies. As opposed to medieval art the primary purpose is not to offer
glory to God but to communicate between human beings.[19] Caravaggio's
pictures, at the turn of the seventeenth century, are paradigmatic: no sky
appears and no one looks up. Caravaggio is concerned primarily with the
difficulties of humankind. The interior drama is what counts.[20] In the same
way, in Bacon's picture, there is no overt reference to the divine.

Such a reading of cultural history is undoubtedly part of the story but,
as has long been recognised, as the grand narrative it is grossly simplistic.

It overlooks the profound roots of the Renaissance in its medieval past, the extent to which 'humanist' themes are current as early as the twelfth century and conversely the continuance of scholastic themes into the sixteenth and seventeenth centuries.[21] In particular it overlooks the extent to which humanism had not just classical but also Christian roots. We have to recognise, of course, that Reformation hostility to religious images undoubtedly constituted a 'push' factor in the development of an autonomous secular art.[22] For Calvin and for many other Reformers the second commandment made depictions of the deity impossible.[23] The mediation of the saints was rejected and thus many of the central themes of medieval art were no longer available. In Protestant areas hostility to images led to one of Christianity's periodic bouts of iconoclasm. Counter-Reformation polemicists also criticised the art of the early Renaissance and preferred allegorical figures of the virtues and moral fables.[24]

What is not so often seen is that there was a 'pull' factor as well: when Luther denied the division between sacred and lay, when he insisted that 'secular' callings were on all fours in the service of God with priestly or religious callings, he opened the way to a completely new understanding of the secular. Luther explained the petition 'give us today our daily bread' as meaning: 'all that belongs to the maintenance of the body and the bare necessities of life such as food and drink, clothes, house and home, cattle, furniture, money, a good wife, well behaved children, faithful servants, a benevolent and just government, a suitable climate, peace, good health, honour and chastity, good friends, reliable neighbours and many other such things'.[25] We cannot call this simply 'the Protestant principle' because it transcended the confessional divide. The new spirituality meant that Teresa of Avila found God in the kitchen and George Herbert elided divine and domestic service. Calvin's hostility to images, it has been argued, led him to redefine what counted as religious. There is not simply an iconoclasm, but also an iconpoiesis in the Reformation which understands that the world mirrors the divine in its banal, day-to-day reality.[26] This, I shall argue, is one of the deepest sources of the rise of so-called secular painting, burgeoning forth in portraits, landscape, still life, genre paintings, and finally in the turn to abstraction. The turn to the secular, then, may not

be a sign of Christianity losing its grip, but, on the contrary, of realising its true implications, in a more concrete and practical way than the medieval theology of immanence had allowed. As Auerbach argued, Christianity centres on a long narrative of the everyday:

> That the King of Kings was treated as a low criminal, that he was mocked, spat upon, whipped, and nailed to the cross – that story no sooner comes to dominate the consciousness of the people than it completely destroys the aesthetics of the separation of styles; it engenders a new elevated style, which does not scorn everyday life and which is ready to absorb the sensorily realistic, even the ugly, the undignified, the physically base. Or – if anyone prefers to have it the other way round – a new *sermo humilis* is born, a low style, such as would properly only be applicable to comedy, but which now reaches out far beyond its original domain, and encroaches upon the deepest and the highest, the sublime and the eternal.[27]

Of course this was recognised in the Middle Ages in its own way but there the celebration of everyday life is found more in folk art than in high art.

If the story of redemption prioritised the everyday, then so did the creation narrative, which pronounced the created world good. Though there was a strong Platonic stream in Christianity which denigrated the created world and which looked to a truer world the other side of mortality, equally there were here resources for the celebration of the beauty and richness of the created world, exactly as we see in Beuckelaer and Bacon. The church always rejected the Manichaean option and the bitter struggle against the Albigensians was, paradoxically (given the cruelty involved), waged in the name of the goodness of creation. As the Swiss theologian Karl Barth put it, in this respect echoing Luther, creation is good because it is the product of the divine joy: 'It is the goodness of God which takes shape in it, and God's good pleasure is both the foundation and end of creation, and is therefore its ontological ground'.[28] For Barth this confidence in creation rests on our knowledge of redemption. In a comment which has interesting implications for both landscape painting and for still life, he argues that 'All the wretchedness of human life is bound up with

the fact that sound common sense and the *natura docet* have no power at all firmly to plant our feet on the ground of the confidence that the created world is real'.[29] Dutch seventeenth-century landscape painting, we could argue, very differently from that of Poussin or Claude, rests on a knowledge of redemption and very often alludes to that redemption in overt ways. This grounding of the created order in redemption is precisely what enabled Barth to argue that 'There is no such thing as secular history in the serious sense of the word'.[30] The secular as an autonomous 'godless' sphere simply disappears. This is to do away with dual-system book keeping, to refuse to separate nature and grace, creation and covenant, the revelation of creation and the revelation of salvation.[31] It is this refusal of the nature–supernature schema which grounds the positive appreciation of secularity. A 'self conscious secularity of sensibility' is, on this view, part and parcel of Christian revelation.[32] This means that the truly secular is compatible with the sacred if it is not, indeed, the sacred per se.[33] For Barth, Mozart was the paradigm. Mozart 'does not wish to say anything: he just sings and sounds ... Nor does he will to proclaim the praise of God. He just does it – precisely in that humility in which he himself is, so to speak, only the instrument with which he allows us to hear what he hears: what surges at him from God's creation, what rises in him, and must proceed from him'.[34] This, I shall argue, also applies to painting.

To argue thus is to disagree with the perspective of Norman Bryson who believes that whereas in the south of Europe there was an effortless opening on to sacred spaces and transcendental truth, 'in the Northern context this access to the transcendent is exactly blocked and prevented. The transcendent realm cannot be pictured. The God of the Reformation is a hidden God. Vision has no access to the things of the spirit'. He believes that the contrast between secular and sacred in paintings like Beuckelaer's means that the sacred can only be glimpsed – through a glass darkly – through the medium of a fallen world.[35] I suspect that more or less the opposite is true, and for the whole of Christian Europe, precisely in view of a shared theology of creation.[36]

SECULAR PARABLES

How does art contribute to faith? There is widespread agreement that it does, but little agreement on how exactly. For some all art is explicitly revelatory. Others focus on explicitly Christian art. I shall argue that great art can function as a kind of parable – to be precise, a secular parable. [37] Parables provoke, tease, challenge, illuminate, surprise. As a literary form they are themselves art, often described as 'word pictures'. In Jesus' use they challenge his hearers to think about God's reality in the midst of ordinary things. Rather than a collection of moral platitudes, which is how the nineteenth century understood them, they are invitations to reflection.

'The earth is the Lord's and all that is in it' (Psalm 24.1). This is the presupposition of the idea that God may manifest Godself in and through the ordinary. Alternatively put, it is because the Risen Christ rules in the heights and the depths and is sovereign over the whole world of creation and history that we have to be ready to 'eavesdrop in the world at large'.[38] Note, this includes the creaturely world, the world which Beuckelaer and Bacon display for us with so much love and delight. *Precisely because the creaturely world is created by God, precisely because, in theological terms, creation is the expression of grace*, it 'has also as such its own lights and truths and therefore its own speech and words'.[39] We can expect to hear true words, words of great seriousness, profound comfort and *supreme wisdom*, outside the church, in which the community finds itself 'lightened, gladdened and encouraged in the execution of its own task'.[40] The more seriously and joyfully we believe in God revealed in Christ the more we shall see such signs in the worldly sphere, and the more we shall be able to receive true words from it.[41] Painters, I want to say, are those who *see* such signs and help the rest of us to see them.[42] In *The Bright Field* the poet R. S. Thomas dwells on one of his favourite images: when the sun streaming through clouds picks out one field among many. Like the poet 'the painter renders visible as a phenomenon what no one had ever seen before, because he or she manages, being the first to do that every time, to resist the given enough to get it to show *itself*'. The genius of the artist is, Jean-Luc Marion helpfully says, in resistance to the given, a resist-

ance which alone enables us not to take the world for granted and which, in the new seeing which it enables, is part of what is meant by revelation.[43]

For many commentators the paintings of Beuckelaer and his like have to be read in a moralising way. The point of the New Testament theme in the background is to highlight the snares of self-indulgence symbolised by the produce on the market stalls.[44] Much ingenious argument is adduced to support this point, drawing on the ethical and satirical literature of the sixteenth century, but to accept this seems to demand that we deny the evidence of our own eyes.[45] In much seventeenth-century genre painting the actors are depicted in taverns wearing a leery grin or giving us a knowing wink. Nothing is more remarkable about Beuckelaer's and Bacon's paintings than the sobriety and self-evident decency of the market stallholders. Sixteenth-century Europe was a society beset by famine, where no one presumed to eat without saying grace – giving thanks for the gifts of creation – first. As visible words these pictures are words of 'great seriousness, comfort and wisdom' and lighten, gladden and encourage us. They are paintings of grace.

That creation is the expression of grace means that we cannot possibly think in terms of the disenchantment of the world, a secular reality to which more has to be added if God is to assume centre stage.[46] This is not to say, on the other hand, that the world, for all its beauty, depth and mystery, is intrinsically revelatory.[47] This is denied by God's freedom in revelation and contradicted by experience.[48] We cannot 'read off' God from creation any more than we can from Scripture – a fact we need to remember in particular in relation to some theories of landscape painting. If we could, God would be imprisoned by some created reality. Scripture has been compared to the pool of Bethesda: it remains lacking in life until the angel stirs the waters.[49] It is not an oracle which any one can command or a text which can be manipulated. In the same way, 'The painter can do no more than construct an image; he must wait for this image to come to life for other people'.[50] To argue otherwise is to lose sight of the personal address of revelation in some general pantheism.

The New Testament parables, in which types or caricatures of everyday life are transformed to become 'real testimony to the real presence of God

on earth', are a model of how images of the secular world, such as market stalls, might function as 'visible words'.[51] The parables are not reportage: they are *art*. That distinction is crucial.

> As Jesus tells them, the material is everywhere transformed, and there is an equation of the kingdom with them, and of them with the kingdom, in which the being, words and activities of labourers, householders, kings, fathers, sons etc. become real testimony to the real presence of God on earth, and therefore to the events of this real presence. In sum, the New Testament parables are as it were the prototype of the order in which there can be other true words alongside the one Word of God, created and determined by it, exactly corresponding to it, fully serving it and therefore enjoying its power and authority.[52]

What we are thinking of, then, is the way in which portraits, landscapes, still life, pictures of markets, of Venus, of peasants, may become 'real testimony to the real presence of God on earth'.[53] Art focuses our attention with 'a radiance so intense that it goes beyond the original', but it then sends us back both to the original and its source.[54] In this way it does not become an end in itself but remains a parable. Much of the art considered in this book is, like the paintings of Bacon and Beuckelaer, representational. This does not mean it is 'realistic' in the sense of being primarily concerned with a faithful likeness. All great art expresses dimensions of reality hidden from normal perception. It makes visible those dimensions 'hidden from view but . . . transparent to the human spirit as it ponders and reflects on what confronts it'.[55] The 'excess' of art is the excess of our sense of the depth and mystery of reality, calling for parable rather than the prose of the catalogue or 'scientific' description.

To see how this might be possible we can turn to Mozart once again. Barth observes that Mozart, though he was not a particularly active Christian, and led a rather frivolous existence, heard, and causes us to hear, the whole context of providence, the 'peace which passes understanding'. In this way his music is a kind of auditory parable and we may look for visible parables in the same way.[56]

Barth believes that secular parables primarily address the Christian community, offering no criticism without affirmation and no affirmation with-

out criticism.[57] But Mozart, of course, addresses people far beyond the community. Surely we want to say that those also heard 'the peace which passes understanding' who could not identify it as such? The Lordship of God, in God's revelation, runs far beyond the church. What the church offers, in its storytelling, in appealing to christic criteria for revelation, is a constant question about the true nature of the divine. Theology is essentially interrogative, something which art, in its challenge to our lazy and preconceived ways of seeing, shares.

Secular parables, then, are part of God's revelation. They are this without losing their secular character or undergoing any inner transformation, without any question of transfiguration or transubstantiation. As part of a process, as part of God's exercise of freedom, they acquire a function and capability as thus exercised which they did not have intrinsically.[58]

PAINTING AS PARABLE

Let us suppose, then, that Beuckelaer's and Bacon's paintings are secular parables. They are parables just like Jesus' parables: precisely in their secular reference they speak about God. In the parables of Jesus, 'religion becomes secular without loss, Israel becomes Adam, the law becomes the way of humankind, and the son of Abraham becomes the Son of man'.[59] The new world in which this was possible, as opposed to the world where religious symbols were obligatory, is most perfectly illustrated by Velázquez whose waterseller has been rightly described as having the gravity of a figure of religious history.[60] He has that gravity because the boundaries of secular and sacred are no longer rigid, because, even in Counter-Reformation Spain, the secular is also recognised as the sphere of God's operation.

Thinking of painting as parable is helpful in marking it off from those accounts which believe that art gives us immediate access to the divine. Theosophists such as Kandinsky held this view, arguing that art alone can reveal to people the meaning of life.[61] Some theologians also consider art to be explicitly salvific. For them art not only thrills but 'heals me, judges me, touches me at a depth which nothing else can reach'.[62] Artists 'produce work of moral beauty, they embody or incarnate truth, they enable us to

see and to know, they are life-givers, they bring us to judgement ... they sow seeds which germinate secretly within us, they bring us to the edge of a mystery which is as vast and as exciting for them as it is for the rest of us yet they seem to know the way to it and can lead us there ... The gallery has become the place of pilgrimage'.[63]

More excusably, the Marxist Ernst Fischer claims that art restores the unity humankind lost in the rise of the division of labour and the class system.[64] It is the hallmark of the true work of art, he argues, that in it the division of human reality into the individual and the collective, the specific and the universal, is suspended. The job of art is redemptive in bringing humankind from a fragmented to an integrated state. 'Art enables man to comprehend reality, and not only helps him to bear it but increases his determination to make it more human and more worthy of mankind'.[65] The artist's task is more or less prophetic, being to make plain to people the rules of social and historical development, to solve for them the riddle of the essential relationships between human beings and nature and human beings and society. The artist's duty is to enhance the self-awareness and life awareness of the people of his or her city, class and nation and to guide individual life back into collective life.[66]

To these rather over-heated claims we have to oppose Nicholas Wolterstorff's stern words. Works of art, he writes, become surrogate gods, taking the place of God the Creator:

> Aesthetic contemplation takes the place of religious adoration; and the artist becomes one who in agony of creation brings forth objects in absorbed contemplation of which we experience what is of ultimate significance in human life ... When the secular religions of political revolution and of technological aggrandizement fail their devotees, when they threaten to devour them, then over and over the cultural elite among modern Western men turn to the religion of aestheticism.[67]

Claims that art is intrinsically revelatory fail to understand that the imagination can serve two masters. 'It serves the lie because it deceives Eros with its fantasies and reality because it accustoms the eye to Necessity'.[68] For many theologians art seems to lie beyond the Fall. Another

Marxist, John Berger, understands why this cannot be the case. The 'bogus religiosity' which surrounds original works of art, he argues, is actually a function of their market value. 'Its function is nostalgic. It is the final empty claim for the continuing values of an oligarchic, undemocratic culture. If the image is no longer unique and exclusive, the art object, the thing, must be made mysteriously so'.[69] Art reproductions function to bolster the illusion that nothing has changed and art is used to make inequality seem noble and hierarchies seem thrilling.

The version of the creative artist to which the art as salvation doctrine subscribes is, of course, quite new, a child of romanticism, and would have seemed astonishing to many of those artists before whose work people now stand awestruck and in silence. It is a form of idolatry which arises because in our culture the sense of the divine transcendence is either incredible or too easily conceived.[70] It is part of the justified worry of aniconic traditions such as Judaism that aestheticism can silence the text, can cause us to fail to hear what it has to say.[71] Furthermore, a moment's reflection makes clear that art can in no way address the primary problems of the new millennium – climate change, war, famine, poverty, disease, debt, drugs, environmental pollution and the displacement of peoples.[72]

Enthusiasts for art as salvation have also not heeded Walter Benjamin's celebrated warning that 'There is no document of civilisation which is not at the same time a document of barbarism'.[73] The deification of art was based on bad faith from the start in that the goals which it was supposed to serve – freedom, happiness and beauty – remained unrealised in the social world. 'The pure humanity of art became the counter image of what obtained in reality.'[74] For all these reasons we cannot allow that art is redemptive in itself.

How, then, to affirm at one and the same time the seriousness of art and yet its non-ultimate nature? One suggestion is that we consider it as a form of play. Participation in art, Karl Barth argued, is a general element in what is demanded of us, for as the children of God we cannot avoid acting in play too. It is when the character of art as play is forgotten that art is treated as a final word, a constitutive principle of life. This is not only idolatrous but leads to the disintegration of art.[75]

To understand art as play is not to trivialise it, making it an affair of the playground. On the contrary, 'When play is taken seriously – and when it is not we have no true art – it takes upon itself the character of decision, and the problems of the present are taken seriously precisely because they are seen in their limitation and are basically transcended in aesthetics.'[76] Play and ethical decision are not opposites but shade into each other.[77] Precisely as play, art is also Leonardo's 'persistent rigour', an ongoing struggle for the truth. Because this is the case we can speak of 'parables of the kingdom'.

PARABLES OF THE KINGDOM

The parables Jesus tells are parables of the *kingdom*; they point to the emergence of a new world. They have a political dimension. Is this also true of the paintings I am claiming may be secular parables? There has always been overtly political art, art glorifying rulers, celebrating victories or, more recently, supposedly proletarian virtues. Equally, there is a long tradition of the art of protest, which includes, for example, Goya's *Third of May* and Picasso's *Guernica*. We have seen that many commentators regard Beuckelaer's paintings as didactic, and this was certainly the case for much genre painting, both early and late.[78] It is true that the power of images to change consciousness and bring about social change can be seen by the extent to which authorities go in order to repress them.[79] The power of symbols is recognised in the bitter disputes over icons in the church and in all varieties of iconoclasm. That symbols run deep is the ground for their political control. But in the world of the mass media image and of the art market, does art still have the power to promote change? Robert Hughes doubts it:

The idea that an artist, by making painting or sculpture, could insert images into the stream of public speech and thus change political discourse has gone, probably for good, along with the nineteenth-century ideal of the artist as public man. Mass media took away the political

speech of art ... in a mass media society ... art's principal social role is to be investment capital, or, in the simplest way, bullion ... As far as today's politics is concerned, most art aspires to the condition of Muzak. It provides the background hum to power.[80]

Given this rather gloomy assessment let me nevertheless suggest three ways in which painting can function as a parable of the kingdom.

In the first place art has what theologians call an eschatological reality. It arises out of vision and, often if not invariably, envisions an alternative future:

Artistic creation will always aim at the unheard of, at that which has never been, at giving shape to the impossible, at impossible shaping. In principle all artistic creation is futuristic. It will always have to come back to reality ... the reality that was created by God and has been reconciled to him, but this as redeemed reality in its senses and anticipated perfection ... True aesthetics is the experiencing of real and future reality. As painting and sculpture it ventures to look at the outward form of present man and present nature as we can apparently see these only with our present eyes, but with the intention of seeing them with very different eyes and therefore of creating them anew in a better way, so that always and necessarily it sees them futuristically.[81]

Already in 1928, when this was written, and in the context of the Weimar republic, art is understood within the context of a theology of hope, of the belief that the world may be shaped more faithfully to the vision of God's kingdom. The word and command of God demand art, since it is art that sets us under the word of the new heaven and the new earth.[82] Art may be marginal but this is a margin which is part of the heart of the matter, and on it 'everything may be at issue'. 'To be unaesthetic is fundamentally to reject the signs that point beyond the present, the very nonpractical but very significant signs that art sets up.'[83] Others insist that art creates a demand 'for the complete satisfaction of which the hour has not yet struck', or that it anticipates the messianic kingdom, 'the return of the

world to that created fullness in which we may declare, with God, that all is "very good".[84]

Second, art contributes to the greater good, to the shalom of which aesthetic delight is a key component.[85] Art is 'a modest but irreplaceable contribution to the perfection of being', a kind of cooperation with God which increases, to the extent that human beings can do so, the sum total of being and beauty in the world.[86]

Third, art teaches us to see things differently. The great French thinker Simone Weil argued that attention lay at the root of prayer and others have extended this to both personal and political virtues.[87] If attention is key to all forms of learning then artists might be seen as tutors in seeing each other and ourselves. 'To be just in our seeing requires a long apprenticeship, learning from those with practised eyes, and alert to the ways in which our vision is laden with interests, theories and many levelled associations.'[88] There is something in this, though of course Weil was speaking of the attention learned in school studies, and it can be learned in any sphere of human endeavour, from farming to philosophy or perhaps even football. Art is not exclusively privileged in this regard but it is, indisputably, an important school of attention.

The objection to all three of these arguments is the elitist nature of art. We can compare the crowds at a Monet exhibition with the small numbers in church but we should then go on to compare the numbers at the Royal Academy with those in the football stadiums. Recognising this means that the defence of art as a genuine parable of the kingdom is part and parcel of the defence of the role of high culture as a whole in the divine economy of redemption. High culture is not the whole of culture and it exists in creative tension with popular culture and with folk culture: the borders between the three forms are porous and isolation of any one form always leads to sterility. If we accept that culture as a whole, in all of its manifestations, is an area in which God works to make and to keep us human, then the specific role of high culture, it seems to me, is to insist on difficulty, on excellence, on 'the best which has been thought and said' and, in the context of painting, of what has been seen and experienced visually. The justification for art galleries, and for taking art seriously, lies in the

claim that we can engage here with uniquely serious and perceptive forms of creativity, with challenges to our received sensibilities which, in the strict sense, educate us.

In these rather modest ways I would argue that art contributes to the human good, to our political and social well being. Let us return for the last time to Beuckelaer and Nathaniel Bacon. What do they offer us in a world of savagery, poverty and climate change? They offer, I would say, a steady, glowing faith in the goodness of the created order. It is nothing but faith, but it is a justifying faith. Considering their work as secular parables does not save us, but it invites us to reflect on the goodness of the world we inhabit, and to do that, in the context of the ecological crisis, is tantamount to a summons.

The remaining six chapters of this book are grouped in two blocks, one under the heading 'Image', the other under 'Nature'. Art historically, without any attempt at completeness, the second chapter deals with the great mythological themes which were often grouped, misleadingly, under the term 'history painting', the third with genre painting and the fourth with portraiture. The second part of the book looks straightforwardly at landscape, still life and abstract art. The main divisions of secular art in the period between 1450 and 1970 are therefore represented. Theologically the two parts correspond, roughly speaking, to the traditional Christian division of redemption and creation. In no way do they represent an attempt at a systematic theology, an attempt to cover all the areas of Christian theology through secular art. Nevertheless, the second chapter raises issues which relate to the nature of revelation and to eschatology, the third to liberation theology and the fourth to theological anthropology. In the second part two chapters are concerned with what we can call a theology of creation, and the final chapter addresses the apophatic tradition. Throughout I shall be trying to see how absolutely secular paintings can be understood from the perspective of faith, perhaps even as parables of the kingdom.

IMAGE

Moses did not see God but heard God's command; in the same way, God spoke to the prophets. From this speaking developed a tradition of narrative, reflection and praise. Israel was a nation which traced its origins to God's Word and polemically defined itself vis à vis its neighbours, which used images. The prohibition of images in the first commandment did not rule out artistic decoration, to be sure, but it established in Jewish culture a profound wariness of images. Jewish art was committed to the 'non finito' – leaving part of the image incomplete, to be completed by the imagination, so that the sovereignty of God in creation would not be challenged. For the rabbis the attempt to mediate between human beings and God by way of material symbols was the root cause of idolatry.[1]

For all the beauty of Greek statuary and, if report can be trusted, Greek painting, the tradition of reflection whose most important voice is Plato was also hostile to images. Plato felt images tended to replace the original order of divine being with a man-made order of non-being. In that sense images could be idolatrous, leading us to worship an imitation of the truth (or Form of the Good) instead of the reality. He believed that art strengthened the lower elements in the mind at the expense of reason.[2] Christian teachers drank deeply from this spring. In this vein Clement of Alexandria, in the third century, wrote that 'when art flourished, error increased'.

Facing page: detail of fig. 9

He was opposed to religious images, insisting on 'an image that is perceived by the mind alone – God, who alone is truly God'.[3] These two streams of reflection on images led to periodic bouts of iconoclasm within Christianity, right up to the sixteenth century.

On the other hand Christians worshipped someone described as 'the very image of the invisible God' (Col. 1.15, Heb. 1.3). We grow into Christ's likeness, 'transformed into the same image from one degree of glory to another' (2 Cor. 3.18). The development of Christianity as a religion of images hangs on this identification, for God's image and wisdom was now made visible in human form. Though later iconoclasts could claim that it was providential that we had no image of Christ, their opponents pointed out that the incarnation meant that revelation was irrevocably visual. John of Damascus, in the eighth century, can speak for the tradition. It was obviously, he said, the height of folly and impiety to give form to the deity.

> But after God in his bowels of pity became in truth man for our salvation, not as he was seen by the prophets, but in being truly man, and after lived upon the earth and dwelt among men, worked miracles, suffered, was crucified . . . since all these things actually took place and were seen by men, they were written for the remembrance and instruction of us who were alive at the time . . . But seeing that not everyone has a knowledge of letters nor time for reading, the Fathers gave their sanction to depicting the event and images as being acts of great heroism, in order that they should be for a memorial of them. Often, doubtless, when we have not the Lord's passion in mind and see the image of Christ's crucifixion His saving passion is brought back to remembrance and we fall down and worship not the material but that which is imaged just as we do not worship the material of which the gospels are made nor the material of the cross but that which these typify.[4]

These arguments could cut both ways. For some, the fact that the unique image had appeared in Christ meant that no other images were permitted. Christianity could be seen as reinforcing the prohibition of images and thereby ending idolatry.[5] Luther, on the other hand, insisted that 'You find no word of God in the entire scriptures in which something material and

outward is not contained and presented.'[6] 'It is impossible', said the nineteenth-century Bishop of Durham, B. F. Westcott, 'that the facts of the incarnation and Resurrection can leave art in the same position as before. The interpretation of Nature and the embodiment of thought and feeling through outward things must assume a new character when it is known not only that Creation is the expression of the will of God and in its essence very good, but also that in humanity it has been taken into personal fellowship with the Word, through whom it was called into being.'[7] 'If God has elected to show himself definitively in the form of a human life', writes Aidan Nichols, 'then may not the artist shape and fashion visual images which will add up to an exegesis of revelation?'[8] On such grounds the church for centuries urged the educative value of images, and art was regarded as a visual key to divine grace.[9] It mediated between the spiritual and the physical, body and soul, being material itself but dealing with inner reality.[10] Indeed, it can be argued, the form-creating, image-making activities of human history are basic to any quest for a spiritual unity within the conflicting forces of our existence.[11]

The conflict of interpretations illustrates how ambiguous words can be, but perhaps images are more ambiguous still.[12] This ambiguity may be a virtue: in the image, 'There is something hidden and yet revealed, transcending the world of facts and ideas, belonging instead to the territory of image and symbol.'[13] No form of art is susceptible simply to analysis: 'If I could tell you [what it meant]', remarked Anna Pavlova, 'I would not dance'. 'The meaning embodied in the artwork is communicated in a unique sui generis manner. It is found in the very organisation of the sensuous and lies in the spatial schemata of the canvas. This meaning defies translation into the clarity of prose because it is inexhaustible.'[14] That meaning which goes beyond words in any work of art is what makes it potentially revelatory.

At the same time, every work of art, whether painting, music or dance, has its context. There is no unmediated vision. The painter sees with eyes taught both by fellow artists and by his or her whole culture. Leonardo made mistakes in his anatomical drawings because his reading of Galen led him to see things which were not there.[15] Even a peasant painter like

Jean-Francois Millet knew Virgil off by heart and Ronald Paulson talks of the 'extraordinary literacy' of Constable's letters. 'All art originates in the human mind', insists Ernst Gombrich, 'in our reactions to the world rather than in the visible world itself, and it is precisely because all art is "conceptual" that all representations are recognizable by their style.'[16]

For this reason, as well as the intrinsic ambiguity of images, paintings also attract a conflict of interpretations. Thus Botticelli's *Primavera* has been found to exemplify everything from melancholy to laughter, pregnancy to consumption.[17] In a fascinating study Stephen Daniels has charted the ways in which Constable's art has been interpreted and used politically by both left and right since the painter's death.[18] It is a fantasy to think that there is some visual realm unmediated by culture, in which we interpret the visual solely through the visual. Gombrich went so far as to argue that it was a 'heresy' to think any painting records a sense impression or feeling. 'All human communication is through symbols, through the medium of a language, and the more articulate that language the greater the chance for the message to get through.'[19] For that reason parable, which is a word picture, seems an excellent category for thinking about art theologically and for that reason images have more than aesthetic significance – the whole point of the first commandment. Iris Murdoch argued – extravagantly – that the appreciation of art is a completely adequate entry into (and not just an analogy of) the good life, since it is the checking of selfishness in the interest of seeing the real.[20] There is probably no completely adequate entry into the good life but there is no reason to doubt that, pace Plato, learning to appreciate images may lead us more deeply into an understanding of truth and reality. A painting, says Aidan Nichols, may serve as a profoundly educative lure for human beings, a fact highlighted by noting that in medieval Russia the very word for education, *obrazovanie*, suggests 'becoming like forms', where 'forms' means images or icons.[21] Such a discipline of seeing has all the more importance in a world awash with images, where most images are employed to sell us either goods or ideologies, and, in both cases, mostly lies. In such a world attention to profound images could cleanse the doors of perception.

In the three chapters which follow I have concentrated on three sets of images. I begin with Botticelli's two most famous secular images, among the first and still among the greatest secular paintings ever done. Their context in the Florence of the iconoclast Savonarola makes them especially fascinating. By way of contrast I turn to images of peasants from the period roughly fifty years after Botticelli, to the end of the nineteenth century. According to many interpreters these are images of class hatred and derision: I beg to differ, and I want to set earth and air, the ethereal and courtly and the mud-stained and poor, alongside one another. Pictures of peasants were often genre pictures – charming, amusing or sentimental – but in some of these pictures genre is left far behind and we have great art in which the dignity and tragedy of poverty is evoked. Finally, in Chapter 4 I turn to portraits for, as the eighteenth-century art critic Jonathan Richardson noted, Christians have every reason to expect something revelatory in depictions of the face.

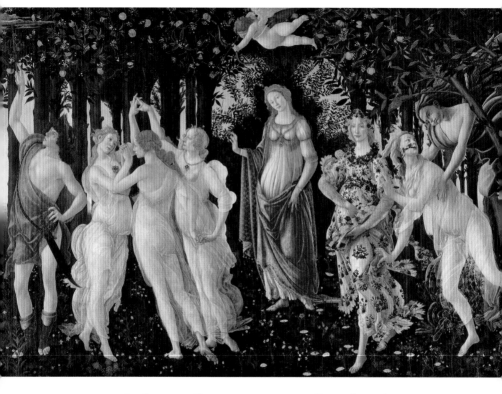

6 Sandro Botticelli, *Primavera*, c.1482, Uffizi Gallery, Florence

2

RADIANT HUMANISM

On 7 February 1497, the last day of carnival, the Dominican friar Giro-lamo Savonarola celebrated mass in Florence, and a vast procession, led by children, made its way to the Piazza. Here a huge bonfire had been prepared, 60 feet high and 240 in circumference. On this had been piled up luxuries, books, including editions of Boccaccio, but also pictures. Vasari talks of the destruction of sculpted heads of beautiful women and '*figure ignude*'. Botticelli is recorded to have painted many such themes, and their disappearance has leant substance to the idea that some of his paintings were burned on the pyre.[1] We know for certain that Botticelli was a *piagnone*, a follower of Savonarola, from his *Mystic Nativity*.[2] Apart from this, and a crucifixion, Botticelli seems to have painted little after Savonarola's death. Vasari records that he died 'ill and decrepit' in 1510.[3]

In a beautiful phrase Karl Barth speaks of the 'radiant humanism' of the Christian scriptures. He does not elaborate, but the remark comes in the context of his exposition of the Christian doctrine of what it means to be human. When Barth went to Florence he used to say, 'I have a friend in this city' – and this was Botticelli! If one wants radiant humanism surely it is the paintings of Botticelli, and not primarily the religious paintings but the great mythologies, *Primavera* (fig. 6) and the *Birth of Venus* (fig. 7).[4] But was it not precisely in respect of such paintings that Savonarola persuaded Botticelli that he had made a terrible mistake? How are we to

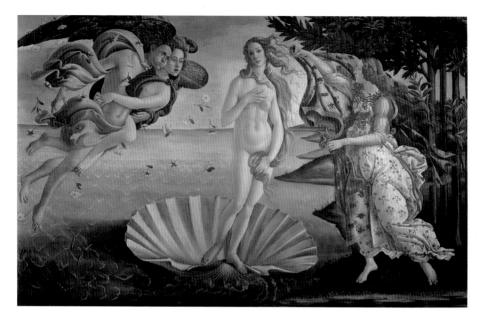

7 Sandro Botticelli, *Birth of Venus*, c.1485, Uffizi Gallery, Florence

reconcile 'radiant humanism' and the Bonfire of the Vanities? Does the humanism of *Primavera* have anything to do with the gospel of Christ? Germain Bazin describes Fra Angelico, who decorated the priory in which Savonarola lived and worked, as a 'Christian humanist', and by and large one wants to accept the description, but the preponderance of depictions of the cross in San Marco comes as something of a shock.[5] In each of these the blood streams down from Christ's feet and side to the foot of the cross, the symbol of redemption. In the prior's cell Savonarola's banner is preserved. It bears the text which the Dominicans took as their motto, 1 Cor. 1.23: 'We preach Christ crucified'. His most popular treatise, reissued repeatedly for the next two centuries, was called 'The Triumph of the Cross'. San Marco was an observant cloister and throughout the fifteenth century different priors, while encouraging Fra Angelico and building up a great humanist library (which included the purchase of the Medici library

by Savonarola, when the state was in difficulty), nevertheless called people to what today would be considered an ascetic Christianity. This call rang true with many besides Botticelli. Michelangelo is said to have painted the Sistine Chapel roof with only the sermons of Savonarola for company. The poet Girolamo Benivieni, defending the burning (which, he says, included panels and canvases covered with precious but indecent paintings), warns that any Christian condemning it should 'put off the spectacles of Satan's pride, and assume those of Christ's humility, before passing judgement'.[6] Savonarola wanted a purified Florence centred on worship of the crucified Lord. He was happy with art, but wanted a sacred art which served the gospel. In this he stood in a tradition that went back at least to Bernard of Clairvaux and that had countless medieval exemplars, and was soon to be taken up by Calvin and his followers.[7] Given this, is it feasible to talk of the 'radiant humanism' of Christianity and is there any way in which paintings such as *Primavera* and the *Birth of Venus* can be understood as in some sense evangelical, as 'secular parables'?

THE THEOLOGICAL MEANING OF BOTTICELLI'S SECULAR ALLEGORIES

A debate about the meaning of these paintings has gone on now for well over a century, and we cannot speak of consensus. Warburg and Horne understood them as relatively straightforward illustrations of classical or neo-classical texts.[8] Gombrich, by contrast, insisting on the importance of contextual reading, began from the clue that *Primavera* was painted for the nephew of Lorenzo the Magnificent, Lorenzo di Pierfrancesco, who was part of the Neoplatonist circle around Marsilio Ficino. He drew attention to a letter from Ficino to the younger Lorenzo, in which Venus and Mars and the other planets functioned allegorically as illustrations of the virtues to which the young man had to conform.[9] Gombrich cited a passage in which Ficino argued that Venus was an allegory for *humanitas*. A person's soul, said Ficino, ought to contemplate 'Venus herself, that is to say Humanity':

This serves us as an exhortation and a reminder that we cannot possess anything great on this earth without possessing the men themselves from whose favour all earthly things spring. Men, moreover, cannot be caught by any other bait but that of Humanity. Be careful, therefore, not to despise it, thinking perhaps that 'humanitas' is of earthly origin. For Humanity herself is a nymph of excellent comeliness born of heaven and more than others beloved by God all highest. Her soul and mind are Love and Charity, her eyes Dignity and Magnanimity, the hands Liberality and Magnificence, the feet Comeliness and Modesty. The whole, then, is Temperance and Honesty, Charm and Splendour. Oh, what exquisite beauty! How beautiful to behold. My dear Lorenzo, a nymph of such nobility has been given wholly into your power. If you were to unite with her in wedlock and claim her as yours she would make all your years sweet and make you the father of fine children.[10]

Gombrich did not claim that this explained the composition of the painting, but he did claim that it explained its ambience. By contrast Ronald Lightbown, in 1978, wrote that 'The great argument against interpreting the *Primavera* in too lofty and didactic a mode is the sensuality, discreet but unequivocal, which pervades it . . . the Graces, Flora and Chloris are designed to excite concupiscence . . . the natural tension of desire for beautiful young forms.'[11] He considered it simply a beautiful, and rather erotic, gift for a wedding. In the same way *The Birth of Venus* is 'a celebration of love and a celebration of woman's beauty . . . It is a mistake to suppose that every secular painting of the Renaissance was heavily charged with moral significance'.[12] More recent scholars have preferred to read it in terms of the Petrarchan courtly love tradition, or in terms of the chivalry of the joust.[13] Such readings seem to me to reflect the attenuated sense of symbolism of our own culture, and certainly the assumption of a split between sacred and secular at this time is largely anachronistic. As we noted in the first chapter, there were indeed paintings not on religious themes, but they existed within a context where every detail was understood from the perspective of faith.

Burckhardt famously characterised fifteenth-century humanism as pagan, and argued that it got more pagan as the century went on.[14] There is a

case for arguing this, and indeed some contemporaries felt it, but at the same time one has to recognise that the enthusiasm for all things classical, for Hermeticism, for astrology and magic, was for some of the best minds inextricable from Christian faith. We can see this in what many people regard as the manifesto of Renaissance humanism, Pico della Mirandola's 'On the dignity of man'. Pico was not only a humanist and friend of Ficino, but equally a friend of Savonarola, who gave his funeral ovation. He was buried in the Dominican priory. He was a great enthusiast for the Kabbalah, and his account of it gives a flavour of the way everything was read as a source of Christian truth:

> When I had procured [the books of the Kabbalah] at no small expense and had read them through with the greatest diligence and unwearied labour, I saw in them (God is my witness) a religion not so much Mosaic as Christian. There is the mystery of the Trinity, there is the incarnation of the Word, there the divinity of the Messiah; there I read the same things on original sin, on Christ's atonement for it, on the heavenly Jerusalem, on the fall of demons, on the order of angels, on purgatory, on the punishments of hell, which we daily read in Paul and Dionysius, in Jerome and Augustine. In those matters that regard philosophy, you may really hear Pythagoras and Plato, whose doctrines are so akin to Christian faith that our Augustine gives great thanks to God that the books of the Platonists came into his hands.[15]

Note that original sin and atonement find their place in what can be discovered in the Kabbalah. His account of human dignity cites Scripture and Plato more or less equally, in much the same way that, two centuries earlier, Aquinas had cited Scripture and Aristotle. Similarly Ficino was not just a Platonist and humanist, but also a priest, and in the early days an admirer of Savonarola.[16] That he had a bad conscience about the possibility of moving too far in a pagan direction is shown by the story his biographer, Giovanni Corsi, tells us about the writing of the *Theologia Platonica*. As the writing got under way, Corsi tells us, Ficino grew more and more oppressed, so that he was unable to work. 'Marsilio intended at this time to develop fully the book of *Platonic Theology* almost as a model

of the pagan religion, and also to publish the *Orphic Hymns* and *Sacrifices*; but a divine miracle directly hindered him more and more every day, so that he daily accomplished less, being distracted, as he said, by a certain bitterness of spirit.' He realised that he was suffering these things because he had strayed too far from Christian thinkers. 'For this reason, with a change of heart, he interpreted the Platonic theology itself according to the Christian tradition.'[17] A mark of this 'turn to tradition' is his respect for Aquinas whom he cites frequently, and calls 'the splendour of Christian theology'.[18] One has to say that this respect hardly extends to the adoption of a Thomist theology. It was, however, the importance of Dionysius for Aquinas (Aquinas cites him 1700 times!) which made it plausible for Ficino to find him congenial. The background of much medieval thought is Neoplatonic, but Aquinas stopped short of emanationism, and insisted that creation is the product of God's will. His understanding of the way in which all things 'participate' in God is therefore very different from Neoplatonism. He understands it in terms of the operations of grace, whereas Neoplatonism always tends towards pantheism, an uninterrupted gradation of being between God and the microbe. Human beings, for both Pico and Ficino, occupy a central place in the great chain of being, relating to God and the angels on one side and to the body and the earth on the other. Creation as a whole is the work of the great artificer and human beings image the artificer in artistic creation. The divine art expresses itself supremely in the beauty of creation and human artistic creation responds to this beauty. 'Man's power is very like the power of divine nature', writes Ficino, 'since man rules himself through himself, that is, through his own counsel and art: uncircumscribed by the limits of corporeal nature, he emulates the individual works of higher nature'. Human cogitative reason 'displays for all to see the powers of its ingenuity and skill by way of the varied textures of wools and silk, and through pictures, sculptures, and edifices'. The arts 'fashion the matter of the world and rule over the animals and so imitate God as the artificer of nature'.[19] In perhaps his best-known work, his commentary on the *Symposium*, Ficino elaborates his vision of a world where all is created by and for love, and where love expresses itself in beauty: 'When we say "love" understand "the desire for

beauty". For this is the definition of love among philosophers. Beauty is a certain grace which most often originates above all in a harmony of several things. For from the harmony of several virtues in souls there is a grace; from the harmony of several colours and lines in bodies a grace arises; likewise there is a very great grace in sounds from the harmony of several tones.'[20] Love is nothing else except the desire of enjoying beauty. Earthly beauty is, as Plato had said, the first step on the ladder which leads us to the contemplation of the most beautiful of all objects, God.

The argument that this Neoplatonic ambience is necessary to understand Botticelli's secular paintings is currently out of fashion, but it seems to me cogent.[21] From his early portraits we know that Botticelli was a master of naturalism and Vasari tells us that Botticelli was 'an uncommonly good draughtsman and, in consequence, for some time after his death artists used to search out his drawings ... which show great skill and judgement'.[22] Botticelli *could* have opted for realism, but he abandoned this for imaginative vision under the influence of the Neoplatonic account of beauty. These great paintings are not precisely religious,

yet the sentiment is not really far removed from that of the *Madonna of the Magnificat* or the *Madonna with Five Saints* ... The same face may serve for Venus or for Mary, not, as in some later painters, because devotional feeling has been lost in classical reminiscence, but because the painter has apprehended through the pagan legend and the Christian story the light of a spiritual world that all nations and ages have desired. Therefore, the goddess of heavenly love and the Virgin Mother, daughter of her Son, may share in the same ethereal grace and wear the same expression of wistfulness, as of two beings who have come to bless the earth, but in so doing have forsaken their true home.[23]

Many writers have spoken of the 'melancholy' or wistfulness of Botticelli's faces, but perhaps what they are getting at is better caught by the term 'solemnity', a solemnity which has nothing moralising about it, but has caught that vision of the divine beauty which is mirrored in creation itself and, as Ficino argued in his *Platonic Theology*, in the body which is totally informed by the soul.

Ficino's letters are full of conventional Platonic accounts of the body weighing down the soul. In one letter, however, he writes, in words that call Botticelli to mind at once, 'The beauty of the body lies not in the shadow of matter but in the light and grace of form; not in darkness, but in clear proportion; not in sluggish and senseless weight, but in harmonious number and measure.'[24] Although Ficino may have been responsible for the Lateran Council adopting the doctrine of the immortality of the soul in 1512, he diverged from Platonism in affirming the resurrection of the body.[25] Since all motion ends in God the heavenly body will be at rest, but it will be a body 'elevated to the clarity and power of celestial bodies'.[26] In the light of both the *Symposium* commentary, and of these two great mythologies, we might speak of a realised eschatology in which there are real anticipations of the divine, glimpses of glory, in the whole of creation.

It was part of this thought world to understand the created world as a system of signs. There is nothing which is 'simply' this or that. God is present in the very heart of things, the axis of all that is: essence, life, mind, soul, nature, matter.[27] It was this view of the world which made the allegorical method, which had in any case been the common currency of the church since the third century, second nature. It was this which made it possible to read the 'secular' world as Christian: both Origen and Bernard of Clairvaux, for example, had allegorised the secular love poem which is the Song of Songs as a story about God and the soul. For this reason it seems to me that Gombrich is right to insist that, 'If we approach Botticelli's picture with the artificial antithesis of Pagan or Christian we will only get a distorted answer. If our interpretation is right this dilemma was as unreal to Botticelli as it was to Ficino. The "paganism" of Apuleius' description had undergone a complete transmutation through Ficino's moral enthusiasm and exegetic wizardry.' Echoing Robb he then goes on, 'The highest aspirations of the human mind were opened up to non-religious art. What we witness is not the birth of secular art . . . but the opening up, to secular art, of emotional spheres which had hitherto been the preserve of religious worship. This step had been made possible through the transformation of the classical symbols in the solvent of Neo-Platonic thought.'[28] In Ficino's thought, he comments, every experience can be turned into a symbol of

something higher than itself. 'With this magic wand, the secularization of life could at the same time be undone and sanctioned.'[29]

Another piece of evidence which argues against a secular reading of these great paintings is Mirella D'Ancona's study of the flower symbolism in Botticelli's painting. Beginning from a study of a now lost altarpiece, in which Botticelli painted in the names of plants (thus showing that they were not simply pretty pieces of decoration), D'Ancona turns her attention to the *Primavera*. She finds forty plants, all of which have reference to love or to spring. Significantly, she points out that Botticelli has painted a single carnation with three heads between Mercury's calf and the frame of the picture. The Greek name for carnation is 'Dianthos', flower of God. This flower, she argues, thus 'conveys the idea of the unity of the divinity in the three persons of the Trinity'. Below the carnation is a linen plant. In Book 4 of his commentary on the *Symposium* Ficino instances the linen plant as an example of attraction between humans. Linen is supposed to attract the flames of fire. D'Ancona comments, 'The flames descend onto the linen and ignite it and then, when burning, from the linen the flames ascend to heaven, having gained momentum and strength. Botticelli has depicted the flames above the plant of linen, on the mantle of Mercury. Some flames are depicted right side up, and some upside down, to show both the downward attraction to the linen and the upward path of the fire to Heaven.'[30] It is quite implausible to view this as simply decoration, like a William Morris frieze.

This is not all, however. In a number of his works Ficino set out correspondences between Christian and astrological or classical signs. Thus in his account of the hierarchy of Pseudo-Dionysus, angels correspond to the Moon, archangels to Mercury, principalities to Venus, powers to the Sun, and so on, with the Trinity corresponding to the Empyrean.[31] The Virgin and Venus share many symbols as attributes, including the star, the rose, the garden, the mirror and the shell. This leads to a 'superimposition of images'. Similarly Mercury is often called 'Logos', the messenger of God, and his role as a guide of souls recalls Christ's role as divine mediator.[32] The poet Buonincontri, a friend of Ficino's, called the Virgin Mary a 'goddess of goddesses' and admitted that he had addressed her 'under the

fictitious name of Venus'.[33] That critics should note the resemblance between Botticelli's Virgins and his Venus is thus hardly surprising.[34] The mutual illumination between the gospel and Plato accounts for this. Venus recalls Mary; the dead Christ recalls the sleeping Mars. Christian scenes, like the stable at Bethlehem, or the two figures of Augustine, are depicted in a classical framework, and Augustine is shown reading Plato. The woods in the background to *Primavera* recall the Paradise from which we have been locked out, but which we shall re-enter after death. Botticelli did not operate in two worlds, secular and sacred, but in one, a Christian world for which the *Symposium* supplied the key. Perhaps one could compare what is happening here in art to the way that Justin accommodated Plato. Socrates, too, Justin argues, was inspired by the Logos, though only in Christ did the Logos take flesh.

In attempting a reading of the *Primavera* we could list all the available interpretations, which now extend to a metaphorical celebration of the liberal arts.[35] Rather, I will follow Ficino's example and read it eclectically. Most commentators agree that the painting relates to a wedding, probably that of Lorenzo di' Pierfrancesco with Semiramide Appiani in 1482. Venus is at the centre of the picture in her garden, the garden of love, which is also the Paradise which is our origin and our end. She is, on Panofsky's reading, the Natural or clothed Venus, the source of our human love.[36] She addresses the viewer directly and that gaze forms the axis of the painting. It has been suggested that we should read the painting from left to right, but in fact our attention circles around the figure of Venus and comes back to her. Botticelli has created an arch of trees which frame her and help create the solid still centre of a painting in which there is otherwise so much movement. Her womb is full, suggesting fecundity, and her right hand is raised in a conventional gesture of blessing – directed in this case to the Graces and to Mercury. Above her, her son Cupid aims a fiery dart at the middle of the three Graces – conventionally Chastity, a fitting representation of a bride. This Grace looks towards Mercury – perhaps the bridegroom – who dispels the clouds with his wand, and who looks heavenwards, signifying the transcendence of earthly for celestial love. Mercury is another figure who, in classical mythology, is associated

with spring.[37] For Panofsky, on the other hand, Mercury signifies reason, impervious to Cupid, but not able to rise to the realm of the celestial Venus.[38] One way or another the meaning of the picture is that progression from earthly to divine love which, for Ficino, was the meaning of the human journey. The Graces dance a solemn and beautiful round, a symbol of the music of the spheres which permeates the whole cosmos, and a fitting celebration of a wedding. To the right we have the representation of the rape of Chloris by Zephyrus – the mythical expression of the coming of spring. The beautiful figure advancing with her lap full of flowers may be Flora, which is what she seems most naturally to be iconographically, but may also be Youth, advancing into the garden of love.[39] The whole is a radiantly transfigured celebration of the love of women and men who exist not as 'dull, sublunary lovers' but in a universe issuing from love and returning to it. No shadow darkens the picture. Botticelli was described by Vasari as 'sophisticated' and Edgar Wind finds that the whole picture spells out the three phases of the Neoplatonic dialectic – 'procession' in the descent from Zephyr to Flora, 'conversion' in the dance of the Graces and 're-ascent' in the figure of Mercury. The marvel of the picture is that Botticelli transforms philosophical pedantry with lyrical sentiment.[40]

Botticelli's departure from naturalism to express the ideal is very clear in his depiction of the celestial, or unclothed, Venus. Her differences from antique form, Kenneth Clark comments, are not physiological but rhythmic and structural. 'Her whole body follows the curve of a Gothic ivory. It is entirely without that quality so much prized in classical art, known as aplomb; a central plumb line. Indeed the Venus' foot makes no pretence of supporting her body, and almost the whole of her weight is to the right of it. She is not standing, but floating.'[41] Botticelli represents 'a point of balance between classic and medieval thought'. This is precisely what fifteenth-century Neoplatonism offers us. The vision of the final end of human beings, of the knowledge that we are created by God and restless till we rest in God, comes from the Christian tradition. The interpretation of that in terms of the attractive power of the beauty of God comes from Plato. This Venus represents that attractive power which kindles our contemplative powers, which leads us to God; the natural Venus kindles our

human love. Divine love is superior to human love but both are equally estimable.[42] Beauty draws the soul to God, and God is the source of beauty and as the most beautiful of all things the final end of contemplation. He shared this view even with the instigator of the Bonfire of the Vanities, Savonarola, who also believed that beauty in the material world is a reflection of the divine.

BEAUTY AND THE CROSS

For centuries Christian theology has pondered on the relation between beauty and the divine, a relation problematised by the crucifixion. Christ was from the beginning understood through Isaiah 53, the figure who 'had no beauty, that we should desire him', and the crucifixion was a standing reproach to any primarily aesthetic approach to life, any divinisation of beauty in itself. Some such realisation must stand behind the Bonfire of the Vanities. At the same time Christ was 'the desire of the nations' and theologians in the Platonic tradition identified God with the essence of beauty.[43] On the one hand formal criteria of beauty were obviously inadequate to speak of God and on the other hand the delight inspired by beauty was rooted in God. Formal beauty, exquisitely painted by Botticelli, is an analogy of the beauty of God. In his commentary on the *Symposium* Ficino proposed a typical assimilation of the gospel and the Platonic tradition: 'The one and self same circle may be called beauty insofar as it begins in God and attracts to him; love, insofar as it passes into the world and ravishes it; and beatitude insofar as it reverts to the Creator.'[44] In his commentary on Dionysius' *Divine Names* Aquinas seems to agree with this, describing beauty as 'a participation in the first cause, which makes all things beautiful. So that the beauty of creatures is simply a likeness of the divine beauty in which things participate'.[45] In the *Summa theologiae*, however, although he discusses beauty in the context of the Three Divine Persons he nevertheless rejects an ontological account of beauty in favour of a phenomenal one, distinguishing sharply between the beautiful and the good, thus separating 'the aesthetic experience from its metaphysical main-

spring, love'.[46] Aquinas distances himself from the Neoplatonic account of beauty in order to preserve the divine transcendence.

An appeal to the significance of beauty which has some analogies with that of Ficino can be found in authors who in no way share his metaphysic. Paul Tillich recalled the impact of seeing Botticelli's *Madonna and Child with Singing Angels* in Berlin, while on leave from the trenches in the First World War. 'In the painting there was Beauty itself . . . As I stood there, bathed in the beauty its painter had envisaged so long ago, something of the divine source of all things came through to me. I turned away shaken . . . I believe there is an analogy between revelation and what I felt . . . the experience goes beyond the way we encounter reality in our daily lives. It opens up depths experienced in no other way.'[47] A secularist like John Berger finds himself moved to write about beauty in a similar way. 'However it is encountered', he writes, 'beauty is always an exception, always in despite of.'

> This is why it moves us . . . we live in a world that has to be resisted. It is in this situation that the aesthetic moment offers hope. That we find a crystal or a poppy beautiful means we are less alone, that we are more deeply inserted into the existence than the course of a single life would lead us to believe . . . All the languages of art have been developed as an attempt to transform the instantaneous into the permanent. Art supposes that beauty is not an exception – is not in despite of – but is the basis for an order . . . Art does not imitate nature, it imitates a creation, sometimes to propose an alternative world, sometimes simply to simplify, to make social the brief hope offered by nature . . . the transcendental face of art is always a form of prayer.[48]

The step back that Aquinas takes in the *Summa*, the insistence on the contingency and otherness of the creature, is important, and it reveals a crucial faultline in Christian theology. At the end of the day Aquinas stays with the primacy of revelation, which is to say, with the Scriptural narrative, according to which beauty is defined and critiqued by the cross. What we find in Ficino and Tillich by contrast, reflected in Botticelli, is an appeal to beauty which constitutes its own form of natural theology. Many critics

need to use the word 'grace' when writing of Botticelli's paintings. 'Botticelli dreams fantastic arabesques', wrote Lionel Venturi, 'slow and continuous dance-rhythms, the gracefulness of line; and he knows how to realize them in their function of relief and movement. Nothing can take from his line its contemplative value, its fairy-like delicacy, even when it is based on natural vision. And natural vision thus becomes the form of his dream.'[49] Botticelli delighted in drawing all objects responsive to the power of wind, notes Nesca Robb. 'His works are full of this wind-born movement which shivers through the outer world and communicates itself to the dancing figures that look as if they were poised for flight . . . Swift light movement has always been pre-eminent among symbols of spiritual life and, above all, of spiritual joy.'[50] What we have in all these paintings is an imaging of the grace which will characterise the resurrection body according to Ficino.

In his great *Social History of Art* Arnold Hauser refers to the second half of the Quattrocento in Florence as having the culture of a 'second generation', no longer primarily concerned with business but with culture and pleasure. Hauser feels that Neoplatonism is the philosophical movement which accompanies this change.

> Neoplatonism, like Platonic idealism itself, was the expression of a purely contemplative attitude to the world and, like every philosophy that falls back on pure ideas as the only authoritative principles, it implied a renunciation of the things of 'common reality'. It left the fate of this reality to the actual holders of power; for the true philosopher strives, as Ficino thought, only to die to temporal reality and to live in the timeless world of ideas. It is obvious that this philosophy appealed inevitably to a man like Lorenzo, who had destroyed the last vestiges of democracy and disapproved of every kind of political activism.[51]

This view accounts for Hauser's severe assessment of Botticelli's 'effeminate melancholy'. Against this we might set the argument of D. H. Lawrence that the miners of his Nottinghamshire villages 'needed beauty more than they needed bread'. The crowds that flock to the Uffizi to see these paintings, and the popularity of the images in reproduction, are a response to this beauty.[52] Ultimately, a theological reading of Botticelli's secular paint-

ings does not rest on arguments about fifteenth-century Neoplatonism, interesting as these are, but on the role of beauty within the Christian revelation, on the claim that the cross does not simply cancel or contradict the beauty of the created world, but rather insists that it has to be read in the light of pain, sin and evil. The cross represents a hermeneutic of suspicion vis à vis all mere aestheticism. Dominican that he was, Savonarola was aware precisely of this, and in this he was much more deeply in line with the Christian tradition than Ficino.[53] In Luther's terms, he wanted a theology of the cross, not a theology of glory. It was this suspicion which led him to consign earthly vanities to the bonfire. At the same time, as John de Gruchy puts it, 'Truth without goodness and beauty degenerates into dogmatism, and lacks the power to attract and convince; goodness without truth is superficial, and without beauty – that is without graced form – it degenerates into moralism. Alternatively we could say that truth and goodness without beauty lack power to convince and therefore to save.'[54] For von Balthasar, 'We can be sure that whoever sneers at the name of beauty as if she were the ornament of a bourgeois past can no longer pray and soon will no longer be able to love . . . In a world without beauty . . . the good also loses its attractiveness.'[55]

Here, then, is the antinomy which Christian theology faces. We have to ask whether Savonarola, like Calvin after him, did not succumb to dogmatism and moralism. For all the undoubted rightness of Aquinas' careful reservations in the *Summa*, is it not the case that there is an understanding of grace in Botticelli's paintings which has to be understood and appreciated if it is going to be possible to speak of radiant humanism? Is it not the case that what is drawn here is a theology of creation, an 'original blessing', as a later Dominican called it, which has to be affirmed? Savonarola and Botticelli: these two linked figures of the Florentine Renaissance raise the question of the nature of revelation. Botticelli, a *piagnone*, a pious follower of Savonarola, puts to us the question whether he does not witness to the truth of God in his secular paintings in a way that we cannot do without, and which Savonarola, Aquinas and the mainstream Christian tradition have shied away from. Without this witness, we have to ask, can we really speak of the gospel as radiant humanism?

8 Pieter Brueghel the Elder, *Peasant Dance*, 1566–7, Kunsthistorisches Museum, Vienna

3

PIG EARTH

Peasants dancing, eating, brawling, even defecating, were a surprisingly common theme in early sixteenth-century art. Such pictures constituted 'a striking contrast to the ideals of refinement and elegance that inspired upper class life'.[1] That refinement and elegance was certainly aspired to by Botticelli's patrons, and if his paintings stood alone as secular parables we might suspect the assimilation of the gospel to a Platonizing exegesis. A very proper endorsement of art can become an improper aestheticisation in which issues of social justice are sidelined, as they were under the Medici. By way of counterpoint, therefore, I want to explore images of peasants in art. Such depictions are much less familiar than those of Venus but they nevertheless form a consistent theme from Brueghel the Elder to Oscar de Rivero. They form a bridge between the secular icons of Botticelli and the portraits that I will look at in the next chapter: in many cases they depict individuals, but individuals without a name. They are people very near the bottom, if not at the very bottom, of the social hierarchy. What were the artists doing? Why did they paint peasants? Can we learn anything from these depictions, and if so what? Are they informed by Christian teaching? Do they challenge it? Can they, in short, be regarded as secular parables?

CLASS RIDICULE

Recent discussions of sixteenth-century depictions of peasants have on the whole concluded that they represent a form of class ridicule. Much of the discussion has centred on two of Brueghel's best-loved pictures, the *Peasant Dance* (fig. 8) and the *Peasant Wedding* (fig. 9), both painted in 1566 or 1567. In the former the two largest and most active figures are a peasant, with a spoon in his cap, bringing his wife to join two other couples in a dance in a village square. We view the whole scene from low down, which enhances the monumental stature of the leading figures. Another man pulls his wife into the dance further back in the picture. A large crowd is discernible in the background. The occasion is clearly festive, possibly a religious festival judging by the picture of the Virgin which is nailed to the oak tree whose leaves proclaim it to be high summer. Music is being provided by a bagpiper to the left, who is being proffered refreshment. More peasants are seated at an inn table whose other inhabitants are somewhat the worse for wear. Behind them a couple are locked in an embrace which presumably would not be in place in polite society.

The *Peasant Wedding*, on the other hand, takes place indoors and the crossed sheaves above the only figure seated on an independent chair may indicate that it is harvest time. The bride is seated under her crown, flanked by two women. Food is being served at speed, and wine is being called for and poured with a flourish. Two bagpipers are in service, though one is looking to the food. A crush of people at the door seem to be coming in for the festivities. In the right-hand corner, a monk or friar, perhaps the celebrant, is in lively conversation with a well-dressed man with a sword. People are doing what they do at weddings: eating, drinking and talking; the din is audible.

How should we read these paintings? For some, Brueghel's peasants are humanity seen through the eyes of class condescension and even class hatred.[2] Others view them as a form of satire emerging from humanist circles for whom peasants were almost bestial figures.[3] Peasants were said to be born under Saturn and in the prints of the *Seven Planets* by Heemskerck, published by Brueghel's own employer, the children of Saturn are beggars,

9 Pieter Brueghel the Elder, *Peasant Wedding*, 1566–7,
Kunsthistorisches Museum, Vienna

cripples, ploughmen, figures working in the field and tending livestock. Another book, published in 1564, says peasants are destined to come to a bad end, ailing, avaricious, sad, unfaithful, dishonest, sluggish, too fond of food and drink.[4] The people who bought these pictures, by contrast, saw themselves as sober and restrained. On this view the peasant pictures provided Brueghel's viewers with an opportunity to discuss the role of education and the importance of adult models for the young.[5] Shoes are said to be a sign of envy, and these are prominent both here and in the picture of *Dulle Griet* (fig. 10).[6] The broken or overturned pitcher was familiar as a sign of sexual promiscuity and hatchets also have a sexual significance.[7] The faces in the *Peasant Dance* and the *Peasant Wedding* are supposedly

10 Pieter Brueghel the Elder, *Dulle Griet*, 1561–2,
Museum Mayer van den Bergh, Antwerp

negative images, a blend of illustrations in Renaissance physiognomy books and direct observation.[8] The wheat sheaf in the *Wedding* is by some also construed as a sign of rebellion, which Brueghel's associates would not have approved of.[9] When viewed from this perspective the paintings satisfy the goal of ancient satire which aimed to 'put philosophy on a popular level by dealing with serious subjects in a light and witty fashion and stimulate people's thinking about moral problems.[10]

It has also been argued that the suggestion that anyone might have felt sympathy for peasants in the sixteenth century is ludicrous. Laughter, it is claimed, was never sympathetic. The peasant, for sixteenth- and seven-

teenth-century audiences, was the repository of practically every vice imaginable, including gluttony, fornication, love of ostentation, laziness and aggression, but all uniting in the sin of intemperance.[11]

This account of the depiction of peasants seems to me demonstrably wrong and I want to propose, by contrast, that there were three dominant modes for understanding peasants, as reflected in art: namely comedy, appreciation and solidarity.

PEASANT COMEDY

In his lectures on fine art in the 1820s Hegel argued that in Dutch peasant paintings 'we have before us no vulgar feelings and passions but peasant life and the down to earth life of the lower classes which is cheerful, roguish and comic. In this very heedless boisterousness there lies the ideal feature: it is the Sunday of life which equalizes everything and removes all evil; people who are so whole heartedly cheerful cannot be altogether evil and base.'[12] Svetlana Alpers agrees with this judgement. She believes that the theory of peasant satire is simply mistaken and that the pictures should be viewed as comedy. She argues that the peasant is never specifically labelled in any of the sources – verbal or pictorial – as an example of sin. In particular vomiting, fighting, love making and so forth, which are sinful in other contexts, were seen in a different light when they took place at the festive holiday that was a kermis or wedding.[13] The wedding dance, she points out, was exempted from stricture by even some of the severest reformers. In Brueghel's picture of the wedding dance, therefore, the emblems of lust are disarmed by the very occasion. In engravings of the kermis the moral was 'Christmas comes but once a year' or, 'It's not a kermis every day'. She attacks what she called the 'exaggerated solemnity of the modern scholar's view', which wants to see moral sermons in everything. Consistently with her celebrated thesis about seventeenth-century Dutch art she argues that 'Brueghel's paintings reveal a more detached knowledge of peasant mores and a greater responsibility towards ethnographic accuracy than that of any other artist of his time.'[14]

Sixteenth-century comedy is not just Erasmian wit but also Rabelaisian humour for which folly is not something to be scourged but implicit in the human condition that we all share.[15] Brueghel's breadth of sympathy with humanity has been called 'almost Shakespearean', and we can recall that while the rude mechanicals in A Midsummer Night's Dream produce mirth, certainly, nevertheless a tendency to cruel mockery is rebuked by the Duke.[16] It may also be that peasants illustrate that fundamental of human life, our dependence on food, and that they may thus illustrate a universal state.[17]

Alpers concludes that the recognition of a comic mode offers a better explanation for the rise of a secular, realistic low-life art than attempts to read it didactically or moralistically. Looking at the discussion of peasants by the Dutch seventeenth-century writer Bredero, she argues that for him ordinary life, realistically rendered, was specifically concerned with the stuff of which comedy was made. The peasants to whom Bredero introduces us are not meant to evoke censorious response, nor to encourage mocking laughter; rather, they appeal to our instinct for feasting and physical pleasure.[18] For Alpers what we find in Brueghel is the bond of human sympathy found in laughter at our common human lot. It is not class ridicule but an essentially comic understanding of the world. Many commentators note the element of caricature in Brueghel, but this caricature embraces all classes as we can see from his Netherlandish Proverbs or The Fight between Carnival and Lent (fig. 11). It is by no means restricted to the peasantry.

With regard to Brueghel this has the support of his earliest biographer, Carel van Mander, who tells us that 'Brueghel practised a good deal in the manner of Jeroon van den Bosch, and made many similar, weird scenes and drolleries. For this reason, he was often called Pier den Droll. Indeed, there are very few works from his hand that the beholder can look at seriously, without laughing. However stiff, serious and morose one may be, one cannot help laughing or smiling.' Van Mander tells us that Brueghel and a friend often went on trips among the peasants, especially to their weddings and fairs. Brueghel 'delighted in observing the manners of the peasants in eating, drinking, dancing, jumping, making love, and engaging in various drolleries, all of which he knew how to copy in colour very

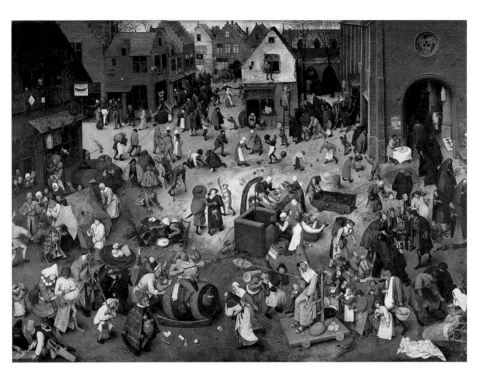

11 Pieter Brueghel the Elder, *The Fight between Carnival and Lent*, 1559,
Kunsthistorisches Museum, Vienna

comically and skilfully, and equally well with water colour and oils . . . He
knew well the characteristics of the peasant men and women of the
Kampine and elsewhere. He knew how to dress them naturally and how
to portray their rural, uncouth bearing while dancing, walking, standing,
or moving in different ways.'[19]

Beuckelaer's father-in-law, Pieter Aertsen, also fails to satirize peasant
figures. His peasants, rather, represent vulgar incidents simply to provide
entertainment.[20] While we can grant that peasant satire certainly existed,
therefore, there is another, very plausible reading of the humour involved
and one which, with regard to Brueghel, has contemporary support.

APPRECIATION

Too often in the discussions of representations of peasants the ambivalence of the medieval and Reformation tradition on this topic has not been recognised.

In fact peasants were regarded in the Middle Ages as both degraded and exemplary, as justly subordinated yet close to God.[21] The description of a filthy, wicked or bestial peasantry represented a commentary on the theory of natural slavery, which went back to Aristotle, and which was a useful ideological prop for feudalism, but which was always challenged by the Christian idea of the image of God.[22] Peasant revolts famously appealed to Genesis for the idea of original equality. Langland's version of 'Everyman' is a ploughman, and Chaucer's ploughman calls forth unstinted praise. Wycliffe insisted that 'Christ, our God, was during the time of his pilgrimage, the poorest man'. Beginning at this time, the late fourteenth century, we find widespread praise for the peasant throughout Europe.[23] The dependence of the rest of society on those who produced food was widely recognised. A late fifteenth-century German poem asks, without them,

> Who would produce the wheat,
> And also the good wine
> By which we are often gladdened?[24]

Another poem from the same period says there is no prince so worthy of praise as the peasant, who is truly noble, 'for all the world lives off his labour'.[25] In the 1515 edition of Erasmus's *Adages* peasants appear as the most innocent of mankind and the most essential to society. The leaders of the Reformation placed agriculture among the Christian occupations most beneficial to society. Montaigne argued that the simple peasants are honest people and honest people are the true philosophers. Peasants honoured royal tours in both France and England, and not simply as laughing stocks.[26]

Robert Reyce, writing in Suffolk in 1618, noted that 'I think it fit to begin with the poorer sort, from whom all other sorts of estates do take their beginning. And therefore of our poor thus much . . . as well the poor as the rich proceed from the Lord . . . the rich cannot stand without the

poor . . . and the humble thoughts which smoke from a poor man's cottage are as sweet a sacrifice unto the Lord as the costly perfumes of the prince's palace.'[27] At the same time in France the saintly Bishop François de Salles was preaching the need to attend to the poor. Throughout the Middle Ages Christianity taught the moral superiority of the poor and helpless. It was widely believed that rural folk would be saved because of the simplicity of their lives and because of their toil.[28] Peasants were regarded as divinely elected by reason of suffering, productivity, and their innate character and way of life.[29] 'The view that the Bible rather than a learned theological tradition contained religious truth, together with Luther's notion of the dignity of the common man, encouraged a more pointed version of the traditional theme of pious simplicity, a version capable of defending faith against learned impiety. The peasant, embodying this faith, was close to God not merely for negative reasons (lack of sophistication) but in his everyday existence through work rather than renunciation.'[30]

There was, therefore, certainly a critique of the peasantry as degraded and bestial, but it did not stand alone. Which tradition is it that Brueghel draws on? Ernst Fischer argued that in Brueghel 'The working people are not given a glow of false beauty, no invisible halo hovers over their heads, their strong, coarse, characteristic features are drawn with a sure hand, often almost to the point of caricature. But these caricatures are not . . . an expression of contempt for the plebeian, but the true realist's determination to represent the people as they are, with their achievements and their vices, their strengths and their shortcomings.'[31]

The peasant satire thesis as applied to Brueghel is also contradicted by the evidence of at least three other of his pictures. In *The Fall of Icarus* (fig. 12), for example, the ploughman in the foreground has a massive dignity. The picture shows the mythological to be a peripheral, transient element in the panorama of nature. The heroic-mythological is absorbed into the round of the seasons, peripheral to the routine of everyday life.[32] This ploughman is the ploughman of Langland or Chaucer, not a figure of fun, but the very centre of the moral landscape.

We can compare this picture with Brueghel's *The Adoration of the Kings* (fig. 13) which is also a peasant scene. The Son of God is born to peas-

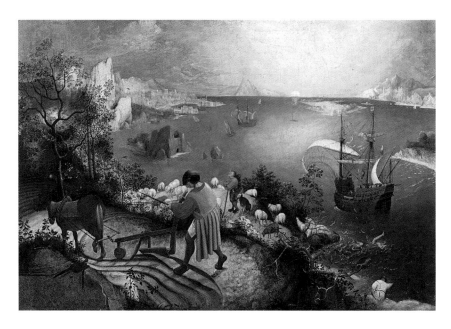

12 Pieter Brueghel the Elder, *The Fall of Icarus*, c.1558,
Musées Royaux des Beaux Arts de Belgique, Brussels

ants, in a stable built with unseasoned timber. If the soldiery and the peas-
ants to Joseph's left are caricatured then so are the kings, and the child
shrinks back not just from the myrrh but from the figure offering it. This
is a birth in a world threatened by violence, a constant theme both in
Brueghel's world and in his art. It is implausible to suggest that this picture
is the product of a learned and rather worldly-wise humanist circle. On
the contrary, we are reminded of Luther's sharp remark that Erasmus knew
nothing of the gospel, whereas we see from these pictures that Brueghel
understood it profoundly. The picture is a commentary, we might say, on
any vicious and repressive government whether in the sixteenth century or
today. Similarly, Brueghel's *Massacre of the Innocents*, which was so savage
it had to be toned down for the Emperor, with bundles of cloth substi-
tuted for children with their throats cut, is a savage indictment of what

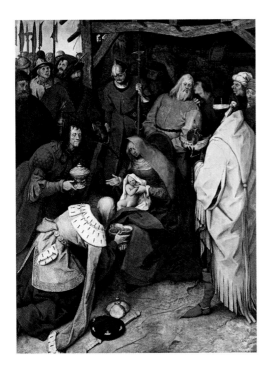

13 Pieter Brueghel the Elder,
The Adoration of the Kings,
1564, National Gallery, London

power (in this case the Duke of Alva) does to the peasantry. There is no
question here as to which side Brueghel is on.

In the following century some scholars believe that Adriaen van Ostade
charts the development of the peasantry from poverty to prosperity.[33] This
move is then read in terms of Norbert Elias's thesis about the civilising
process. Elias argued that over several centuries manners changed and
notions of civility replaced earlier more warlike mores. Perhaps there was
a move from Rabelaisian to more dignified pictures of peasants.[34] But given
the way the peasantry continued to be treated throughout Europe, as
reflected in the law codes of every country, this seems implausible and we
need to look for some other explanation.

By far the most extraordinary images of the seventeenth century come
from France about twenty years earlier, from the second of the Le Nain

57

brothers, Louis. Both Brueghel's pictures and those of van Ostade, along with most other peasant pictures in the seventeenth and eighteenth centuries, either border on, or actually are, genre pictures: they depict types, in typical situations (fig. 14). Such pictures were often sentimental, often bordered on kitsch, and were designed either to elicit a smile or squeeze a tear as in this picture by Ostade.[35] 'If the artist sets out to please, he or she will compromise the good of the thing made.'[36] This is the real weakness of the genre tradition. Nothing could be further from the peasant paintings of Louis Le Nain. After two centuries of neglect his paintings achieved canonical status in France in the second half of the nineteenth century, though they are now, once again, less well known. As has been recognised, these are in fact religious paintings. Both his *Peasant Meal*, of 1642 (fig. 15), and his *Peasant Family in an Interior*, of 1648 (fig. 16), are full of overt eucharistic symbolism. Painted in greys and browns, with the red of one or two glasses of wine to contrast, one could be forgiven for taking them for Huguenot pictures, though Laon, their home town, was not Huguenot. The subdued colours set the mood of the paintings suggesting the sobriety and earnestness of a conventicle. In the earlier picture a group of peasants sit or stand around a low table before a fireplace. A small dog on the far left is closest to the picture plane and invites us to read the painting from left to right, from whence the sunlight is streaming in. Only a small child just off centre looks straight at the viewer, drawing us in. Closest to the picture plane, on the right, a peasant solemnly, almost sacramentally, drinks a glass of wine. Behind him stands the one woman in the picture, her eyes modestly lowered. The central male figure, also holding a glass of wine, looks into the light streaming in from the right, his right hand clasping a knife to cut bread with. His gaze is reflective, meditative. Behind him is a boy ready to play a fiddle, looking intently at this man (music plays a part in most of Louis Le Nain's paintings). This figure recalls the solemn angels of Botticelli who also often make music. To his right sits a broad-shouldered man, in ragged clothes and bare feet, gazing thoughtfully into space. To his right again another boy, again with bare feet, looks out of the picture. The family is not in desperate poverty: this is shown by the wine and by the bed with its curtains behind the figure on the right, but as with the Ostade *Peasant*

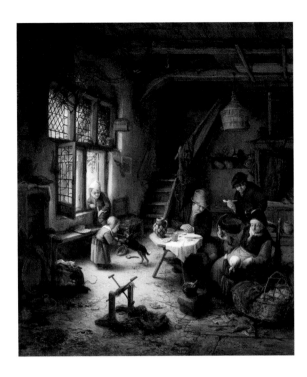

14 Adriaen van Ostade, *Peasant Family*, 1661, private collection

Family these are not wealthy people either. The sense of solemnity, of reflection, is profound. Nothing could be further from any class hatred.

The *Peasant Family* is the largest of Le Nain's peasant pictures and again uses the device of a small dog closest to the picture frame to lead the eye from left to right. Two children face the fire, which is blazing warmly. The mother of the house sits in her working apron, covered in dirt, holding a jug and a glass of wine. To her right a young girl, whose headscarf suggests earlier pictures of the Virgin, looks into the fire. In the centre of the picture a barefooted and rather tousled boy plays the flute or recorder. To his right and behind a low table on which there is one plate (almost a ciborium) sits the man of the house, looking straight at us, his hand clasping a knife to cut the huge loaf of bread. In front of the table sits the eldest daughter, also wearing her working apron. Her hands are folded in her lap

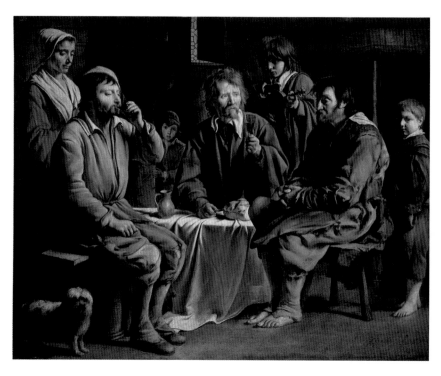

15 Louis Le Nain, *Peasant Meal*, 1642, Musée du Louvre, Paris

and she, too, looks at us. A young girl – sister, or servant – stands behind her, looking down. The youngest child, barefoot, sits on the floor at the right-hand edge of the painting looking obliquely out. The mood is not as sombre as the earlier painting, but it is again a picture of serious and massive dignity. The colours are the colours of the earth, the colours of labour. What Van Gogh wrote about Millet is true of Le Nain: 'One must be master of so many things to paint rural life . . . How striking that saying about Millet's figure is: His peasant seems to be painted with the earth he is sowing! How exact and how true. And how important it is to know how to mix on the palette those colours which have no name and yet are the real foundation of everything.'[37]

16 Louis Le Nain, *Peasant Family in an Interior*, 1648, Musée du Louvre, Paris

These are people who work the land, or mirror it. The highlights on the glaze of the bowl and of the copper or brass pot on the floor give life to the picture. A salt pot is the only other thing on the table – not a reference to the rudiments of a meal, as is sometimes suggested, but to Matthew 5.13 – 'You are the salt of the earth'. In both of these pictures there is no speech but there is music – again rather like being in church. The paintings depict the family, the centre of moral life and the centre of production, the salt of the earth as compared with the ostentatious luxury of the court. We the viewers observe the family. We look up to them from a low viewpoint. If these paintings are not a transposed version of the Holy Family, still they are images of the true Christian, of authentic Christian

living, images of 'the saints' in a New Testament sense which would have been absolutely familiar to Protestant Europe, as to the Huguenots, who at this time continued to be free to worship in France.

For whom could these pictures have been painted – in the reign of Louis XIII, while Richelieu was Chief Minister, and where already luxury and power were the rule at court? They are a standing rebuke to the ruling ethos of the day. Forty years later, in his *Characters*, La Bruyère, wrote of the peasants he observed:

> One sees certain ferocious animals, male and female, scattered over the countryside, black, livid and burned by the sun, bound to the soil which they dig and turn over with unconquerable stubbornness; they have a sort of articulate voice, and when they stand up they exhibit a human face, and in fact, they are men. They retire at night into dens, where they live on black bread, water and roots; they spare other men the toil of sowing, tilling and harvesting in order to live, and thus deserve not to be without the bread which they have sown.[38]

La Bruyère was a reforming Christian, critical of contemporary mores, but what a difference of voice from these pictures! In the whole of the Western tradition, outside overtly religious art, I know no pictures which present more compellingly, with a subdued passion, the dignity of labour, the dignity of the peasant on whom the rest of society depends. Whatever the merits of the argument about the civilising process it is hard to believe that the vision behind these pictures is anything other than Christian, whether in the tradition of La Salles, of Jansenism, or of France's persecuted Huguenot minority.

SOLIDARITY

Peasants were a familiar theme in late seventeenth-century and eighteenth-century art, but this was the peasant sanitised, working, as Henry van de Velde noted in rage, under an eternally benevolent sky, quaffing their pots

of ale. They have as much to do with real peasants as the games of Marie Antoinette. 'It needed a revolution to get free of this torpor.'[39] In point of fact it had to wait for the most celebrated of the peasant painters, Jean-François Millet. Millet was born and brought up on a peasant farm in Normandy, just such a farm as Le Nain depicts, not desperately poor but not rich either. His champion, and later biographer, was the civil servant Alfred Sensier, who tended to exaggerate Millet's peasant simplicity for reasons of his own but there is no reason to doubt the main themes which emerge from their correspondence.[40] Millet took classes in Paris but considered that he learned most from his studies in the Louvre. What is striking is the monumentality of his figures, his attempt to give his peasants an epic, almost Homeric grandeur (a point critics made at the time). 'Next to Michelangelo and Poussin', he told Sensier, 'I have always loved the early masters best, and have kept my first admiration for those subjects as simple as childhood, for those unconscious expressions, for those beings who say nothing, but feel themselves overburdened with life, who suffer patiently without a cry or complaint, who endure the laws of humanity, and without even a thought of asking what it all means. These men never tried to set up a revolutionary art, as they do in our days.'[41]

I shall take three of his pictures, beginning with *The Winnower* of 1848 (fig. 17).[42] The single figure stands in the gloom of a barn, illuminated only by the red of his headscarf, the dull blue of his trousers, tied with straw, and the dull gold of the corn. Millet captures the muscular swing of the whole body which is involved in this kind of work. We see the dirt on the man's heels, his trousers tied with straw. Millet abandons line for *sfumato* to suggest the epic grandeur of his figure. Unlike genre painting, Millet uses the minimum of anecdotal detail, and thus emphasises the archetypal reality of his figures, natural but symbolic. According to Sensier, for Millet 'the man of the soil represents the whole human family, the rural labourer provides him with the most evident signs of our actions, our labours, our sufferings'.[43] The picture was well received. Théophile Gautier noted that while it was impossible to imagine anything rougher, fiercer or more uncultivated, nevertheless the winnower emerged as a truly magisterial figure.[44] In this year of revolutions no one suspected the picture of political mean-

17 Jean-François Millet,
The Winnower, 1848,
Musée D'Orsay, Paris

ings. All this changed, however, very quickly. I have noted the ambivalence in European attitudes between mockery and admiration, but of course fear was another factor, aroused by the many medieval peasant revolts and by the Peasants' War of 1525. All of these struggles called forth savage repression and ratcheted up a negative rhetoric for which peasants were less than human. In the mid nineteenth century this rhetoric appeared again in France, and it was Millet who bore the brunt of the attack.

The Gleaners, one of his most famous pictures, appeared in 1857 (fig. 18). It is characteristic of Millet's pictures of peasants, unlike those of Le Nain, that we rarely see their faces. They are representatives of back-breaking labour. The three women here, licensed by the commune of

18 Jean-François Millet, *The Gleaners*, 1857, Musée D'Orsay, Paris

Chailly to glean in the fields, are brought right into the front of the picture plane. They are exercising the rights of the poorest part of the population to glean what is left over after the main harvest – in full swing in the distance – has been completed. The work involves being bent to the ground throughout the day. The woman on the right eases her back in the course of the work. The modelling is achieved by colour which, unlike Le Nain, is surprisingly warm, particularly in the blue and red scarves of the two women actually gleaning. The picture is artfully composed: Millet uses the golden section, emphasised by the fact that the resting gleaner, whose bonnet is straw-coloured like that in the distant field, touches the horizon line. Millet thus emphasises their monumentality and at the same time

locks them into their labour. Right-wing critics hated it. Paul de Saint-Victor said in *La Presse*, '[Millet's] three gleaners are the three Fates of poverty, scarecrows in rags'.[45] The critic in *Le Figaro* noted sourly that one could see behind the gleaners, on the horizon, the pikes and scaffolds of 1793.[46] Castagnary, defending Millet, began by noting the decline of historical painting and its replacement by genre, landscape and portrait painting which emphasised human individuality now that the old social organism of theocracy and monarchy were more or less dead. 'The modern artist', he wrote, 'believes that a beggar under a ray of sunshine has truer beauty than a king on his throne',

> that a yoke of oxen moving off to work under a cold and bright morning sun is deserving of as much religious dignity as Jesus preaching on the mountain side; that three peasants, bent double, gleaning in a harvested field, whilst in the background the owner's wagons groan under the weight of the sheaves, tugs the heart more painfully than all the tortures inflicted on a martyr. This canvas, which calls to mind frightful sufferings, is not, as Courbet's are, a political harangue or a social thesis. It is a very beautiful and very simple work of art, free of all declamation. The theme is poignantly true but, treated with great freedom, it is raised above party passions and reproduces, without any lies or exaggeration, one of the pages of true and grand nature, of the kind one finds in Homer or Virgil.[47]

Gautier wrote, 'M. Millet, it is plain, understands the true poetry of the fields. He loves the peasants whom he represents. In his grave and serious types we read the sympathy which he feels with their lives. In his pictures sowing, reaping and grafting are all of them sacred actions, which have a beauty and grandeur of their own, together with a touch of Virgilian melancholy.'[48] The references to Virgil are not fortuitous because Virgil was in fact some of Millet's favourite reading.

The Man with a Hoe of 1863 was his most controversial painting (fig. 19). Millet depicts an exhausted figure, resting on his hoe in a stony field. He dominates the landscape and demands our response. Millet is suggest-

19 Jean-François Millet, *The Man with a Hoe*, 1863,
The J. Paul Getty Museum, Los Angeles

ing that ruthless toil crucifies, as indeed it did.[49] A poem in response to it
by the American Edward Markham caught its meaning:

> Bowed by the weight of centuries he leans
> Upon his hoe and gazes on the ground,
> The emptiness of ages in his face,
> And on his back the burden of the world.[50]

Saint Victor, again, hated it. 'For M. Millet', he wrote, 'art amounts to ser-
vilely copying ignoble models. He lights his lantern and tries to find a cretin;
he must have tried hard before finding the "peasant resting on a hoe"! Such

types are not common, even in a mental hospital. Imagine a monster without a brain (*sans crâne*) with a dull eye and an idiot grin, planted side on, like a scarecrow, in the middle of a field. No glimmer of intelligence humanizes this brute at rest. Has he come to work or to kill?'[51] 'For the very first time', van de Velde wrote in 1899, 'the peasant is shown as he truly is, slaving on the earth'. For him, Millet catches the hatred the peasant feels for the unrelenting earth, with which he has to struggle eternally.[52]

Religious references are frequent in Millet's paintings and here, as Castagnary recognised, there is almost certainly an allusion to the Man of Sorrows. A crown of thorns, he points out, can be seen on the ground to the left of the figure. Millet responded to his critics:

some say I deny the charms of the countryside. But I see in it more than charm, infinite splendours. Just as they do, I see the little flowers, of which Christ said 'Solomon in all his glory was not arrayed like one of these'. I clearly perceive the haloes of the dandelions, the sun shedding over the earth beneath, far away into the distance, its heavenly glory. But there on the plain I also see the steaming horses at the plough, and on stony land I see an exhausted man, whose grunts have been audible since morning, stretching for a moment and trying to catch his breath. The drama is wrapped in splendours. That is not my invention: 'the cry of the earth' is a term that has existed since time immemorial. I expect my critics are men of erudition and taste; but I can't put myself in their shoes, and as I have never known anything else in my life but the fields, I try as best I can to say what I saw and experienced while I was working there. Those who think they could do better are obviously in an enviable position.[53]

The painting aroused fury because it seemed to deny the upward mobility that lay at the heart of conventional faith in human progress.[54]

In his early work Van Gogh was inspired by Millet whom he called 'father Millet', 'a guide and counsellor to the younger painters in all things'.[55] Millet painted the dreariness, the misery, the hopelessness of a peasant's work and life, not from the outside but as a peasant among peas-

20 Vincent Van Gogh, *The Potato Eaters*, 1885, Van Gogh Museum, Amsterdam

ants, wrote Ernst Fischer: 'The same bowed backs, the same heads, but still more dreadfully, more hopelessly bent earthwards, recur in the paintings of Van Gogh, who began by copying Millet and who in the loneliness of his genius went far beyond him.'[56] I want to end this chapter by looking at Van Gogh's *The Potato Eaters*, painted in 1885 (fig. 20). Here as in Le Nain we have a family at supper, but how different the atmosphere! Two women, two men and a child are found in a dark dingy room, lit by an oil lamp. Their faces are gaunt. Three reach out to the dish of potatoes, while one of the women pours some tea. Van Gogh gave accounts of his progress on the picture to his brother Theo. 'I have tried to emphasize', he wrote, 'that those people, eating their potatoes in the lamplight, have

dug the earth with those very hands they put in the dish, and so it speaks of manual labour, and how they have honestly earned their food'.

I have wanted to give the impression of a way of life quite different from that of us civilized people. Therefore I am not at all anxious for everyone to like it or to admire it at once.

All winter long I have had the threads of this tissue in my hands, and have searched for the ultimate pattern; and though it has become a tissue of rough, coarse aspect, nevertheless the threads have been chosen carefully and according to certain rules. And it might prove to be a *real peasant picture. I know it is.* But he who prefers to see the peasants in their Sunday best may do as he likes. I personally am convinced I get better results by painting them in their roughness than by giving them a conventional charm ... If a peasant picture smells of bacon, smoke, potato steam – all right, that's not unhealthy ... one must paint the peasants as being one of them, as feeling, thinking as they do. Because one cannot help being the way one is.

I often think how the peasants form a world apart, in many respects so much better than the civilized world. Not in every respect, for what do they know about art and many other things?[57]

Like Millet, there were explicit religious references in Van Gogh's paintings, and there is certainly intended to be something of a sacramental character in this picture, a reference to the eucharist, and perhaps a look back to Le Nain's *Peasant Meal*. The oil lamp recalls the light of the spirit in Renaissance eucharistic paintings such as Tintoretto's *Last Supper* in San Rocco, Venice. By the time Van Gogh painted this there was a real 'cult of the peasant' in France, but he will have nothing to do with it.[58] Where others found the nobility of labour, untouched by the dismal processes of industrialisation, he found only poverty and suffering. Both in his earlier mission work and in this picture what Van Gogh was expressing and seeking, as the letter I have quoted makes clear, was solidarity.

By the end of the nineteenth century peasants had ceased to be the enemy within the gates and had become Rousseau's noble savage, examples of

labour to everyone else, loyal and faithful in contrast to the proletarian mob. Such idealisation perhaps has some contact points with the noble ploughman of late medieval thought, but this was always contrasted with other more negative attitudes. For obvious reasons the poor, and the labourer, very rarely appear in the great tradition of European painting. History painting was the dominant genre for nearly three hundred years. Genre painting, which did feature the poor, did so in stereotypical ways designed to make a moral point. The sympathy with which the poor are viewed when they are seen independently is, therefore, all the more impressive. To understand their significance we have to remember that the agenda of the liberation theology which emerged in Latin America at the end of the 1960s was not the non-believer, as it was in Europe, but the non-person. These paintings, it seems to me, render the invisible visible, the non-person a person. Like the Beatitudes they tell us something as well about the privileged role of the poor – the physically, concretely poor, the dispossessed and oppressed – in God's kingdom.[59] They ask us to reflect not just on labour and poverty but more broadly on our understanding of the human and therefore on the God in whom we believe. They invite us to different understandings of body and society. In these ways, and in a way poles apart from an elite art like that of Botticelli's, they may be considered 'secular parables'.

21 Raphael, *Baldassare Castiglione*, 1514–15, Musée du Louvre, Paris

4

CATCHING SHADOWS

THE GOSPEL AND THE FACE

'We have some advantages which earlier painters did not have', remarked Jonathan Richardson in 1725. ''Tis our religion, which has opened a new and a noble scene of things; we have more just, and enlarged notions of the deity, and more exalted ones of human nature than the ancients could possibly have: and as there are some fine characters peculiar to the Christian religion, it moreover affords some of the noblest subjects that were ever thought of for a picture.'[1] The great Elizabethan miniaturist Nicholas Hilliard had already commented in the sixteenth century that the painter must favour 'our divine part which is the human face'. 'Of all things', he wrote, 'the perfection is to imitate the face of mankind, or the hardest part of it, and which carrieth most prayers and commendation'.[2] In *The Gentleman's Exercise*, written the year after the appearance of the Authorized Version, Henry Peacham opined that portraiture offered unbounded delights: 'Since man is the worthiest of all creatures, and such pleasing variety in countenances so disposed of by the divine providence, that among ten thousand you shall not see one like another', faces were the draughtsman's starting point.[3] Constantijn Huygens, one-time patron of Rembrandt, argued that the human face is 'a miraculous digest of the whole man, both in body and spirit'. 'Portraitists make us immortal, allow

us to commune with our ancestors, and afford us the pleasure of reading the character of our fellow men in their physiognomies.'[4] From a very different standpoint two and a half centuries later Charles Blanc wanted to remind critics that, 'if the purpose of art is to express life . . . the human figure is the most exalted image that an artist can propose for a model, because it sums up all prior creation. Filling the immense space that separates intelligence from vegetation it manifests the highest degree of life, which is to say thought . . . it is impossible to equate, to give equal merit to, landscape and the human figure.'[5] For Francis Bacon, nihilist that he was, portraits were the supreme form of art, articulating the obsession with life which lay at the heart of art.[6] The frame around great portraits, reflected Hegel, is like a door into the world the sitter is entering. In Dürer's portraits, he argued, 'we have before us the entirety of a spiritual life. The longer one looks at such a picture, the more deeply one immerses oneself in it, all the more does one see emerging from it. It remains like a clear-cut, spiritually full sketch which contains the character perfectly, and it executes everything else in colours and forms only to make the picture more intelligible, clearer, more of an ensemble, but without entering, like nature, into the detail of life's mere poverty.'[7]

Such views are just what we might expect from a culture influenced by a religion which sets as much store on the face as does Christianity. In a subtle piece of storytelling which lies at the root of much biblical reflection on the face the Yahwist had depicted Jacob's encounter with God in terms of his encounter with the face of his estranged brother, Esau (Gen. 32). Alluding to Moses' inability to see the face of God, Paul claims that in the new dispensation 'we all with unveiled face, beholding the glory of the Lord, are being transformed into his likeness from one degree of glory to another; for this comes from the Lord who is the Spirit' (2 Cor. 3.18). This possibility rests on the revelation of God in the face of Christ: 'For it is the God who said "Light will shine out of darkness", who has shone in our hearts to give the light of the knowledge of the glory of God in the face of Christ' (2 Cor. 4.6).

In recent years, following the lead of another French Jewish philosopher, Emmanuel Levinas, the face has become a focus for theological reflection.[8]

Each face, it has been argued, is an interrupting summons to justice and peace, with endless ramifications for economics, politics, institutions and other structures.[9] Christianity is characterised by the simplicity and complexity of facing: being faced by God, embodied in the face of Christ; turning to face Jesus Christ in faith; being members of a community of the face; seeing the face of God reflected in creation and specifically in each human face, with all the faces in our heart related to the presence of the face of Christ; having an ethic of gentleness towards each face; disclaiming any overview of others and being content with massive agnosticism about how God is dealing with them; and having a vision of transformation before the face of Christ 'from glory to glory; that is cosmic in scope'.[10] The face stands for the way the other questions the self and is unassimilable. The face is an 'epiphany', a 'revelation' embodying otherness and particularity. No matter to what extent we are formed by our culture and our social role, we might say, still the individual face goes beyond it.

> What is your substance, whereof are you made,
> That millions of strange shadows on you tend?[11]

Shakespeare, as usual, catches the mystery which does not diminish with acquaintance but increases. Portraiture is chasing shadows: it is 'the sign of an absence, an expression of nostalgia, a response to death'.[12] 'The portrait conveys both absence and presence', wrote Pascal, 'pleasure and displeasure. Reality excludes both absence and displeasure'.[13] If that is the case, how is portraiture possible? How can shadows be caught? Raising precisely such questions the rabbis prohibited depictions of the face. Arguing that the divine could be encountered in and through the face it was then felt that idolatry could only be avoided if the face was incompletely rendered, perhaps by using a profile or putting one eye into complete shade.[14] Rothko, a Jew himself, agreed: 'Whoever makes use of the [human figure] mutilates it. No one can paint the human figure as it is, in having the feeling of producing something that expresses the world.'[15] Rembrandt famously leaves the eyes of many of his portraits in the shade so that the viewer has to supplement the artist's work. Analogously, the rabbinic principle wanted to insist that a complete or total portrait should

not be sought. In putting his name on the portrait of Boniface Amorbach, Holbein used the imperfect (*Dipingebat*) 'to show that the work is imperfect, that the portrait always remains unfinished, because one can never pin down one moment in the inexorable course of life'.[16]

It is possible that some such principle lay behind the lack of realistic portraiture in the Middle Ages, though perhaps more important was the intense focus on the divine rather than the human, on the other world rather than on this.[17] This is suggested by the fact that it took the Renaissance glorification of the human to produce the portrait as we know it. Even so, portrait painting rarely occupied a very high place. Carel van Mander wrote, at the beginning of the seventeenth century, 'Most artists are attracted by a sweet profit, and as they have to support themselves, they take this by-path in art – the painting of portraits from life. Artists travel along this road without delight, in time to seek the main road – the painting of compositions with human figures, the road that leads towards the highest in art. Many fine, splendid talents have remained unproductive, and this is regrettable.'[18]

He was prepared to qualify this judgement, but only to the extent that portraiture exercised the painter's skill: 'The term, by path, or side road, as I have used it, may seem too severe. It needs, perhaps, a little softening with a brush or a feather. I say, therefore, that something very good can be made of a portrait; the face, the most lively part of the human body, has a great variety of interesting expressions, and an artist by translating one of these expressions may reveal the virtues and the expressive power of art.'[19]

Van Mander's negative judgement on portrait painting was widely shared. According to some sixteenth-century theorists, portraiture required merely sufficient technical proficiency on the part of the artist to copy nature. It involved no invention of the kind found in history painting. 'Even an artist of mediocre talent', Armenini claimed, 'can master this art of portraiture'.[20] In the twentieth century portraiture was disparaged on other grounds. For Clive Bell descriptive painting was not art. Portraits 'leave untouched our aesthetic emotions because it is not their forms but the ideas or information suggested or conveyed by their forms that affect

us'.[21] Much twentieth-century art theory disparaged portraiture because it was too mimetic: an ironic version of the Renaissance idea that history painting, which employed real invention, was the summit of painting.

In addition to art-critical reservations, hesitations about portraiture are expressed not on the grounds of its ranking in the overall artistic hierarchy but on the grounds that we no longer know who the individual is, a line of questioning which, of course, pulls in completely the opposite direction to the revelation of the face. Psychoanalysis, the awareness of the extent to which we are formed by social interaction, and the loss of self articulated in postmodern theory, all raise questions about identity and therefore about the very possibility of portraiture. Proust pointed out that we are not a materially constituted whole, identical for everyone, which each of us can examine like a list of specifications or a testament but that our social personality is a creation of other people's thought.[22] Again, we are aware today that, as Rilke put it, we do not have one face but several, depending on the situation in which we find ourselves.[23] John Berger suggested at the start of the 1970s that the fact that individuality was now understood in terms of historical and social relations meant it was unlikely that any important portraits would ever again be painted.[24] 'We can no longer accept that the identity of a man (sic) can be adequately established by preserving and fixing what he looks like from a single viewpoint in one place . . . Our terms of recognition have changed since the heyday of portrait painting.'[25]

To these difficulties the theologian might want to reply that personhood is so central to the Christian revelation that the gospel stands or falls with the possibility of recognising the face: no face, no moral personality, no responsibility, no moral action, no sin, judgement or forgiveness. The fashionable idea that we can no longer be certain who we are is denied every day both in the courts, and in the Christian liturgy of confession and absolution. But this is not to say that any old portrait is *ipso facto* revelatory. Portraits, in fact, express very varying understandings of the human, as well as very varying degrees of skill. What, then, might be the characteristics of a portrait which in some way expressed the gospel, which might be construed as a 'secular parable'?

THE GLORY OF MAN

This was the title that David Jenkins gave to his 1966 Bampton Lectures, exploring the significance of the incarnation for our understanding of the human. Impossible today, it nevertheless catches that Renaissance humanism which gave birth to the modern portrait.[26] Various reasons are adduced for the disappearance of the realistic portrait in late antiquity and the Middle Ages: the pressure of the aniconic tradition of Islam might be part of it, as well as the loss of the skills of perspective in what in some respects it still makes sense to call the 'dark ages'. The central focus on the divine already mentioned is also doubtless part of it. The obverse of that was the theme of 'contempt of the world' which received repeated expression from the sixth century to the sixteenth and which was even restated by Erasmus.[27] According to Innocent III, writing on this theme,

> Man was formed of dust, slime and ashes: what is even more vile, of the filthiest seed. He was conceived from the itch of the flesh, in the heat of passion and the stench of lust, and worse yet, with the stain of sin. He was born to toil, grief and fear: and more wretched still, to die. He commits depraved acts by which he offends God, his neighbour, and himself; shameful acts by which he defiles his name, his person, and his conscience; and vain acts by which he ignores all things important, useful and necessary. He will become fuel for those fires which burn forever and are forever hot and bright; food for the worm which forever nibbles and digests; a putrid mass which will forever stink and reek.[28]

If that is your view of the human, portraiture is probably not going to be a high priority. Nothing could be further removed from accounts such as Juan Luis Vives' *A Fable about Man*. Here Jupiter created human beings to put on a play for the gods. They did it so well that they were seated among the gods: 'When the gods saw man and embraced their brother, they deemed it unworthy of him to appear on a stage and practice the disreputable art of theatre, and they could not find enough praise for their own likeness and that of their father. There indeed was mind full of wisdom, prudence, knowledge, reason, so fertile that by itself it brought

forth extraordinary things'.[29] Pico della Mirandola, who, we remember, was buried with all honour by Savonarola, likewise pictures God speaking to man: 'In conformity with thy free judgement in whose hand I have placed thee, thou art confined by no bonds, and thou wilt fix the limits of thy nature for thyself. Neither heavenly nor earthly, neither mortal nor immortal have we made thee. Thou art the maker (*plastes*) and moulder (*factor*) of thy self.'[30] In the Neoplatonic circles in which Mirandola and his contemporary Botticelli moved, human beauty was believed to be a reflection of divine beauty, and human intellect regarded as a microcosm of the universal mind.[31]

Portraits which illustrate this vision of the human are legion: Van Eyck's self-portrait, in the National Gallery in London; Bellini's portrait of the Doge Leonardo Loredan; Titian's picture of a Man in a Blue Doublet, possibly a self-portrait, though sometimes described as a picture of Ariosto; Holbein's *Ambassadors*. To do duty for all of these I will take just one, Raphael's picture of Baldassare Castiglione, author of *The Courtier* (published fourteen years after the portrait) (fig. 21). His palette, markedly subdued in comparison with that of Bellini or Titian, reflects Castiglione's belief that a courtier should always behave with composure and self-control. At the same time he must have *sprezzatura*, the ability to do the manifold things expected of a Renaissance man, such as study, writing poetry, playing music, as well as soldiering, effortlessly. Raphael has captured this 'nonchalance of movement and action' in a portrait which, according to Castiglione himself, was so lifelike that his wife and child spoke to it and joked with it while he was away. It is hard to imagine that Psalm 8, which would have been known by heart by both artists, is not in the background:

> What is man that thou art mindful of him . . .
> Thou hast made him but little lower than God,
> And crownest him with glory and honour.[32]

Women were not absent from this glorified vision either: above all one thinks of the great portraits of Leonardo, but also of Agnolo Bronzino. The portrait of Lucrezia Panciatichi in the Uffizi, for example, painted in

22 Agnolo
Bronzino, *Lucrezia
Panciatichi*, 1541,
Uffizi Gallery,
Florence

1541, has inspired viewers through the centuries (fig. 22). Her husband
was also painted, in the same slightly mannerist, elongated way. At this
stage the two were Huguenots, which makes it odd that her hand rests on
a book of prayers, opened at a page for offices to the Virgin. Perhaps the
portrait is intended to make the point that they are above suspicion, but
if so it did not save them from arrest and torture ten years later. The words
on her necklace say *Amour Dure Sans Fin* (love lasts eternally), and the
portrait accompanies her husband's. The beauty of her costume, the gold
and pearl necklace, her long, elegant fingers and her full lips have all sug-

gested to viewers that the piety may not have been for real. Lord Mark in Henry James's novel *The Wings of the Dove* says of her, 'Splendid as she is, one doubts if she was good', but nothing in her story leads us to suspect that. Others have detected melancholy, suggested not only by the serious eyes, which are quite without a smile, but also by the mannered elongation of the picture. Vasari, on the other hand, praised the picture as true to life, commenting that it lacked only breath to make it fully alive.

Renaissance theorists argued that the purpose of portraits was the encouragement of virtue.[33] Thomas More wanted 'images (statuas) of notable men' put up in the market places of his Utopia 'for the perpetual memory of their good acts; and also that the glory and renown of the ancestors may stir and provoke their posterity to virtue'.[34]

The librarian to the Earl of Arundel in the 1630s, Franciscus Junius, noted that it was 'a praise-worthy custom observed among the Ancients, That they did shew themselves forward to consecrate the memories of such men as had deserved well of the world: and because they could not endure that vehement longing they had after the virtues of the deceased Worthies, they did at once seeke to remedy their sorrow, and to stir up other noble spirits to the love of virtue'.[35] This is not so very different from the old defence of images.[36] 'In both cases the portrayal moved memory towards moral instruction.'[37] The obverse of this is that portraits of the humble were regarded as a moral irrelevance.

In looking at Renaissance portraits it is hard to know if they are idealised. Alberti recalled the ancient story of Demetrius, who was blamed for painting in too lifelike a way rather than making things look beautiful.[38] The priest Giovanni Agucchi argued in 1620 that literal representations may please the ignorant but good painters aim at the beauty which nature seeks to create but fails to do in any one subject.[39] Reynolds thought portraits which were too accurate were 'narrow, vulgar and misshaped' while Hegel spoke of portraits which were accurate 'to the point of nausea'.[40] Panofsky argued that all portraits had both to catch the unique on the one hand, what distinguishes this person from every other human being, and that which the sitter shared with the rest of humankind on the other. Roughly speaking he thought the North erred on the side of individuality

and the South of universality. In Italian art, he thought, the sitter tends to be depicted 'as a representative example of humanity in general'.[41] We cannot be sure, therefore, that early modern testimonies to the truthfulness of portraits do not subscribe to an idealised vision, especially as the aim was to say something about the universal human condition through the particular. Portraits of beautiful women, especially, often verge on the allegorical.[42] In the case of Van Eyck, however, idealisation seems most implausible. We have an interest in the particular that some have traced to nominalism but that may equally be owing to the specifically Christian interest in what is individual. 'The face of the other, for Christian eyes, must of necessity be visible *only* in the peculiarities of its features, and only within an unforecloseable sequence of perspectives and supplementations; it is always an aesthetic event. The other is "placed" within being, within the infinite, not as a mere localized essence, but as a unique and so adequate expression of the infinite.'[43] This, I suggest, is what we see in the best Renaissance portraiture.

The celebration of the human that we have in Renaissance portraiture did not go unchallenged. The Reformers harboured suspicions about vanity, and even about idolatry, appealing to Wisdom 14.15–16 where the origin of idolatry is found in a father's image of his dead son.[44] Such a warning was enshrined in many Reformation texts, including Calvin's *Institutes* and *Homilies*. If there were to be pictures of Reformers, then they should be depicted with books in their hands, paradoxically making visible the subordination of image to text. Calvin's biographer Theodore Beza argued thus that the realistic portrait could help the dead to continue speaking. The Italian theologian Gabriele Paleotti, writing in 1582, agreed that people might benefit from contemplating portraits of the virtuous, but was suspicious of the motives of those who commissioned portraits of themselves and utterly against portraits of those whom he considered vicious. He objected to flattering portraits and to frivolous accessories like pet dogs, flowers or fans, and he particularly condemned the exchange of portraits by illicit lovers.[45] The Jansenists of Port Royal likewise condemned portraiture because it ignored the fact that humanity was fundamentally marked by sin. For Pierre Nicole, a contemporary of Pascal, it

was even a form of complicity with evil. The only portrait a Christian could endorse was presentation of his or her interior and spiritual reality which will be presented before God.[46]

Despite the hesitations it is possible that the Reformation contributed to the development of the portrait. As a result of the Reformation, it has been argued, portraiture came to dominate English painting. The secular art of the portrait, well established before the iconoclastic processes of reform, survived and flourished. What had previously been a minor art became central, seemingly filling the gap created by Protestant fidelity to the second commandment.[47] Renewed devotion in both Reformation and Counter-Reformation encouraged private religious self-scrutiny and this led to the rise of autobiography as a literary form. Such forms of devotion heightened the consciousness of the self as subject and promoted the idea of individuality as something to be cultivated. This may contribute to the increasing vogue for self-portraits – though whether one could consider the great Dürer self-portraits in this way must be arguable.[48]

BODY AND SOUL

Christianity inherited – it did not invent – an anthropology of body and soul. If, with Platonism, you believe in an immortal soul, which is essential being, housed in a bodily shell which is contingent and non-essential, then there is a problem depicting the soul.[49] According to Xenophon Socrates asked the painter Parrhasius, 'Do you not imitate the character of the soul?' To which he replied, 'But how could such a thing be imitated, Socrates, which has neither proportions, nor colour, nor any of the things which you mentioned just now, and which, in fact, is not even visible?'[50] Dürer expressed a similar frustration in his portrait of Luther's ally Melanchthon, though Holbein took up the challenge and believed he had depicted his very soul.[51] Aquinas taught that the soul *gave form* to the body; it was, in fact 'the substantial form of the whole body'.[52] Ficino believed the same in the fifteenth century.[53] It follows from this that it ought to be possible to say something about the soul by looking at the

body. Christian artists wrestled for centuries with the problem of depicting the divine and the human in one person. Of course they had a whole armoury of symbolism to help them, but at the Renaissance artists tried increasingly to depict this union in naturalistic ways. The difficulty of the attempt was echoed in the need to depict an ensouled body and a bodily soul. Christians were committed both to matter and to that which transcended matter, which in-dwelt it and made it patent of glory. The challenge to any adequately Christian portrait, therefore, is to present this relationship – which is a different problematic from that of Aristotle's representation, where the function of a portrait is to bring before us an absent subject.[54] It bears both on body and soul: on the one hand the soul, the living quality of a person, what makes them different from every other person, must be depicted. Equally, the body has to be depicted as inspirited, and not simply flesh – a tendency in much recent art, which has reacted against the privileging of the face.

Discussion of portraiture since the Renaissance has repeatedly returned to distinctions between portraits and likenesses, or between portraits and effigies. ''Tis not enough to make a Tame, insipid resemblance of the features', wrote Jonathan Richardson, 'a portrait painter must understand mankind, and enter into their characters, and express their minds as well as their faces'.[55] The mere resemblance is a 'likeness'; what captures the soul of the sitter is a portrait. Some portraits are not likenesses and not all likenesses are portraits.[56] There are many difficulties implicit in this distinction. The 'soul', for example, may stand for a mass of contradictions, inconsistencies, and even attempts at deception, and the great portrait has both to understand this and then suggest it in paint.[57] Arguably, Rembrandt's self-portraits, over a period of more than thirty years, represent just such an attempt to get beyond deception as do, in very different ways, the portraits of Stanley Spencer and of Lucien Freud (though we have Huygens' acid suggestion that Rembrandt's portrait of one of his friends did not resemble him in the least, and there may have been other complaints to this effect).[58]

A second difficulty relates to the formal convention of the portrait: most are posed and the sitter is silent. But as the sculptor Bernini said, 'If a man

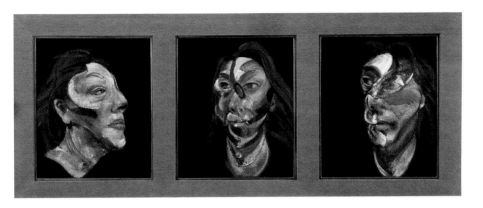

23 Francis Bacon, *Three Studies for a Portrait of Isabel Rawsthorne*, 1965,
Robert and Lisa Sainsbury Collection, Sainsbury Centre for Visual Arts, Norwich

stands still and immobile he is never as much like himself as when he
moves about. His movement reveals all those personal qualities which are
his and his alone.'[59] A formal portrait therefore abstracts or freezes a
subject in a way which may not capture who they are. Francis Bacon
addressed this abstraction by adopting multiple views of his subjects. In
Three Studies for a Portrait of Isabel Rawsthorne one image of her depicts
her holding a nail, which was intended to say that mimetic representation
was an attempt to nail the subject down (fig. 23).[60] He wanted to catch
the 'emanation' or energy of his subject and deliberately eschewed literal-
ness in order to do this.[61] Formal portraits are also expected to conform
socially (though this has often been ignored in the past century). 'In
general', writes Richard Brilliant, 'most private portraits with any preten-
sion of "dignity" resemble funeral orations or eulogies which typically
portray the deceased in positive, formulaic ways'.[62] The point is well taken,
and it is here that the great portrait, like those mentioned in the previous
section, rises above the eulogy. Another difficulty is that a portrait is, after
all, art: like any other painting it represents compositional choices, choices
as to palette and so forth which affect the picture profoundly.[63] Graham
Sutherland chose to depict Churchill from below, a position routinely

85

adopted for honorific portraits. Churchill thought the picture portrayed him as if he was in the process of passing a particularly difficult stool. His wife burned the result.

Berenson distinguished between a portrait and an effigy, the former depicting inwardness, the latter role and social standing.[64] Official portraits may be almost entirely emblematic and the symbolism was, in the Renaissance, sometimes elaborated in tediously allegorical detail.[65] Kokoschka deliberately avoided details of social status and 'tried to intuit from the face, from its play of expressions, and from gestures, the truth about a particular person, and to recreate in my own pictorial language the distillation of a living being that would survive in memory'.[66] In theological terms, he tried to depict the soul beyond the trappings society gave it. The very attempt might be regarded as proceeding from too naïve a view of the process of social formation, but equally we have to allow for individual resistance to or indifference to, for example, social honours. Andy Warhol produced famous images of Marilyn Monroe and of Jackie Kennedy which played on the difference between public image and private person.[67] Political images like those of Lenin or of Che Guevara have become clichéd political icons – mere effigies. From the mid nineteenth century onwards, and closely related to the advent of photography, most artists have left realistic portraiture behind. Matisse's 1905 portrait of his wife Amelie, *Portrait of Madame Matisse. The Green Line*, a product of his fauve period, is certainly a likeness, as far as one can judge by the photographs; it is technically brilliant, in its creation of perspective by the use of colour; but whether it gives us any insight into Amelie is another matter and perhaps it was never meant to (fig. 24). Picasso, when he wanted to, could produce portraits like those of Ingres though again, in his cubist period, the portrait of his dealer Daniel-Henry Kahnweiler, done in 1910, is virtuosic, witty, and pays elegant homage to someone who understood and appreciated the new movements in art, but does not give us an insight into the man (even though it required twenty sittings!) (fig. 25). These portraits seem to meet the demands of critics like Bell, who put design and inventiveness before likeness. On the other hand we have Picasso's celebrated portrait of Gertrude Stein, which required eighty sittings, and which

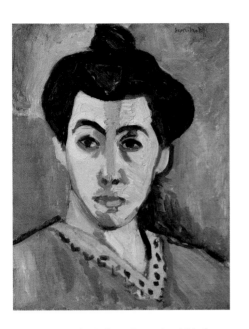

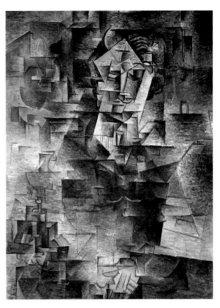

24 Henri Matisse, *Portrait of Madame Matisse. The Green Line*, 1905, Statens Museum for Kunst, Copenhagen

25 Pablo Picasso, *Daniel-Henry Kahnweiler*, 1910, Gift of Mrs Gilbert W. Chapman in memory of Charles B. Goodspeed, 1948.561, The Art Institute of Chicago, Chicago

he only completed after seeing Iberian sculptures on holiday. When it was objected that Stein did not look like the picture Picasso responded, 'She will do!' which, beyond Picasso's ever present sense of humour, says something about the way in which we can grow into images of ourselves.

Given all these difficulties are we deceiving ourselves in thinking that there are pictures, in the Western canon, which bring the soul before us? Frances Hodgkins problematises the question for us by giving us self-portraits composed of still lifes made up of objects important to her. She tells us something about the type of person she is, therefore, about her preferences, and therefore about her soul (fig. 26). What she does not do is relate it to the body. This the realistic portrait tries to do, and to some

87

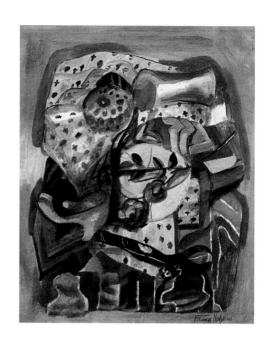

26 Frances Hodgkins,
Self-portrait, *c*.1935, Auckland
Art Gallery, Auckland

extent we have to take contemporaries' verdicts on the success or other-
wise on trust, aware that they may favour idealisation.

Leonardo's great feminine portraits seem good candidates, despite his
reputation for almost inhuman Olympian detachment.[68] The portrait of
Ginevra de' Benci, now in Washington, was Leonardo's first secular paint-
ing (fig. 27). It was commissioned by a Venetian merchant Bernado Bembo
who seems to have wanted it simply to capture the beauty of Ginevra, with
whom he had a platonic relationship. Appropriately, she was a great enthu-
siast for Petrarch and aspired to be a poet herself. She is painted against
a juniper bush which puns on her name and is a symbol of virtue and
beyond that, still waters, elegant trees and a distant town, nature and
nurture, culture and natural beauty. Leonardo presents his sitter turned to
the viewer: this turn of the neck from the body, which is diagonal to the
picture plane, is what gives the picture its dynamism, along with the lively
curls of her hair. In Kenneth Clark's words,

27 Leonardo da Vinci, *Ginevra de' Benci*, 1474–8, Ailsa Mellon Bruce Fund,
1967.6.1.a, National Gallery of Art, Washington

There are passages, such as the modelling of the eyelids, which Leonardo
never surpassed in delicacy . . . Most ingenious is the way in which all
the light areas except the face are given broken irregular contours by
the juniper leaves, or the shimmering water, so that the outline of the
lady's cheek and brow dominate the design. There is a similar contrast

28 Jean-Auguste
Dominique Ingres,
Monsieur Bertin, 1832,
Musée du Louvre, Paris

in texture between the beautiful curves of her ringlets and the stiff, spiky character of the juniper. But all these technical devices are subordinate to the feeling of individual character with which Leonardo has been able to charge the portrait, so that this pale young woman had become one of the memorable personalities of the Renaissance.[69]

The cast in her eye makes her seem to look beyond us: the gaze is serious, reflective, sulky. She is presented in the three-quarter pose previously reserved for men, something which would have been still more evident if the portrait had not been cut down at some stage. 'She is totally fleshly and totally impermeable to the artist ... What she is truly like she conceals; what Leonardo reveals to us is precisely this concealment, a self-

absorption that spares no outward glance.'[70] If that is really true it does not contradict the idea that the sitter's soul is made known in the painting, for in all revelation (and revelation is involved in every personal encounter) there is a dialectic of concealment and making known.[71]

The conscious attempt to suggest presence was the agenda of the nineteenth-century portrait painters, where of course, a very different understanding of the person was now assumed. The agenda now is not body and soul but 'personality', sketched vividly in the novel. Ingres' portrait of the newspaper editor Monsieur Bertin, painted in 1832 (fig. 28), is a fitting complement to the literary realism of Balzac. Ingres has painted a 'mover and shaker' who addresses the viewer forthrightly, his hands splayed on his knees, ready to get up and get on with his job, or argue some point to the uttermost, imparting a sense of movement and urgency to the picture. Here, too, as with the Raphael, a sober pallet is used, but this time to capture the business environment. Every detail is sharp, from the wart on the right eye to the reflection of the window in the armchair. Ingres has given us a consummate portrait of a leading bourgeois, opinionated and used to being obeyed.[72]

The idea that there are indeed portraits which, despite all the difficulties, capture the soul of the sitter dies hard. On the other hand John Berger suggested that only 1 per cent of portraits have any psychological insight and that the average Renaissance portrait–although suggesting considerable presence–has very little psychological content.[73] It is a myth, he argued, that the portrait painter was a revealer of souls. The comparatively few portraits that reveal true psychological insight suggest obsessional interests on the part of the artist and are, in fact, works of self-discovery.[74] In arguing thus perhaps he had in mind Oscar Wilde's contention that every portrait that is painted with feeling is a portrait of the artist, not of the sitter. The sitter is merely an accident, the occasion. It is not the subject who is revealed by the painter; it is the painter who, on coloured canvas, reveals him- or herself.[75] As photography made realistic portraiture unnecessary, so design came to play an ever larger part. In Klimt's later work, for example, 'the sitter scarcely exists in her own right. She has been obliterated by the personality of the artist.'[76]

Whatever the truth of Wilde's remarks (and it is often suggested, of course, that Leonardo's women portraits verge on self-portraits) Berger seems to do less than justice to the realistic portrait tradition, something which could be argued from the difficulty of trying to see how presence can be suggested in the absence of psychological content. It is clear that many of the portraits that fill our portrait galleries, preside over board-rooms or surround college halls fail to reveal anything important about the sitter, but this may simply reflect the small number of portraits painted by artists of the very first rank, and it is certainly bound up with the power relation between painter and sitter.

PORTRAITS AND POWER

With the exception of self-portraits most portraits are paid for by the sitter or, in the case of women– in the past at least– by the sitter's husband or lover. The artist therefore is under some pressure to flatter the patron. As the painter's business is chiefly with people of condition, remarked Richardson, 'he must think as a gentleman, and a man of sense, or 'twill be impossible to give such their true, and proper resemblances'.[77] Concerning what sort of resemblances portraits ought to have, he adds later, opinions are divided: 'some are for flattery, others for exact likeness'.[78] Any serious attempt to delineate character and disclose its complexities, writes Richard Wendorf of Stuart and Georgian portraiture, would necessarily be at odds with the primary function of public and commemorative portrait-ure.[79] For John Berger, professional portraiture after Gericault (which includes Ingres, of course) degenerated into servile and crass personal flat-tery, cynically undertaken.[80] There are two issues here: one is the extent to which flattery is bound to distort any true delineation of the face; the other is whether portraiture is not simply a record of the upper class, an extended record of those who have patronised and oppressed others throughout history.

Just as the majority of portraiture does not aspire to be anything more than a likeness, so there are just a few famous exceptions to the flattery of

29 Diego Rodriguez
de Silva y Velázquez,
Pope Innocent X,
1649–50, Galleria
Pamphili, Rome

power. Velázquez lived a completely conformist life, and throughout aspired to be ennobled: he played the court game. There is no suggestion that somehow he secretly 'saw through' the whole charade, nor did he despise court life like the poet Luis de Gongora, whom he painted. At the same time he had a fundamental honesty, and a compassion, which determined his approach to powerful and powerless alike. In his paintings 'you feel the shadow of life passing all the time'.[81] His portrait of Innocent X (fig. 29), which so exercised Francis Bacon, is the classic account of power which manages to be both critical and deferential at the same time (the Pope rewarded him with a gold medal and chain for it). The Pope was notoriously choleric and splenetic, with a red face and an expression, according

to a contemporary, of 'a cunning lawyer'. He poses in what was conventional papal regalia, red and white, but Velázquez chooses to orchestrate the reds in the painting, which has the effect of highlighting the red in his face. Red is the colour of anger and of power, and Velázquez, without any overt attempt at subversion (as far as we know) uses it to highlight his subject's real concerns. The Pope's hands are relaxed, his body turns, and he holds a letter in his left hand. He sits, Velázquez suggests, in the intervals of a busy diplomatic schedule, at a time when the papacy was still a key political post. The Pope's remark, when he saw it, 'It's too real' (*troppo vero*), probably did not refer to the accuracy of the representation, but to the capture of the Pope's worldliness, caught in his wary and distrustful gaze. Velázquez has managed to say something about how power corrupts: it is chilling, for example, to read this painting alongside the Beatitudes.[82]

A very different approach to power is represented in Frans Hals' pictures of the Men and Women Regents of the Poor House at Haarlem, where he himself finished up (fig. 30). Seymour Slive reads these paintings purely in art critical terms as speaking to us of 'the human condition'. He writes of 'Hals's unwavering commitment to his personal vision, which enriches our consciousness of our fellow men and heightens our awe for the ever increasing power of the mighty impulses that enabled him to give us a close view of life's vital forces'.[83] For John Berger that is mystification. As he points out, the real drama of the painting is the confrontation between Hals, who was destitute, and his need to paint his patrons objectively. Rarely have power relations between artist and patron been so stark and so powerfully subverted.[84]

As a sub-text to the main narrative of pictures of the wealthy and powerful there is a thin tradition of portraits of servants, jesters, clowns and dwarfs and, as we have seen, of peasants. According to Lomazzo it was wrong to paint such people because they could not possibly serve as an example: only the great ought to be painted.[85] Rembrandt, who was indifferent to such theories, painted an unknown servant in a pensive, dignified pose.[86] Usually however, such figures were painted to record the gratitude or affection of wealthy employers. Velázquez's sympathy for the dwarfs of the Spanish court, who were considered attractions, is well

30 Frans Hals, *Men Regents in the Poorhouse at Haarlem*, 1664,
Frans Hals Museum, Haarlem

known. Don Diego de Acedo, for example, is shown engaged in study,
something dwarves were not supposed to be able to do (fig. 31). He is
painted with absolute seriousness, and the viewpoint adopted, from below,
which is typical of honorific paintings, does not patronise him.[87]

Hogarth painted pictures of his servants together on one canvas (fig. 32).
The studies are certainly affectionate, but the painting may have been
intended to demonstrate to prospective patrons what Hogarth was capable
of. The space given for the servants' heads is not equivalent to the space
that would have been allowed in a commissioned portrait but if this sig-
nifies subordination 'it signifies democracy more'.[88] At the same time, we
do not know the names of all the servants: these are fine portraits, which
say something about the character of those depicted but, paradoxically,
they remain nameless. The same goes for the portrait of an unnamed scul-

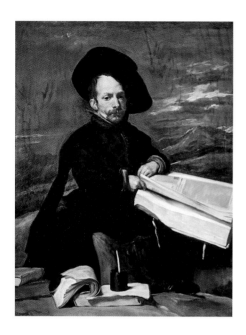

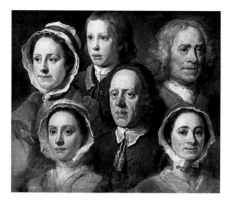

31 (*left*) Diego Rodriguez de Silva y
Velázquez, *Don Diego de Acedo*,
1644, Museo del Prado, Madrid

32 (*right*) William Hogarth, *Heads of
Six of Hogarth's Servants*, 1750–5,
Tate Britain, London

lion at Christ Church, Oxford, who may have represented its Protestant
sympathies against the attempt of James II to Catholicise it.[89] The figure
is dignified and forceful – but nameless. Only the image makes this non-
person a person.

GRACE AND FORGIVENESS

Beyond likeness and the attempt (if that be possible) to express the soul
of the sitter the real hallmark of a truly Christian portrait is, undoubt-
edly, the attempt to convey grace and forgiveness. In this context I want
to look at two very different painters and I will begin with the later of
the two, Francis Bacon.

More than fifty years after their first appearance Bacon's paintings have
not lost their power to shock. Many people may be tacit nihilists, but
Bacon pushes it in our face. Compared with Velázquez, he once said, we

now realise that being human is 'completely futile'. Art was left as a game by which people distract themselves.[90] Standing outside every tradition all the modern artist could do, he thought, was to 'record one's own feelings about certain situations as closely to one's own nervous system as one possibly can'.[91] Bacon furiously distorts his images, but he does so quite self-consciously. 'What I want to do', he said, 'is to distort the thing far beyond appearance, but in the distortion to bring it back to a recording of the appearance'.[92] Isabel Rawsthorne called the portraits of her 'fabulously accurate' (fig. 33). Michael Peppiat comments, 'If a magnificent sense of dignity emanates from the studies of Isabel Rawsthorne it is because the artist's affection is greater than the destructive fury with which he dislocated and twisted her every feature. Bacon once said that he thought of real friendship as a state in which two people pulled each other to pieces – dissecting and criticising mercilessly. This is the act of friendship that Bacon perpetrates in the portraits: a pulling apart of the other until he gets to an irreducible truth about their appearance and character.'[93]

Alan Ecclestone found profound Christian meaning in Bacon's art, 'a prolonged courageous attempt to get us to look at life with a new and more serious moral vision'. Bacon, he said, refuses to dissemble. 'A search for the truth of man's being takes over; the strains, the misgivings, the fears, the interior twists, are all to be faced and revealed . . . Bacon is so important a painter . . . because his work is expressive of just such scanning in depth that prayer endeavours to do . . . What Bacon can help us to see is how the struggle with chaos and old night goes on in the flesh and spirits of humankind.'[94] Another way of putting this would be to say that Bacon paints human alienation, the human being in need of redemption, without grace.

John Berger, on the other hand, regarded Bacon's art as conformist because it lacked what we might call any theology of hope. He compared him not to great artists of the past like Goya but to Walt Disney.

Both men make propositions about the alienated behaviour of our societies; and both, in a different way, persuade the viewer to accept what is. Disney makes alienated behaviour look funny and sentimental and, therefore, acceptable. Bacon interprets such behaviour in terms of the worst possible having already happened, and so proposes that both

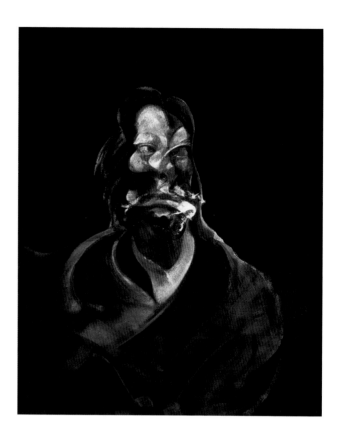

33 Francis Bacon,
*Portrait of Isabel
Rawsthorne*, 1966,
Tate Britain,
London

refusal and hope are pointless. The surprising formal similarities of their work – the way limbs are distorted, the overall shapes of bodies, the relation of figures to background and to one another, the use of neat tailor's clothes, the gesture of hands, the range of colours used – are the result of both men having complementary attitudes to the same crisis.[95]

These two readings represent different takes on grace and forgiveness. For Ecclestone the rigorous honesty of Bacon's search for truth constitutes a form of grace which we have no option but to live by. Bacon was an atheist and a nihilist but, Ecclestone implies, he nevertheless helps us to see the truth about human beings which is the prelude to any possibility of for-

giveness. For Berger, on the other hand, honesty without hope is tantamount to a kind of bitter cynicism, which precludes forgiveness from the start. Here (though it is rather early to make a judgement) Bacon's seeming acceptance into the art critical canon may help us because, although his paintings still shock, they have been accepted as serious comments on the human condition. They may not tell us a great deal about their sitter (Isabel Rawsthorne's remark notwithstanding) but they do tell us important, if rather negative, things about what it means to be human. They show 'the "woundedness" of the world in its entirety'.[96]

Lionel Kochan tells the story of Rabbi Abraham Kuk, in exile in London, who regularly visited the National Gallery for the sake of the Rembrandts which reminded him of a legend about the creation of light. 'We are told that when God created light, it was so strong and pellucid, that one could see from one end of the world to the other, but God was afraid that the wicked might abuse it. What did he do? He reserved that light for the righteous when the Messiah should come. But now and then there are some great men who are blessed and privileged to see and I think that Rembrandt was one of them, and the light in his pictures is the very light that was created by God Almighty.'[97] This light, we may say, is not just that of creation, but of redemption as well. Rembrandt is the paradigm of the Christian portraitist, not because he suggests interiority more than any other great artist, and conveys a sense of an ensouled body and a bodily soul, but in his startling depiction of sin and forgiveness.[98] There is no breast beating in his portraits, nor is there a casual indifference towards sin or failure. Rather, his portraits are an astonishing account of the doctrine of justification by faith. The nineteenth century liked to make a distinction between early and later Rembrandt and drew attention to the way in which he learned from his social failure, but in fact sympathetic portraits of age run right the way through Rembrandt's career. In the portrait of Aechje Claesdr in the National Gallery, for example, painted in 1634 when Rembrandt was only 28 (fig. 34), Rembrandt has painted an elderly woman who has lost all the beauty she may ever have had. Her right eye droops, her flesh is flabby and the nose is rather bulbous. Presumably her son, a Rotterdam brewer, has paid to have her painted. What Rembrandt

has conveyed, beyond likeness, is a sense of life summed up, and met with great compassion. There is no scorn in this absolutely un-ideal portrayal. The picture might almost be taken as a secular version of a 'last judgement'.[99] Rembrandt is not interested in ideals: he paints human beings as they are, but sees the divinity there. His portraits are an illustration of the 'sacredness of everyday life', as argued by Auerbach, and in that respect his interest in the Hebrew bible is no accident.

The same is famously true of Rembrandt's own last self-portraits. In the 1669 self-portrait which hangs nearby (fig. 35) Rembrandt observes himself without a glimmer of self-pity, and yet not simply with the clinical gaze of the professional artist either. It is not just that he is bloody but unbowed. He has painted the man who is *simul iustus et peccator* – at the same time justified and a sinner. In earlier works Rembrandt identifies himself with the Prodigal Son, or with one of the people struggling to raise the cross. As Simon Schama writes, he collapses the boundaries between saints and sinners in his pictures of the apostles, and above all in his account of himself as St Paul, a Paul for everyday sinners. These pictures are, like the portraits, 'leavened by the redeeming light of grace'.[100] This is not true of many of the greatest Renaissance or nineteenth-century portraits: these can tell us something about the glory of being human, or about the way the soul shapes the body. Almost uniquely, Rembrandt tells us about forgiveness.

LEARNING FROM PORTRAITS

Portrait painting survives the disparagement of artists both ancient and modern. Queues still form daily before the Mona Lisa, or before Rembrandt or Van Gogh's self-portraits. In every gallery people linger before the portraits of the past. Part of this is the fascination exercised by wondering about the story behind the portrait, as with Bronzino's portrait of Lucrezia Panciatichi. Portraits are, in this way, novels in miniature, inviting us in the same way to identify, to empathise, sometimes to learn. In particular, Iris Murdoch and others have suggested that looking at art, and

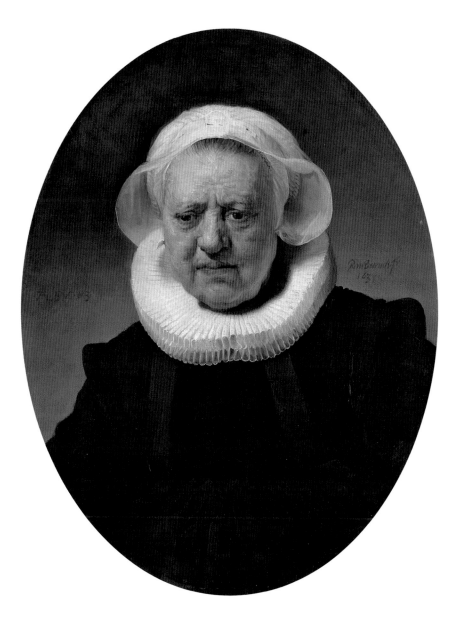

34 Rembrandt, *Aechje Claesdr*, 1634, National Gallery, London

35 Rembrandt, *Self-Portrait*, 1669, National Gallery, London

in this case portraits, can be part of a discipline of attention. John Drury argues that 'Mutual regard, in its obvious and physical form of looking *at* other people and its moral form of looking *to* other people, is the source and cement of human society ... ordinary physical looking is a primary form of grace, and if grace is to be part of social life (which is not worth living without it), it has strong claims.'[101] But seeing justly and properly involves an apprenticeship and artists can help us in that perhaps above all by setting before us the person as question, and therefore as mystery. Portraits can act as a partial check on our perpetual slippage back into superficiality, on taking the other for granted. The artist, says Merleau-Ponty, 'is the one who arrests the spectacle in which most men take part without really seeing it and who makes it visible to the most "human" among them'.[102] At their most profound artists may, as we have seen, even have something to say about the grace in which, according to the Christian tradition, the whole of reality is suspended, sustained, 'as a singer sustains her song', but which it requires revelation to become aware of – to *see*.

NATURE

'There are two Books from whence I collect my Divinity', wrote Sir Thomas Browne; 'besides that written one of God, another of his servant Nature, that universal and publick Manuscript, that lies expansed unto the Eyes of all: those that never saw him in the one, have discovered Him in the other. This was the Scripture and theology of the Heathens.'[1] Browne had an Aristotelian definition of nature in mind, as the inner *telos* of things, and went on to gloss Aristotle's account of the relation of nature and art: 'Now Nature is not at variance with Art, nor Art with Nature, they being both servants of Providence. Art is the true perfection of Nature. Were the World now as it was the sixth day, there were yet Chaos. Nature hath made one world, and Art another. In brief, all things are artificial; for Nature is the Art of God.'[2]

Characteristically for a Renaissance writer, Browne is glossing both the classical and the Christian tradition. Where Aristotle proposed that all things come to be by nature, by art (*techne*) or spontaneously, Browne makes God's overruling of all things the divine form of Art.[3] Almost by way of an aside Aristotle had spoken of art as the imitation of nature, and this had become a commonplace.[4] Thus Leonardo described painting as 'the legitimate daughter of nature ... to be more correct ... the grand-daughter of nature, because all visible things have been brought forth by nature and it is among these that painting is born'.[5] Only the painter who

Facing page: detail of fig. 39

follows nature will make progress. Lip service was paid to this view right the way into the nineteenth century but complex changes in the understanding of nature meant that artistic achievement, from being an imitation of nature, became the norm by which to measure it.[6]

The theme of the 'two books' is implicit in the very idea of creation by the Word and was widely current both in patristic and in medieval writers.[7] It implied a positive construal of nature which was far from universal but which survived uninterruptedly into the eighteenth century and made the re-emergence of both landscape and still life painting possible.[8] It ran alongside a much more abstract theology of creation which was concerned more with causality and with the ontological status of created things. Sixteenth- and seventeenth-century landscapes instance a Christian optimism for which nature was one of the pleasures of the Christian mind. 'Contemplation of nature was a means of becoming close to the Creator, because his Presence was to be found in all things.'[9] Although it was a cardinal who argued thus, the view was equally shared by pious Calvinists. For the Deists of the early eighteenth century the created world was the manifestation of the divine perfection. 'The Creation is a perpetual feast to the mind of a good man', wrote Addison. 'Every thing that he sees cheers and delights him; Providence has imprinted so many Smiles on Nature, that it is impossible for a mind which is not sunk in more gross and sensual delights to take a survey of them without several secret sensations of pleasure.'[10] The artist's task was not so much to imitate nature as to reveal the perfect order to be found in it. That the book of nature was a more reliable guide to the Creator than Scripture, or that the two books had to be read together, was an idea already mooted in the fifteenth century, and not an invention of Deism.[11]

All painting is not simply interpreted but itself represents interpretation. Ostensibly realistic landscapes turn out, on inspection, to be largely invention as the artist adds or takes away features to suit his or her purpose. In that sense, all landscape tends to the ideal or ideological. This was true even of the Barbizon painters in France in the mid nineteenth century, painting at the height of so-called realism. No landscape was ever simply 'facts interpreted by love', as Kenneth Clark famously put it. It always had its 'dark side' which idealism of one kind or another could occlude. Perhaps a tacit

awareness of this evasion played a part in the increasingly rapid abandonment of realism from the 1870s onwards. For Cézanne, for whom truth to nature was virtually a religion, painting from nature was not imitation but realising one's sensations.[12] In 'the moment of cubism' the idea of art holding up a mirror to nature became thoroughly nostalgic: 'a means of diminishing instead of interpreting reality'.[13] It was for this reason that painters like Mondrian and Kandinsky, who began with landscape, ended with abstraction. This was not a flight from the appearances but an attempt to understand them at depth. 'Unintentionally', wrote Mondrian in 1919, 'naturalistic painting gives too much prominence to the particular. The universal is what all art seeks to express: therefore, the New Plastic is justified relative to all painting. For the New Plastic too nature is that great manifestation through which our deepest being is revealed and assumes concrete appearance . . . The appearance of nature is far stronger and much more beautiful than any imitation of it can ever be; if we wish to reflect nature, fully, we are compelled to find another plastic. Precisely for the sake of nature, of reality, we avoid its natural appearance.'[14] If landscape painting was the dreamwork of imperialism, it has been suggested, then perhaps abstraction, the international and imperial style of the twentieth century, is best understood as carrying out the task of landscape by other means.[15]

In the final three chapters I shall try to understand the theological significance of painters' representation of 'nature', beginning at the most obvious place, which is landscape, going on to still life painting, and ending with abstraction. Secular parables, we recall, offer the church no criticism without affirmation and no affirmation without criticism. There is no doubt whatever that the idea of nature became profoundly problematic in the twentieth century, and remains so, partly because of the increasingly complex understanding of reality the natural sciences have given us, but also because of the damage done to the natural world by pollution, overexploitation of natural resources and by global warming. From being 'Mother Earth' nature is now 'a fragile anorexic dependant, to be protected and "managed"'.[16] Artists led the way in expressing the new puzzlement, and we can learn from that. At the same time it may be that, in the face of the so-called 'decline of nature', witnesses from an older optimism may still have something important to say to us.

36 Jacob van Ruisdael, *The Mill at Wijk bij Duurstede*, 1670,
Rijksmuseum, Amsterdam

5

THE WORLD MADE

STRANGE

'There has never been an age', wrote John Constable, 'however rude or uncultivated, in which the love of landscape has not in some way been manifested. And how could it be otherwise? For man is the sole intellectual inhabitant of one vast natural landscape. His nature is congenial with the elements of the planet itself, and he cannot but sympathize with its features, its various aspects, and its phenomena in all situations.'[1] It is well known that not all aspects of landscape appealed to early modern people, who found in mountains and heaths 'the fag end of creation', obvious signs of God's displeasure.[2] Pliny the Younger's account of his delight in landscape, however, and the long tradition of landscape painting in China, lend credence to Constable's belief.[3] In Europe landscape painting had died out with the Roman empire but re-emerged as a result of the new interest in the natural world already evident in the thirteenth century. In the North animal and plant specimens were seen as inseparable from their natural setting and so 'the discovery of nature meant finally and necessarily the discovery of landscape painting'.[4] Scientific concerns were essential to its emergence but a much broader cultural process was involved. 'The dis-

covery of the aesthetic values of landscape was the final outcome of a complex ripening process in which every form of imagination was involved and which concerned the entire attitude of man towards his physical environment.[5] The emergence of landscape as a fully fledged genre in the course of the sixteenth and seventeenth centuries may be connected to growing urbanisation and industrialisation, but, in addition to the growth of scientific interest, owes something to Reformation hostility to religious images, and to the strengthening of an older theology which understood nature as 'the second book of revelation'.[6] So powerful and persuasive did the representation of landscape become that it gave rise to the notion of the 'picturesque': late eighteenth-century tourists travelled, guide book in hand, looking for examples of scenery which reminded them of Claude, Poussin or Salvator Rosa.[7] Landscape was measured by its conformity to painting and huge sums were spent 'landscaping' the parks of stately homes to provide a view worthy of Claude. Romanticism turned this already very considerable stream into the flood of the religion of nature, or John Clare's 'religion of the fields', a structure of affect which has proved enduring. Even today, on summer Sundays, nearly a half of the population of Great Britain 'goes for a walk', and the countryside is the most popular destination. Landscape painting ministered and ministers to this passion for the country and, even though the eye is now guided not so much by painters as by media images, by snapshots, and by tourist advertising, exhibitions of landscape painting can still attract large crowds.[8] But what is going on in these paintings? Are they, as Kenneth Clark suggested, 'facts interpreted by love' or do they negatively distort our perception as part of a class ideology? Furthermore, despite the crowds, familiarity can breed contempt. One critic attending the 2006 Constable exhibition dismissed the artist as 'a miserable, bleak-hearted provincial'.[9] Undergraduates, in the twenty-first century, find it difficult to accept Constable's work as great art. Over-reproduced, the paintings are regarded as high-grade kitsch. Given these responses, and these questions, is there any sense in which landscape painting can still function as in any sense a secular parable?

THE REAL AND THE IDEAL

The idea that landscape painting is a simple record of a given place, a sort of portrait, dies hard. Clark argued that landscape was important in seventeenth-century Holland because the Dutch felt the need of recognisable, 'unidealised' views of their own country, the character of which they had recently fought so hard to defend.[10] Roger de Piles in 1708 in his *Cours de peinture* distinguished between heroic and pastoral landscape, meaning, roughly, the classicising landscape of Poussin in the first place, but nature 'as one sees it every day' in the latter.[11] Constable criticises William Carey for writing 'all about ideal art, which in landscape is sheer nonsense'.[12] Ruskin argued that the problem with landscape painting before Constable lay in 'the painter's taking upon him to modify God's works at his pleasure, casting the shadow of himself on all he sees, constituting himself arbiter where it is an honour to be disciple, and exhibiting his ingenuity by the attainment of combinations whose highest praise is that they are impossible'.[13] Turner, he wanted to argue, painted 'more of nature than any man who ever lived'.[14] Charles Kingsley believed that Turner, but also Landseer, Stansfield and Creswick, represented 'an honest development of the true idea of Protestantism' in their 'patient, reverent faith in nature as they see her, their knowledge that the ideal is neither to be invented nor abstracted, but found and left where God has put it, and where alone it can be represented, in actual and individual phenomena'.[15] He would surely have said the same of the Barbizon painters had he known them. Théodore Rousseau, for example, sought 'exact truth to life'. He acknowledged, however, that this took you far beyond the 'tame delineation of a spot' so derided by Fuseli. 'If you observe with all the religion in your heart', he wrote, 'you end up dreaming of the life of the infinite, you do not copy what you see with mathematical precision, you feel and you convey a real world which enfolds you in all its inevitability'.[16] We love the countryside, Hegel wrote, because 'it is the free life of nature which appears in [things which make up the countryside] and produces a correspondence with the spectator who is a living being too, and secondly, these particular natural and objective things produce moods in our heart which correspond to the mood of nature. We can identify our life with this

life of nature that re-echoes in our soul and heart, and in this possess in nature a spiritual depth of our own.'[17] Landscape painting, he believed, should not aspire to exactness, but should seek to capture 'the characteristic sympathy between objects thus animated and specific moods of the soul'.[18]

Today we are much more disposed to agree that no picture, not even a snapshot, portrays reality 'just as it is'. Everything is interpreted, and all artists have felt free to move items in the landscape, or raise or lower features, to make their picture more dramatic or attractive while the tone of a painting adds something to which no photograph can aspire.[19] All the same, there are degrees of ideality: Claude is not Constable, Poussin is not Constant Troyon. Much landscape painting is idealist in the strict sense in that, even if, as in Claude's case, the artist spends much of his time 'studying nature', he does not give us a view but a mental image pieced together from observation.[20] How might these paintings instruct us in the world of corporate capital and climate change? For that matter, does any of the great landscape painting of the past have anything very much to say apart from the beauty of its composition?

THE SECOND BOOK OF REVELATION

In what is perhaps Jacob van Ruisdael's most famous picture a windmill stands out against a stormy sky; a boat lies becalmed not far off land although wind ruffles the water and stirs the grasses at the water's edge; and three women make their way to the nearby town and the church we can just see over the brow of the hill (fig. 36).

This picture can be read in at least three ways. We can read it as 'just' a picture of a particular place, Wijk bij Duurstede, in 1670 when it was painted. Or we can read it art critically, in terms of the cohesion of forms brought about by the relation of the arms of the windmill and the clouds in the sky.[21] We note that the artist uses the golden section vertically through the mill, and in the horizon line; we note the subtle contrasts of the grey and blue of sky and water with browns, reds and greens of the

land; we note the movement imparted by the light falling through the breaks in the clouds on to the water. Constable loved Ruisdael's work, and we can see in this picture what he called his best lesson on art, that, 'light and shadow never stand still'.[22] We know from other paintings that Ruisdael did not hesitate to dramatise scenes for effect, and put in hills and cliffs where there were none.[23] Here, it seems, he has painted out the town wall and its gate, which would have obstructed the view.

Alternatively we can read it more as an allegory. Why are there three women? Their presence must be related to the fact that at this spot there was a 'Three Marys' gate but there may be a deeper meaning again. Looking more closely at the foreground we notice discarded millstones and rotting stakes – symbols of the transience of life. Perhaps the three women are also the women going to the tomb, finding new life beyond death. Why are the sails of the boat and the mill still, even when there is a light wind? Is it as a symbol of our dependence on God's Spirit? A 1625 emblem book shows a windmill, with sun breaking out from behind clouds, and the motto 'The Spirit gives life'.[24] The stilled sails depict our dependence on God's overarching providence, a central doctrine in Calvinist Holland where believers were taught to find God's providence in 'foliage and grass, rain and drought, fruitful and unfruitful years'.[25] And sunlight through dark clouds can suggest hope amid the storms of life.

We have the paradoxical situation, in the early twenty-first century, that we are skilled at de-coding advertisements, which increasingly work through allusion rather than by direct appeal, and yet we are embarrassed by the suggestion that landscape might be anything other than a literal record.[26] The evidence is, however, that our seventeenth-century ancestors were as skilled at reading theological meanings into things as we are at reading commercial and cultural meanings. For them there was no question of something being 'just a picture': the world was God's second book of revelation as it had been for Christians since at least the fourth century. The Lutheran Sebastian Franck could write in his *Paradoxa*, 'As the air fills everything and is not confined to one place as the light of the sun overflows the whole earth, is not on earth, and yet makes all things on earth verdant, so God dwells in everything and everything dwells in Him.'[27]

The Reformed Dutch Catechism taught that the world 'is before our eyes as a beautiful book, in which all created things, great and small, are like letters, which give us the invisible things of God to behold, namely His eternal power and divinity'.[28] The Reformation prioritised the literal sense over the allegorical, but Dutch emblem books continued to find allegorical meanings in the most abstruse details, insisting that 'There is nothing empty or idle in things'.[29] A poem dedicated to a landscape painter notes that paintings 'sharpen us with profitable lessons through the eye', for while 'the painter depicts what is visible, the spirit will be engaged by it, since Nature, God's daughter, is rich in meaning'.[30] Dutch writers found the hand of providence not only in their history but in their landscape and could even urge people to go out and 'let the eye wander happily through God's landscape painting'.[31] The Dutch lawyer and emblematist Jacob Cats noted that 'Wherever vegetation grows, one can honour the great Creator ... Who in the fields combines his vision with reason, will find many a thing to edify his morals.'[32] There is a question whether what was at issue was allegory or a broader sense, corresponding with a later Deism, that it is the abundance, variety and design of the created world which leads us to a knowledge of God.[33] Ruisdael, complained Constable, had painted a picture called 'An Allegory of the Life of Man' in which there were ruins to indicate old age, a stream to signify the course of life, and rocks and precipices to shadow forth its dangers. But, he asks testily, 'how are we to discover all this?'[34] Perhaps by 1833, when this question was asked, the way of thinking which saw every detail of creation as evidence of God had already been lost, and this is even more so the case today, when the foremost Ruisdael scholar is indifferent to the theological significance of the paintings. On the other hand, if it is true that secularity was not an aberration in a Christian view of things but in some respects represented its true direction, then we can understand Reformed thinking as steering people away from the ideal, and fostering estimation for the everyday world, beautiful as God's creation even in its imperfect, fallen state. 'This underlying consensus stimulated observation of the visible world and at the same time led men to submit it to a conceptual framework. Thus, with respect to landscape painting, aesthetic delight in the visible world con-

veyed inherent spiritual significance.'[35] Consider, further, the remark cited
in the first chapter that 'All the wretchedness of human life is bound up
with the fact that sound common sense and the *natura docet* have no
power at all firmly to plant our feet on the ground of the confidence that
the created world is real.'[36] Ruisdael painted in this age when philosophers
and men of sense were cultivating systematic doubt. In the face of such
scepticism his vision was guided, rather, by the covenant theology of his
Dutch peers for which the created world was part of God's gift and bless-
ing, an intrinsic good. His landscapes are visual witnesses to this belief in
the covenant, solid affirmations of the reality and goodness of the world.
Such landscapes, commented Tillich, are not the landscapes of ordinary
encounter, nor are they completely re-arranged by the painter but are 'the
result of the creative encounter with what one could call the spirit of the
intrinsic power of the landscape'.[37] Alternatively, they expose the 'excess'
of the material world, its basis in grace.[38]

In the eighteenth century, while scepticism about revealed religion grew,
belief in the revelatory powers of nature flourished. 'To seek the Shades of
retirement in order to admire more at leisure the Works of the Creation',
wrote John Cooper in 1757, 'to grow thereby familiar with the concep-
tions of God, to harmonize the Mind to Moral Beauty, by frequently con-
templating upon Natural, and to anticipate in some measure the Bliss of
Heaven, upon Earth, is a resolution worthy a Being, whose Soul is an
emanation of that eternal Source of Life and Light that created all Things'.

The Silence of a rural Scene, the not unpleasing Horror of the varied
Light and Shade in the Woods, the Whispering of the Trees, and
unbounded Prospect of Heaven above, call up MEDITATION, as by a
Charm, and all her Train of Intellectual Attendants. Behold She comes,
awfully moving to his pausing Eye! See! INDOLENCE and all her courts
of Selfish VICES recede from her Presence! VIRTUE precedes her,
BEAUTY and TRUTH attend on each Side, and the laurelled Sisterhood
of ART and SCIENCE immediately follow. In her Hand she bears the
faithful Record of all the ages, and presents to her View Examples of
whatever Wisdom, Valour, and Benevolence inspired.[39]

'Who does not respond with a feeling of pious gratitude when he sees the richness of nature spread out before him in the fertile countryside?', asked Cooper's Swiss contemporary Johann Georg Sulzer.[40] The allegorical reading of the seventeenth century has been replaced by a more general belief in the revelatory powers of nature. Constable was educated into this structure of affect. Above all he wanted to capture the 'chiaroscuro of nature', which he does in his subtle shading of tones, heightening them in the finished picture compared with his sketches. His most iconic picture is *The Hay Wain*, which he himself called *Landscape: Noon* (fig. 37). It is high summer – haymaking is going on in the fields and the wagon comes to take home the crop to the barns and lingers in the ford to swell the wood and stop the wheels from disintegrating in the heat of the day. An angler and a washerwoman quietly go about their tasks but there is an urgency which is belied by the slow passage through the ford: clouds pile up from the west threatening to spoil the crop – essential food for the animals through the winter, and the only thing that stands between plenty and starvation. We have to remember that at this time in the nineteenth century, before the invention of refrigerator ships which brought food from all over the empire, famine was an ever present threat. The labourers in the far distance are sweating in one of the busiest times of year, working from dawn to dusk to get the hay crop in.[41] The painting was done while ricks were being burned in the countryside, but Constable, who corresponded with his younger brother about this, does not acknowledge it in the painting at all. Rather, what he seeks to do in, as he put it, Landscape scenery is to give 'one brief moment caught from fleeting time a lasting and sober existence'.[42] 'Sober' is an important word in relation to this picture.

Kenneth Clark calls *The Hay Wain* 'an eternally moving expression of serenity and optimism' which belies the tension introduced by the clouds which Constable, as a miller's son, perfectly understood. For others the remoteness of the figures in this and other pictures, tiny white dots whose faces we never see, is a deliberate choice which means that we never see the actuality of the weary labourers. We assume they share in the happiness suggested by the landscape.[43] Constable's paintings 'combine Pastoral and Georgic . . . they attempt to reconcile and to conceal the gap between

37 John Constable, *The Hay Wain*, 1821, National Gallery, London

what we do and what our servants do, through the mediating term of nature'.[44] Evading the social reality, labourers become merely symbols and tokens of humanity.[45] Later on, Constable comes to see his paintings of landscape as 'experiments' in 'Natural Philosophy', so the emphasis in his work becomes less social, and the figures carry less and less of the meaning of the pictures, which is displaced into the clouds, where 'the Student of Nature may daily watch her endless varieties of effect'.[46]

Others read the labour in Constable's pictures more benevolently, citing his view that the solitude of the mountains oppressed his spirits and they argue that for this reason he depicts social labour. In all the six-footers except *Stratford Mill*, it has been pointed out, work is being done and in every case it is related to the commercial life of the canal. 'Absorbed in

their work the figures are absorbed into the landscape. This blending has two effects: it naturalizes the labourers' presence in the landscape and, by extension, it naturalizes the work they are shown performing there. Not only men and nature are shown in harmony but also industry and nature. The land is formed for cultivation and the river for navigation: work is the natural attitude in such a place where man's commercialization of nature has come to signify his oneness with nature.'[47] The workers in Constable's pictures, then, are ambiguous figures, pointing to a pre-industrial fantasy of organic production as well as to alienated labour.[48]

Constable was profoundly religious, and understood his art through his faith. 'Our wisest and best teachers, the scriptures themselves teach us', he said, 'that our Maker is most seen in his work – and best adored in our wonder and admiration of them'. In a letter to John Dunthorne in January 1802 Constable wrote, 'Excepting astronomy . . . I believe no study is really so sublime, or goes more to carry the mind to the Divine Architect [as the study of nature]. Indeed, the whole machine which it has pleased God to form for the accommodation of the real man, the mind, during its probation in this vale of tears, is as wonderful as the contemplation of it is affecting.'[49] 'Who', he asked in his *Landscape Scenery*, 'in the ardour of youth, would not willingly forego the vainer pleasures of society, and seek his reward in the delights resulting from the love and study of Nature, and in his successful attempts to imitate her in the features of the scenery with which he is surrounded; so that in whatever spot he may be placed, he shall be impressed with the beauty and majesty of Nature under all her appearances, and thus be led to adore the hand that has, with such lavish beneficence, scattered the principles of enjoyment and happiness throughout every department of the Creation?'[50] In the last of his lectures on landscape painting in 1835 he wrote, 'The landscape painter must walk in the fields with an humble mind. No arrogant man was ever permitted to see nature in all her beauty. If I may be allowed to use a very solemn quotation, I would say most emphatically to the student, "Remember now the Creator in the days of thy youth" . . . the art of seeing nature is a thing almost as much to be acquired as the art of reading the Egyptian hieroglyphics.'[51]

Constable's worship of nature, remarks the editor of his letters, was not a pagan belief; the delight which he himself experienced came to him as proof of the existence of a beneficent creator, and landscape art was the rendering of a tribute worthy of what had been so bountifully bestowed.[52] Landscape, then, becomes revelatory and is believed to convey moral ideas. Constable is often read together with Wordsworth.[53] Both believed that natural phenomena had a moral and spiritual quality of their own. Both were attracted to humble things. 'The sound of water escaping from Mill dams . . . Old rotten Banks, slimy posts, & brickwork. I love such things', Constable wrote to his friend John Fisher. 'As long as I do paint I shall never cease to paint such places . . . I should indeed have delighted in seeing what you describe . . . in the company of a man to whom nature does not spread her volume or utter her voice in vain.'[54] Both Wordsworth and Constable drew on their boyhood. 'I should paint my own places best – Painting is but another word for feeling. I associate my "careless boyhood" to all that lies on the banks of the Stour. They made me a painter (& I am grateful) that is I had often thought of pictures of them before I had ever touched a pencil.'[55] Both sought to recollect emotion in tranquillity.[56]

The mixture of piety and political reaction in Constable could suggest opiate and raises the question whether the faith in the landscape he expresses is anything more than ideological obfuscation. It is quite true that Constable was an old-fashioned High Tory, who regarded even so mild a piece of legislation as the Great Reform Bill as a catastrophe, and whose politically reactionary views probably are reflected in his paintings. It is also true that many of Constable's greatest paintings are not of 'nature' at all but of great buildings like Salisbury Cathedral, great occasions like the opening of Waterloo Bridge, or of romantic ruins like Hadleigh Castle. What he is remembered for, however, is not these, nor even the Georgic nature of his scenes, but his capture of, as it were, the mossy underside of the English landscape. Although his landscapes are peopled he invests the natural world with a quasi-autonomous dignity. His favourite reading was not his contemporary, Wordsworth, but Gray and Cowper with their older and more orthodox sense of the sanctity of nature. He knew perfectly well that the veneration of nature he felt did not necessarily lead to a know-

38 Peter Paul Rubens, *Het Steen*, c.1636, National Gallery, London

ledge of the Creator. He regarded many of his fellow students as 'repro-
bates'.[57] What he was able to convey, and what makes him still treasured
at least within the English structure of affect, is a sense of the 'dearest
freshness deep down things'. He felt the grandeur of God on his pulses
and communicates it in lively, sometimes aggressive, paint. There is a strain
of sentimentality in him which generates contemporary suspicions – the
boy in *The Cornfield* or *Flatford Mill*, the dog in *The Hay Wain* – but it
never quite wins out. A certain angry objectivity sends us back to the
natural world with fresh questions and it is this energy and awkwardness,
the vehicle of intensely felt observation – only visible when face to face
with the paintings, and not in reproduction – which makes him still a
teacher and not a peddler of false consolations.

DREAMING OF EDEN

Some ideal landscapes are the product of an ancient longing for a quiet life, far from the corrupt and busy life of the city.[58] For the medieval and Renaissance imagination this retreat was Eden which Milton describes as 'a happy rural seat of various view'. Eden fused with Arcadia and the figure of the Duke in *As You Like It* who finds 'sermons in stones and good in everything', in pointed contrast to the court, is a familiar one in the Renaissance.[59] Hardly surprising, then, that we find arcadian painting. Rubens' twin pictures of his estate, *Het Steen* (fig. 38) and the *Rainbow Landscape* (fig. 39), are good examples. Constable wrote of them, 'In no other branch of the art is Rubens greater than in landscape; the freshness and dewy light, the joyous and animated character which he has imparted to it, impressing on the level monotonous scenery of Flanders all the richness which belongs to its noblest features.'[60] In the *Rainbow Landscape* a

39 Peter Paul Rubens, *Rainbow Landscape*, *c.*1636, The Wallace Collection, London

huge shady wood of evergreens runs down the right of the picture. In a clear stream ducks dabble and cattle water. Two girls accompanied by a labourer bring water from the stream while labourers are carting a huge harvest home. A rainbow arches over the whole scene recalling the promise of Genesis 9, and the sky which has recently been thundery is now flecked with gold. Rubens uses colour to create depth, as Leonardo had advocated, with blues for the distance, greens for the middle distance and browns for the foreground. The patches of light and dark cause our eyes to move around the painting, while the figures in the foreground make us feel part of the whole scene. The picture of *Het Steen* is likewise a symbol of prosperity and of the abundance of nature, with the family enjoying the view near the house while carters take away produce to market and a sportsman stalks game. A stream runs diagonally towards the house, emphasising the fertility of the fields and their suitability for pasture. The blue and gold of the sky sets the mood of peace and plenty. The front of the house is bathed in wintry light. It is autumn, as it was for Rubens – and perhaps the fallen tree which leads our eye into the picture is a metaphor for Rubens' gouty old age – but all the same it is an autumn richly blessed. It is the landlord's view, of course, but undisputedly edenic. No one ever caught the sense of nature at peace as fully.[61]

Apart from Rubens it is above all Claude who specialises in these visions. His *Landscape with the Marriage of Isaac and Rebecca* is a good example (fig. 40). Tall, bending trees, in the height of summer, frame the picture in which the blue of the sky is mirrored in a limpid river with gentle falls. The light floods through the trees and we can see through the leaves.[62] A millwheel turns slowly, and in the distance a hill rises steeply. On the greensward in the foreground figures play games and picnic, while a herdsman drives his flock and herds home. Claude accentuated the middle ground so that the eye is led through clearly defined horizontal planes to a distant vista: 'the spectator becomes an imaginary traveller, moving towards the light'.[63] Everything is at peace, the rural idyll writ large. Gessner, at the end of the eighteenth century, wrote that 'The mere view of [Claude's] pictures excites that sweet emotion, those delicious sensations that a well chosen prospect has the power to produce in the mind. His

40 Claude, *Landscape with the Marriage of Isaac and Rebecca*, 1648,
National Gallery, London

fields are rich without confusion, and variegated without disorder; every
object presents the idea of peace and prosperity; we continually behold a
happy soil that pours its bounteous gifts on the inhabitants; a sky serene
and bright, under which all things spring forth, and all things flourish.'[64]
Turner speaks of Claude's paintings as being 'Pure as Italian air, calm,
beautiful and serene.'

The golden orient or the amber-coloured ether, the midday ethereal vault
and fleecy skies, resplendent valleys, campagnas rich with all the cheer-
ful blush of fertilization, trees possessing every hue and tone of summer's
evident heat, rich, harmonious, true and clear, replete with all the aerial
qualities of distance, aerial lights, aerial colours.[65]

He himself strove to emulate such scenes, and requested that two of his pictures be hung alongside those of Claude.

Another form of idealism is found in the classicism of Poussin, which the protean Turner also sometimes echoed. It has often been claimed that it was not Christianity but Stoicism which triumphed in Europe, and this was certainly true of many currents in the seventeenth century and of the art of Poussin in particular. For Stoicism the world and everything in it was the product of divine rationality and Poussin, who was more an ancient Roman than a Counter-Reformation Catholic, illustrates this by geometrising his landscapes, something which classical themes enabled him to do. His two paintings of the death of Phocion, the great Athenian general forced to drink poison by his enemies, address the very heart of his own world view. Phocion was an archetypal Stoic hero who, according to Plutarch, 'had an impassive face, and was hardly ever seen either happy or sad. In the army, he went barefoot and with only thin clothes, except only when the temperature was extremely cold. The soldiers used to say that it would be a hard winter when Phocion wore his coat.'[66] Poussin's own dispassionate self-portrait suggests something of the same demeanour. In *The Funeral of Phocion* (fig. 41), in the Louvre, two disciples bear the body away, out of the city whose classical buildings establish a rationality which is in some contrast to the curving tree that frames the picture to the right. People go about their business, herding sheep, or carrying things into the city, and the body of the one who had defended the city for forty years is carried away without ceremony. A river just outside the city catches the light. Foreground and background are linked by the zigzag road which winds into the distance.[67] Blunt notes that Poussin never painted the sea, but only lakes or smoothly flowing rivers because 'the ripples of the sea would have destroyed the absolute stillness of his landscapes'.[68] In *The Ashes of Phocion* (fig. 42), in Liverpool, Phocion's widow, who had told a vain visitor that her adornment was her husband, comes to collect the ashes. On the ground outside the city other women picnic or sit to chat. A temple rises in the very centre, an ironic comment on what is truly sacred, the widow's reverence for her husband, and beyond that craggy rocks and trees in the full bloom of summer frame

41 Nicolas Poussin, *The Funeral of Phocion*, 1648, Musée du Louvre, Paris

42 Nicolas Poussin, *The Ashes of Phocion*, 1648,
Walker Art Gallery, Liverpool

the city space. Both pictures are set out like a seventeenth-century masque, in an enclosed space, and we are led from the trees in the foreground to the figures, to the city beyond and to the carefully composed sky. Poussin is expressing the intrinsic rationality of the world order, despite the tragedy that has taken place, and the acceptance of suffering which was one of the hallmarks of Stoic ethics.[69]

Constable felt that Poussin's landscapes were 'full of religious and moral feeling, and show how much of his own nature God has implanted in the mind of man'.[70] Hazlitt spoke of finding 'the unimpaired look of original nature' in Poussin, 'full, solid, large, luxuriant, teeming with life and power'.[71] But, in marked contrast to Constable, this religious and moral feeling is presented mainly through narrative, usually classical.[72] For Poussin nature and reason are one and the same and therefore 'nature' is severe and rational and its beauty without romance. For Constable, on the other hand, it is a living testament to a benevolent God.[73] Poussin considered the purpose of art to be '*la délectatation*', but meant by this a delight of the senses which led to a more sublime delectation of the soul, 'purified by his clear and rational forms'.[74]

The ideal landscape of Rubens, Poussin and Claude are, as Rubens especially makes clear, an aristocratic vision of ease where labour was unnecessary. 'The purpose of Pastoral', wrote John Barrell, 'is to present an ideal world which is not so far from the life of the early eighteenth century aristocracy, insofar as it is a world from which all industry has been abolished, and food appears, as it were magically, without the intervention of human effort'.[75] A critic in 1644 already noted sourly that 'The Golden age is for those that have gold.'[76] The rural idyll deliberately masks the commercial cycle that connects town and country. 'It frames portraits of happy self sufficiency, of subsistence rather than capitalist farming, of insulation from the effects of foreign wars.'[77] The wealthy patrons who hung landscapes on their walls in the eighteenth century were 'cosmic Tories', convinced that the world was ordered as God wanted it, which included their undisputed ownership of land. Churches were often included in landscapes to make just this point.[78] At the same time, it could be that those who laboured, had they a chance of viewing these pictures, might look

43 Jean-Baptiste-Camille Corot, *Ville D'Avray*, c.1865,
National Gallery of Art, Washington

forward to a situation in which they would no longer have to work, as in
Marx's famous dream of liberated labour in *Capital*.

A rather different vision of Eden is given us by Corot, at least in his
later silvery visions of Mortefontaine and Ville D'Avray (fig. 43). These are
visions of place irradiated by affection. Corot is to landscape what Chardin
is to still life: he offers us a gentle vision of feminised space, in which
young women, gathering brushwood, or doing laundry, are often depicted
but painted in an absolutely unsalacious way. Feathery trees and earth-
coloured buildings are reflected in still water. Judging by the shadows, it
is midday, but unlike his Italian pictures there is no suggestion here of sti-

fling heat. The figures working blend into the landscape: they are earthed, part of the place, '*France profonde*', suggesting a depth of belonging which was absent from the teeming industrialised cities. Kenneth Clark remarks that Corot, unlike Constable, had no Protestant preoccupation with morals, but on the other hand, 'it is hard to believe that the truth of tone in his pictures does not genuinely reflect his own candid and ingenuous nature. He has a naturalness which makes almost every landscape, painted before or since, look slightly artificial.'[79]

In all of these pictures there is a 'dark side' to the landscape, 'a moral, political and ideological darkness' which seeks escape in idealism and is one of the reasons that landscape has become part of the repertory of kitsch. In Corot's case, rural France was in fact wracked by debt, land hunger and depopulation.[80] The 'harmony' sought in landscape can be read as a compensation for and screening off of the actual violence perpetrated there.[81] Such landscapes then become objects of nostalgia, looking back to a time when metropolitan cultures could imagine their destiny in an unbounded 'prospect' of endless appropriation and conquest.[82] To the extent that this is the case landscapes like this may delight us with their beauty, but they cannot instruct us. On the other hand Ernst Bloch read this arcadian landscape in terms of his 'principle of hope', as part of that which inspires humankind to utopian ventures but, significantly, as a vision which quite deliberately took the place of the church, and acted as a substitute goal or religion.[83]

THE RELIGION OF NATURE

Edward Norgate, writing in the middle of the seventeenth century, called landscape a 'harmless and honest Recreation, of all kinds of painting the most innocent, and which the Divill him selfe could never accuse of Idolatry'.[84] There is an irony in this given the religion of nature which had already begun in the late fifteenth century, and which became a veritable cult in the nineteenth. The humanist Conradus Celtis, honoured by the Emperor, and eventually professor at Heidelberg (where he died in 1508), poured scorn

44 Caspar David Friedrich,
Cross in the Mountains, 1807–8,
Gemäldegalerie, Dresden

on worship in church and advocated worship out of doors because 'here are the highest temples of the deity'.[85] Such views developed eventually into a religion of nature. This kind of religion was voiced by the famous surgeon and painter Karl Gustav Carus who advised people, 'Stand then upon the summit of a mountain, and gaze over the long rows of hills. Observe the passage of streams and all the magnificence that opens up before your eyes; and what feeling grips you? It is a silent devotion within you. You lose yourself in boundless spaces, your whole being experiences a silent cleansing and clarification, your I vanishes, you are nothing, God is everything.'[86] Caspar David Friedrich was its artistic representative. If Schlegel desired that his writings be Bibles, remarks Koerner, 'Friedrich fashions the Romantic painter's corollary aspiration: that his canvasses be altars'.[87] When Friedrich showed his *Cross in the Mountains* (fig. 44) the wife of a Dresden painter

45 Caspar David Friedrich, *Morning in the Riesengebirge*, 1810–11,
Schloss Charlottenburg, Berlin

wrote, 'Everyone who entered the room was deeply moved, as if they had
set foot in a temple. The loudest bawlers . . . spoke quietly and solemnly, as
if in a church.'[88] A less familiar painting, *Morning in the Riesengebirge*,
conveys the same sentiments (fig. 45). Here a young couple are up early in
the morning and the woman helps her partner up to the cross, placed on a
rocky eminence overlooking a sea of mist-swathed hills. The horizon divides
the picture in two, and Friedrich has depicted the mountains merging into
the mists and the mists into the sky, 'the vast dimensions of elemental, unin-
habited nature, to which the mists add a breath of nascent energy'.[89] As in
The Cross in the Mountains the relation between God and human beings,
signified by the crucifix, is transposed to a relation between self and 'nature',
though what is meant by 'nature' is problematic.[90] The cross, the one ver-
tical, unites the two halves of the picture.

There are a number of themes here which have analogies in the work of Friedrich's contemporary, the great Reformed theologian Schleiermacher, who visited the artist in Dresden.[91] Schleiermacher believed that women were naturally closer to God than men; his *Christmas Eve* dialogues tell dramatically what Friedrich here illustrates: the woman has to help the man up to the cross. In his *Speeches on Religion* Schleiermacher had written the manifesto of the religion of feeling. In the same way Friedrich believed that 'The painter should not paint merely what he sees in front of him but also what he sees within him.'[92] The 'merely' is a telling contrast with Constable. Friedrich did not paint from nature but from his imagination. He believed in following his 'inner self', 'the Divine in us'. 'Regard every pure mental impulse as holy, honour every devout presentiment as holy, for it is the art within us! In the hour of inspiration it takes on visible form, and this form is your picture.'[93] 'Nature', then, is a figure for the artist's emotions – not what he has seen but what his religious emotions want him to see. Schleiermacher famously described himself as 'a Pietist of a higher order', but that is exactly what Friedrich is in his own way. What is important is not the natural world but the natural world as an expression of his piety. This kind of fervid piety, it seems to us, schooled by the acid realities of the twentieth century, is both melodramatic and solipsistic, further removed in sentiment than the fifteenth century and far more difficult to understand as any kind of secular parable.

TRANSFIGURATIONS

As we saw, Turner was regarded by Ruskin as being more true to nature than any previous artist. This aim, to be true to nature, was shared by the impressionists for whom he was such an inspiration. Turner was a chameleon-like figure, who could paint like Claude, Poussin, or Wilson when he chose. His attempt, along with many others, to capture the sublime, as in *Hannibal Crossing the Alps*, recalls Karl Barth's comment that there are some things in art, such as the incarnation, which should simply not be attempted. Early seascapes such as *Fishermen at Sea* of 1796

are astonishing evocations of what it actually feels like to be caught in rough seas while his *Snow Storm Off Harwich* of 1842 might well have been recognised by Conrad. What became Turner's trade mark are the late oils in which the landscape almost dissolves into colours and, as Lawrence Gowing claimed, became a preparation for abstraction. To set the 1823 watercolour of *Norham Castle* (fig. 46) against the 1845 *Norham Castle, Sunrise* (fig. 47), is to see the way in which watercolour techniques influenced his style, but it also illustrates the characteristic role of the sun in most of Turner's work. He always paints *into* the sun, not with his back to it, and paints the world irradiated with glory. His epigraph is from Ezekiel: 'And there, the glory of the God of Israel was coming from the east . . . and the earth shone with his glory' (Ezek. 43.2). We do not know whether the late paintings are finished, or whether he intended to 'lay them in' on varnishing day, but they represent a preoccupation with the grandeur and glory of nature which is evident in his work from the start. Works like this are 'a flowing sea of brilliant colours and the visual expression of all that is implied by his dying words, "The Sun is God"'.[94]

Like Turner, Monet believed in being true to nature. 'If you don't see nature right with an individual feeling', he said, 'you will never be a painter'.[95] For his champion, Mirbeau, Monet had 'captured [nature] at every hour, at every minute . . . expressed it in all its changing aspects, all its fugitive [effects of] light . . . he renders the impalpable, the ungraspable in nature . . . its soul, the thoughts of its mind and the beating of its heart'.[96] Monet's nature, like Turner's, was increasingly unpeopled – even London, the world's largest city, dissolves into coloured shadows (fig. 48). Clark spoke of Monet's Rouen Cathedral series as 'stubborn' but it is surely in his urban even more than his rural pictures, or the pictures of Giverny, that we are in touch with his vision of a transfigured world. Both artists see the world in vivid colours which are scarcely ever seen in quite the intensity they represent them but which suggest that the border between the ethereal and the mundane is very thin.

The faith of Monet's friends was in a secular pantheism whose truth was confirmed by science, and whose role was to foster humanity's progress towards a just society.[97] Mirbeau considered Monet's landscapes

46 J. M. W. Turner, *Norham Castle*, 1823, Tate Britain, London

47 J. M. W. Turner, *Norham Castle, Sunrise*, 1845, Tate Britain, London

48 Claude Monet, *London*, *c.*1904, Musée Marmottan Monet, Paris

to be 'the revelation of the states of consciousness of the planet, and the super-sensory forms of our thought'.[98] Clark remarks that it was the mystical sense of the unity of creation expressed by light and atmosphere which, however unconsciously, provided a basis of pictorial unity for the impressionists.[99] Monet probably would not have agreed with this: his desire was to record his sensations as accurately as possible. At the same time it is doubtless true that Monet, along with the other impressionists, represented 'a complete confidence in nature and in human nature. Every-

thing they see exists for their delight, even floods and fog.'[100] This was not true for Turner, whose own outlook, as we see it in his long poem *The Fallacies of Hope*, is pessimistic – a pessimism contradicted in the beauty of his canvases. Again, Monet had no interest in politics but his advocates believed, like D. H. Lawrence, that the working class had a need for beauty as much as for bread and that Monet's art 'would act for the social good by embodying those joys and beauties which they believed should and could be the possession of all, and whose role was to foster human-ity's progress towards a just society'.[101] Ernst Fischer comments that the element of revolt in impressionism is counteracted by that of a sceptical, evasive, non-militant individualism, the attitude of an observer concerned only with his impressions. 'And so impressionism was, in a sense, a symptom of decline, of the fragmentation and dehumanization of the world. But at the same time it was, in the long "close season" of bour-geois capitalism . . . a glorious climax of bourgeois art, a golden autumn, a late harvest, a tremendous enrichment of the means of expression avail-able to the artist.'[102] There is more to be said of the vision of Turner and Monet, however, than simply the solace of beauty. Like all truly great artists they cleansed the doors of perception. They have sensed, and help others to see, the glory patent in the ordinary, the transfiguration of the real, breathtaking if not quite in the way that theorists of the sublime implied. It might be objected that the transfiguration is without analogy, but, as John of Damascus argued in the iconoclast controversy, what we learn through the incarnation is the potential of matter to be transfigured. Most of the time we are simply unable to see that: part of the abiding appeal of landscape painting is that, at its best, it opens our eyes, as the eyes of the disciples were opened, to see the ordinary in a completely dif-ferent way.

GOD'S LABORATORY

In mid life Cézanne came back to Catholicism and expressed himself in con-ventionally pious terms. 'An artist, you see', he wrote, 'neither glory nor ambition counts for him. He should do his work because the Good Father

wills it, like an almond tree makes its flowers, like a snail makes its slime.'[103] His work aspires 'to be nothing but an absolutely faithful hymn of praise to the glory of God's creation'.[104] 'I am oriented', he said, 'towards the intelligence of the Pater Omnipotens'. He wanted to 'paint after nature' which, for him, was 'God's laboratory'.[105] He wrote to Emile Bernard in 1904, 'I always come back to this: the painter should devote himself entirely to the study of nature and endeavour to produce pictures that are an education. Chatter about art is almost useless . . . One is neither too scrupulous, nor too sincere, nor too submissive to nature; but one is more or less master of one's model, and above all of one's means of expression. To penetrate what's before one, and persevere in expressing oneself as logically as possible.'[106] Although he admired Poussin this did not make him a rationalist. 'Painting after nature', he said, 'is not copying the objective, it's realizing our sensations. To read nature is to see beneath the veil of interpretation, as coloured patches succeeding one another according to a law of harmony. Thus these colours are analysed by modulations. To paint is to register these colour sensations.'[107] Seeing beneath the veil of interpretation meant studying the geology of a place and 'germinating' with the countryside. Truth to nature did not mean realism. 'Words do not look like the things they designate; and a picture is not a trompe l'oeil.'[108] Cézanne insisted that there were no lines in nature and no shadows without colour. He sought to give shape to an object through accuracy of tone.[109] Like Van Gogh, therefore, his colours bear no resemblance to the familiar world.

These opinions are perfectly illustrated in the picture of *Lac d'Annecy* painted in 1896, now in the Courtauld Institute (fig. 49). Cézanne has followed Poussin and has a tree on the far left of the canvas whose branches sweep right across the foreground framing the lake, the chateau and the hills beyond. The painting is executed almost exclusively in blues and greens, with the long pale reflections of the chateau in the centre of the picture offsetting this sombre tone. Two blue masses of hills, formed by patches of colour in the way he was later to do so spectacularly in his last paintings of Mont St Victoire, rise either side of a valley which sweeps up to the left from the fields and meadows already quite high above the lake.[110] There is no movement of any kind: the painting is not reportage.

49 Paul Cézanne, *Lac d'Annecy*, 1896, Courtauld Institute Galleries, London

In his letters from Annecy Cézanne spoke ironically of 'the travel sketch-books of young ladies'. He himself has distanced himself as far as possible from such sketches, and seeks rather to record sensations and to create an overwhelming mood. Speaking of Veronese he said, 'One is only aware of a great waviness of colour . . . iridescence, colours, a wealth of colours. That is what painting ought to give us first, harmonious warmth, an abyss into which the eyes plunge, a mute ripening of seed. A coloured state of grace . . . Go down with the painter to the dark, tangled root of things, and come up to the surface again with colours bursting into bloom with them in the light.'[111] In this picture Cézanne hardly gives us a coloured state of grace; he rather takes us to the 'dark, tangled root of things'. As

137

Venturi wrote, 'A feeling of panic induced by the height of the mountain and the depth of the lake manifests itself in the blue, graduated to the deepest darks.'[112] Joachim Gasquet spoke of Cézanne's intense concentration, like a silent prayer, before he applied brush to canvas. 'What he was doing was digging down to the ultimate roots of reason and the world, at some level where the human will encounters the will of things and is either regenerated by them or is submerged by them.'[113]

We learn to perceive things as we learn speech: having done so we take both speech and vision for granted. The artist and the poet take us back to 'the springs of speech' or of vision by creating difficulty, by making the familiar strange. In Cézanne's landscapes 'Nature itself is stripped of the attributes which make it ready for animistic communions: there is no wind in the landscape, no movement on the Lac d'Annecy; the frozen objects hesitate as at the beginning of the world. It is an unfamiliar world in which one is uncomfortable and which forbids all human effusiveness.' This is a vision which 'penetrates right to the root of things beneath the imposed order of humanity'.[114] In it the world is rendered strange. 'Only one emotion is possible for this painter – the feeling of strangeness – and only one lyricism – that of the continual rebirth of existence.'[115]

LANDSCAPE AS SECULAR PARABLE

As we have seen, Christians were familiar with the book of nature from the fourth century onwards. Part of the process of secularisation was that the importance of the second book, of nature, gradually increased relative to the first book, of Scripture. Contemporary critics very properly point out all that this omits: much landscape painting is conceived from the landlord's point of view, all is to some extent idealised. Only Brueghel the Elder paints the landscape of toil. It is probably true that the love of landscape which, at least in Britain, cuts across all classes, owes much to a reaction to industrialisation and urbanisation.[116] At the same time, as noted above, hints as far back as the psalms lead us to suspect that love of the landscape, of 'nature', is older and deeper than is sometimes allowed. In this

respect Cézanne's practice suggests the way in which great landscape painting may be considered a secular parable, in that the attention in which it originates is a form of silent prayer and as such what it seeks to do is to understand where God is and what God has done in creation. Where that teaches us most theologically, I have suggested, is where it questions our habitual seeing, stopping us from taking the world for granted.[117] Art, says Rowan Williams, 'in one sense "dispossesses" us of our habitual perception and restores to reality a dimension that necessarily escapes our conceptuality and our control. It makes the world strange.'[118]

It is true that since Cézanne landscape has hardly been at the heart of artistic enterprise. Perhaps its consolations seemed too easy for landscapes of France churned to mud with a million corpses. Today it is suggested that either the nuclear threat or global warming has changed our understanding of the landscape forever. 'Man's devastating exploitation of nature', writes Martin Warnke, 'has put an end to her argumentative force and autonomous authority. Permeated by foreign substances and marked out for destruction, she may still elicit sympathy and inspire relief measures, but she can no longer assist us by furnishing arguments for legitimacy. The rich reservoir of motifs and experiences that once guided human action . . . has run dry.'[119] Landscape art has, for the moment, emigrated to installations, often fragile and temporary, parables of the fragility of nature as a whole.[120] At the same time precisely this crisis has also provoked deep ecology, the idea of Gaia and, on the part of some, a deeper respect for the natural world than ever. The continued popularity of exhibitions of landscape art dating from the seventeenth or nineteenth centuries may indicate that people find in such painting not simply nostalgia, nor painterly brilliance, but resources to respond to the threats posed to the natural world, moral resources to help take arms against them. Perhaps more than ever this painting speaks to us in parables.

50 Jan van Kessel, *Still Life of Flowers and Grapes Encircling a Monstrance in a Niche*, c.1670, National Gallery of Scotland, Edinburgh

6

CELEBRATING CREATION

CREATION AS BLESSING

In the second century of the church's life the major doctrinal struggle was over the goodness of creation. Manichees and other Gnostic groups disparaged the body and creation as a whole. With great difficulty this set of opinions was rejected as an option incompatible with the church's life. One of the things which made it so difficult to establish this was that Platonism's doctrine of the Forms, the notion that the 'really real' was ideal and that here we had only shadows, reinforced suspicion of the goodness of creation. Plato himself disparaged the body. The philosopher, says Socrates in *Phaedo*, frees himself as far as possible from the body. The soul reflects best when it is free from the distraction of the senses. In fact it despises the body.[1] Augustine regarded Platonism as the school of philosophy closest to Christianity partly for this reason. At one point in his life he was touched by what Peter Brown speaks of as a kind of wild Platonism which led him to disparage the senses.[2] 'When I love you, what do I love?' he asks God rhetorically:

It is not physical beauty nor temporal glory nor the brightness of light dear to earthly eyes, nor the sweet melodies of all kinds of songs, nor the gentle odour of flowers and ointments and perfumes, nor manna or honey, nor limbs welcoming the embraces of the flesh; it is not these I love when I love my God. Yet there is a light I love, and a food, and a kind of embrace when I love my God – a light, voice, odour, food, embrace of my inner man, where my soul is floodlit by light which space cannot contain, where there is a sound that time cannot seize, where there is a perfume which no breeze disperses, where there is a taste for food no amount of eating can lessen, and where there is a bond of union that no satiety can part. That is what I love when I love my God.[3]

Famously, when Petrarch climbed Mt Ventoux and was admiring the view, it was Augustine who came to his mind, warning him not to be absorbed in earthly sights but to pay attention to his inner self. These attitudes naturally militated against a cherishing of creation. But, 'The day came when St Francis of Assisi spoke to the birds and hymned the flowers. By regarding all created things in the light of divine grace, he opened men's eyes to the humble surroundings of life. The irresistible rise of a nominalist, Aristotelian philosophy awakened a spirit of inquiry and observation, and put a new value on empirical knowledge of concrete things. The German mystics of the fourteenth century, Eckhart and Suso, declared God to be immanent in the whole of creation and marvelled at the beauty of the world. By now inanimate things had become worthy of the Christian admiration, and worthy too of the artist's attentions.'[4] This is an attempt to explain the revival of still life painting after more than a thousand years. It had flourished in antiquity when it was known as 'rhopography', the depiction of insignificant objects, or, satirising the original term, 'rhypography' – painting of the sordid, referring to depictions of the leftovers of a banquet.[5] Such paintings had fallen into abeyance. 'Not until earthly life and its everyday realities had been given a place in the Christian conception of the world', says Sterling, 'did the essentially religious painting of the Gothic age begin to show an interest in the representation of objects for their own sake'. This account might be challenged by pointing to the

interest of the medieval sculptors, carvers and manuscript illuminators in nature – in trees, leaves and flowers, for example. Studies of animals, birds and plants from life were known both in antiquity and in the early Middle Ages.[6] Already in the thirteenth century an unknown Paduan illustrator of a textbook of herbal medicine 'turned his back on all patternbooks and had the courage to look nature straight in the face'. 'We have reached the point where impressions from life, from the outer world, can give the primary impulse for artistic imagination and invention.'[7] Equally, it was not the fourteenth-century mystics who invented the doctrine of immanence, which had been part and parcel of the church's faith from the beginning. Some look for an explanation to the slow growth of the secular spirit. In the fifteenth century still lifes feature in the margins of religious pictures, or on the back of them and in the next century, as we saw in the first chapter, they become fully independent.[8] Before still life was possible, Sterling thinks, 'Religious tutelage had to be broken. Men had to adapt themselves to the secular spirit, to the scientific and humanistic way of thinking, to the outlook of the Renaissance'.[9]

Another important motive for the return to still life was the respect in which the classical sources were held. Pliny had spoken of a painter called Piraikos who painted 'barbers' shops, cobblers' stalls, asses, eatables and similar subjects'. The Dutch humanist Hadrianus Junius compared Aertsen to him:

Nor should Peter surnamed the Tall, be passed over in silence, whom I believe should be rightly compared with Piraikos of Pliny, if not placed above him, who deliberately as it seems sketched with the pen humble things and has rightly acquired in universal judgement the highest renown. And for this reason he can, at least in my opinion, be equally designated with the tag, painter of low and sordid things, to such an extent does a certain charm shine through everywhere in his works, having expressed most elegantly in country boys the texture and clothing of the body, victuals, vegetables, dead young chickens, ducks, cod, and types of fish and finally every type of kitchen utensil. So, contrary to pleasure that can be fulfilled, his panels never weary by virtue of their infinite variety.[10]

This suggests that Aertsen, Beuckelaer and others may well have gone to classical sources for their inspiration. Norman Bryson argues that in a work such as Velázquez's *Christ in the House of Martha and Mary* painting faced its own future and had to choose between two different conceptions of human life, 'one which describes the great events and one which protests that the drama of greatness is an epiphenomenon, a movement only on the surface of earthly life, whose greater mass is made up of things entirely unexceptionable and creatural'.[11] Of course, for another century and a half after Velázquez history painting was regarded as the summit of art, but meanwhile still life had established itself and attracted the talents of some of the very greatest painters, including Caravaggio and Rembrandt.

Contrary to Sterling's account of the rise of the secular spirit it could be that, as proposed in the first chapter, the intrinsic secularity of Christianity was freed in the sixteenth century on both sides of the confessional divide. Some of the most famous still lifes are profoundly religious and quite overtly celebrate the gift of creation. Cardinal Borromeo, who in his *De pictura sacra*, of 1624, set out the conditions for a sacred art which would conform to the decrees of the Council of Trent, himself collected them for just this reason. Christian joy, for him, consisted in contemplating the wisdom and power of God manifest in creation. The owner of Caravaggio's *Basket of Fruit*, he believed that God had intended the beauty of nature to appeal to contemplative minds, and enjoyed the flower paintings Jan Brueghel did for him because, in the depths of winter, they recalled the beauty of real flowers.[12] Typical of this approach is a still life by Jan van Kessel (fig. 50), the grandson of Jan Brueghel, now in Edinburgh, in which grapes and ears of corn surround a monstrance, where the consecrated Host is displayed. The sanctity of the consecrated bread, an icon of Tridentine piety, is reflected in the signs of creation around it.[13]

Like every painting these sixteenth-century still lifes embody an ideology. 'In the final analysis, these works (like all artworks) do not depict the real or the natural but are cultural signifiers, and the codes by which they operate are not spontaneously invented and reinvented but ideologically determined, not personal to the artist but strategically symbolic of the pri-

orities and desires of a given society at a given time.'[14] Of course, the greater the artist the more he or she may not simply reflect the present but challenge those priorities. Part of the purpose of seventeenth- and eighteenth-century still lifes was precisely to depict the real and the natural, but the question is how the real is understood. The fact that the objects represented are chosen in the first place is said to mark them out as 'objects of desire', and desire is only sustained if it is unsatisfied. 'Thus the objects of still life, although they appear accessible, are actually inaccessible, fictional, created; ideal as opposed to real.'[15] They are like the lovers on Keats' Grecian urn who will always chase and never possess. Desire is a key term in Christian reflection: Augustine seeks to sublimate earthly desires on Platonic lines, so that carnal experience is left behind in the ascent to God. Some at least of the ideological codes involved in still life are theological and, if they are about desire, they are about desire which is nourished and fulfilled by grace, which is to say, fulfilled but, precisely for that reason, because of the beauty and nourishment of fulfilment, prompting the desire for more. The world that we have is one 'in which things make themselves other or are made other (they are more than they are and give more than they have)'.[16] This is the very heart of still life painting.

CELEBRATING THE ORDINARY

Among the most astonishing of early still life paintings are, by common consent, those of Sánchez Cotán, who became a lay brother in a Carthusian monastery and painted in Toledo around 1600. Some of his paintings can be extraordinarily spare, as in the *Still Life with Cardoon and Parsnips* (fig. 51), now in Granada. Cotán's favourite framing space was a *cantarero* or cold larder, where the objects are set against a black and fathomless space. The cardoon, a celery-like vegetable, is propped against the right wall of the larder, in the full light, the earth on it still visible. The carrots are placed over each other forming a complex group and all overlapping the sill, demonstrating the illusionistic virtuosity of the painter. The sug-

51 Sánchez Cotán, *Still Life with Cardoon and Parsnips*, *c.*1602,
Museo de Bellas Artes, Granada

gestion that this still life echoes the vegetarian rule of the Carthusians, or
that it may be a Lenten still life, seems plausible but whatever its religious
provenance it forms an astonishing contrast to the work of a contempo-
rary of Cotán's such as Rubens, with his emphasis on historical or mytho-
logical themes. Why should anyone be interested in a few vegetables? Even
today they do not suggest themselves as a likely theme for art, but this
artist manages to invest what we consider as trivial, ephemeral, the quin-
tessentially domestic, with a truly metaphysical significance. The *Still Life
with Quince, Cabbage, Melon and Cucumber* (fig. 52) is in some respects
still more remarkable: the quince and the cabbage hang on strings against
the same black space, 'turning and glowing like planets in a boundless

52 Sánchez Cotán, *Still Life with Quince, Cabbage, Melon and Cucumber*, c.1602, San Diego Museum of Art, San Diego, Gift of Anne R. and Amy Putnam

night'.[17] The melon is roughly cut open and one slice lies on the ledge. Together with the cucumber it projects over the sill. The objects form a parabola and commentators suggest that Pythagorean geometry, used in the Escorial monastery, may be utilised.[18] Cotán has made art of this extremely simple arrangement of vegetables: they become illustrations of St Thomas's five ways, leading us from the humblest of causes back to God. After the First World War artists like Giorgio de Chirico and Carlo Carra adopted the term 'metaphysical' for their art in which they sought

to convey, according to one of their advocates, 'the direct vision of mystery, contained in the most common and insignificant objects'.[19] Their symbolist art, however, is self-consciously erudite and has none of the simplicity of Cotán. If we want a metaphysical art which understands the mystery in commonplace objects we find it much more obviously, I would suggest, in seventeenth-century Spain.

Other compositions of Cotán's are richer, with the added colour of hanging game fowl, but even these have been read in an austere way. 'Cotán's art', comments Sterling, 'breathes an air intellectual through and through, and also a mystical fragrance'.[20] Norman Bryson reads Cotán's paintings in the light of his Carthusian vocation, which stressed solitude and the importance of fasting. He finds the idea of the conviviality of a meal to be missing from the paintings.[21] 'Food enters the eye but must not pass through touch and taste. The inside of the body is a dark void: this may be one of the metaphorical connotations of Cotán's empty cantareros.'[22] Painting is approached in terms of a discipline or ritual, and the self and the body are eliminated. The work of God completely effaces the work of man.[23] Others, however, deny that these still lifes were moralising in promoting moderation and abstinence, or that they set out to show the dangers of gluttony.[24] Desire here, it seems to me, is not perpetually deferred or denied. In these paintings the 'fruits of the earth' are depicted as desirable, part of the desirability of creation, as grace. Grace is the quenching of desire: in the fruits of the earth we have objects which can be both the objects of desire and quench that desire again and again, an unlimited desire which is not pathological because it is a response to the gift of creation. A still life of Francesco de Zurbarán's (*Still Life with Lemons, Oranges and Rose*, painted in 1633) (fig. 53), has been described as 'an ennobling vision of nature's simplest things', an expression of religious devotion, where the objects are arranged 'like flowers on an altar, strung together like litanies to the Madonna'.[25] Zurbarán, says Sterling, 'was endowed in the highest degree with that "faculty of wonder" which lies at the heart of all truly creative art . . . Every still life painter of originality does no more than express his sense of wonder at the beauty of things.'[26]

53 Francesco de Zurbarán, *Still Life with Lemons, Oranges and Rose*, 1633, Norton Simon Museum, Pasadena

It seems a mistake to think of Zurbarán, in view of his other still lifes, which depict an elegant, if not luxurious, lifestyle, sharing an 'Ignatian mission' with Cotán.[27] However, equally with Cotán his still life painting speaks of the 'Yes' of creation, of the goodness of the world which we have been gifted.

Precisely because it is good this world demands and deserves attention. The severe focus of Cotán's work means that 'what is valueless becomes priceless' and 'attention itself gains the power to transfigure the commonplace'.[28] More than other genres of painting, perhaps, still life is concerned with paying attention, with 'looking at the overlooked'. The whole project of still life 'forces the subject, both painter and viewer, to attend closely to preterite objects in the world which, exactly because they are so familiar, elude normal attention'.[29] They have been compared to pebbles smoothed by the tides of human attention so that they become familiar, creating 'an abiding world where the subject of culture is naturally at ease and at home'.[30] Others find a spiritual intensity in such still life paintings

which makes us consider the meaning and the point of the – often very ordinary – things represented. The paintings 'make us slow down, look carefully at a walnut, a jug or parsnip, make us realise that we had never truly looked at one before, and acknowledge how astonishing they are'.[31] There is, to be sure, an important tradition, especially in Holland, of paintings of exotic and expensive flowers, fabulously chased silver and gilt, absurdly baroque glass ware which is more a pleasure to see and to handle than to drink from. Suddenly, however, says Bergstrom, artists began to take delight in describing all the things that belonged to everyday life.[32] This, in spite of the fact that history painting remained at the top of the painting hierarchy for several centuries after the Renaissance. Portraits and still life were supposed to involve less work than history painting. 'The value and rank of every art', said Sir Joshua Reynolds, 'is in proportion to the mental labour employed in it, or the mental leisure produced by it. As this principle is observed or neglected, our profession becomes either a liberal art, or a mechanical trade. In the hands of one man it makes the highest pretensions, as it is addressed to the noblest faculties: in those of another it is reduced to a mere matter or ornament; and the painter has but the humble province of furnishing our apartments with elegance.'[33] To him it seemed obvious that painting had to be concerned with greatness. Much still life, by contrast, is the painting of the Magnificat: it puts down the proud and raises up the humble. In this way Cotán's paintings are 'conceived as exercises in the renunciation of normal human priorities. They exactly reverse the scale of values in which what is unique and powerful in the world is the pre-ordained object of the gaze, while that which lacks importance is overlooked.'[34] Still life celebrates 'the ordinariness of daily routine and the anonymous, creatural life of the table'.[35] We are in the world of Theresa of Avila who believed that Christ 'walked among the pots and pans' and saw grace shining through the objects of daily usage.[36] At their best still life paintings 'imbue the everyday with the miraculous, they allow us to keep recovering that miracle, and they change the way we look at the world'.[37] It is this sense of grace in the everyday, or of its miraculous nature, which is the primary theological significance of still life painting.[38]

Art is bravura, skill, display: in all still life much of what is admired is the illusionism – the different textures and surfaces, scrumpled tablecloths, the suggestion of condensation on the outside of a glass, the feel of different fruits and vegetables. The stories which the Renaissance artists enjoyed from the ancient world were of Zeuxis deceiving birds through the realism of his grapes, and then of his rival deceiving him through the realism of his painted curtain. Caravaggio's still life was kept unframed for years, presumably so that people's astonishment and deception could be enjoyed. This means that painting the humble and ordinary is not an easy task for, paradoxically, the ordinary can become the vehicle for display. 'The central issue is how to enter the life of material reality as a full participant, rather than as a voyeur, and how to defamiliarise the look of the everyday without precisely losing its qualities of the unexceptional and unassuming.'[39] The painter who does this most successfully is Jean Baptiste Chardin, during the last days of the *ancien régime*. Chardin was successful in his own day and won royal patronage not only from the French court but from Frederick the Great of Prussia, but his paintings are the opposite of the grand manner. He has a 'studied informality of attention', which pays an equal regard to the most modest activities, above all those of the kitchen.[40] 'It is always nature, always truth', wrote Diderot of Chardin's pictures in the 1759 exhibition. 'You could take the bottles by the neck if you were thirsty; the peaches and the grapes give you an appetite and call for your hand.'[41]

Three examples, all in the Louvre, make the point. *Le Menu de Maigre* (fig. 54) (a fast-day meal, or a Lenten meal) gives us a kitchen table with an earthenware pot, two boiled eggs, a couple of spring onions, an iron skillet and an upturned copper pot, three hanging fish and a pestle and mortar. The painting is artfully arranged around the vertical fish set against the horizontal table. The glaze of the pot, the burnish of the copper and the silver of the fish are what add life to the painting, but it is devoid of any ostentation. The simplicity is as great as that of Cotán but the mood, or spirituality, is quite different despite the similarity of topic. Where the Spanish painter suggests grace and austerity Chardin paints domesticity. There is a warmth of gaze directed not primarily at the food but at the

54 Jean-Baptiste-Siméon Chardin, *Le Menu de Maigre*, 1731,
Musée du Louvre, Paris

55 Jean-Baptiste-Siméon Chardin, *Le Menu de Gras*, 1731,
Musée du Louvre, Paris

56 Jean-Baptiste-Siméon Chardin, *The Copper Urn*, 1734, Musée du Louvre, Paris

humble cooking implements which are used. It is 'work of human hands' rather than 'fruits of the earth' which is the centre of attention. *Le Menu de Gras* (fig. 55) (a meat-day, or feast-day meal) has the same simplicity: there is none of the luxury of the Dutch banquet or breakfast pieces: kidneys are the most prominent food. The light falls gently on copper, glaze and glass. The kitchen in these pictures is not a sacred place, nor is it a frenetic place where great feasts have to be conjured amid expletives, but a place of nurture, the blessing of the most basic facts of human life. One of Chardin's earliest and most successful pictures, *The Copper Urn*, likewise shows this blessing. It shows the urn, a ladle, an iron pot and an earthenware jug. 'The urn seems to be the heart of domestic life, usually hidden, but here revealed'[42] (fig. 56). Gide, writing of it, said it had the gravity of a Cartesian meditation.[43] Pursuing that clue, Descartes' fifth

57 Vincent van Gogh, *Still Life with Basket of Potatoes*, 1885, Van Gogh Museum, Amsterdam

meditation is entitled 'Concerning the being of material things and again concerning the being of God'. Because of the tricks perception plays on me, Descartes argues, it is only from the standpoint of faith that I can believe in the reality of the material world. Chardin invests the domestic world with that certainty. 'Chardin is fond of well-worn objects, polished by dint of being handled; man's presence is always implied in this unfailingly moving communion of life with matter. He bathes these objects in a delicately varied light expressive of the comforting warmth of the home, but devoid of any deliberately lyrical effects.'[44]

Chardin's world, it has been said, is a feminine one. In Dutch still life, especially in the gorgeous displays of Kalf, it is wealth and achievement

which is celebrated, 'the male gaze of capital'.[45] Chardin, by contrast, 'wants to enter feminine space gently and invisibly. He wants to capitulate, to make himself and his canvas porous to female space'.[46] The son of a maker of billiard tables, he has a respect for the labour of others which extends to the most ordinary work of the kitchen.[47]

Very different from this petit bourgeois world are the still lifes Van Gogh painted while in Nuenen. The *Still Life with Basket of Potatoes* is an evocation of the daily life of poverty (fig. 57). These are not quasi-metaphysical objects, like the vegetables of Cotán, but heavy, mud-caked, the product of toil. Van Gogh uses primary colours and lays them on thickly, with the brush strokes visible. The earlier *Still Life with Cabbage and Clogs* likewise divests this humble vegetable of all the beauty it had for Nathaniel Bacon or for Cotán and turns it simply into humble and essential food.

Twentieth-century still life kept up the tradition of celebrating the ordinary, but often returned it to male space – the space of the café and urban life, using smoker's accessories, bottles and newspapers.[48] Chardin's evocation of feminine space is therefore bracketed on either side by masculinity.

THE SHADOWSIDE OF CREATION

I have spoken of still life as celebrating the material world, but that world, of course, has a shadow side, the realm of suffering, death and decay. Still life painting addresses this in three ways. In the first place one of the major genres of still life is the vanitas painting, in which symbols of transience and mortality – wormholes in cheese, an extinguished or spluttering candle, a watch, a skull – are introduced. For Bryson the vanitas paintings of the seventeenth century grow out of the deep internalisation of the priority of the word over the image in Calvinist culture, but of course the theme goes back to ancient times, both in the carpe diem theme of Epicurean philosophy and in Ecclesiastes.[49] A sense of sin and judgement is a marked feature of late fifteenth-century piety and many tombs from the period have a vanitas theme. Both Calvinism and the Counter-Reformation heightened

58 Max Beckmann, *Still Life with Three Skulls*, 1945, Gift of Mrs. Culver Orswell, Museum of Fine Arts, Boston

this sense. The picture of three skulls with a richly jewelled watch by Antonio de Pereda makes the point without any possibility of doubt, the watch standing not only for the passage of time but for the vanity of worldly possessions. Since one of the objects of still life painting was to make the viewer think, veiled allusions such as cards, to symbolise the waste of time, or roses in a fragile glass to suggest the fragility of youth, are more usual. The theme persists right up to the present. Max Beckmann, for example, paints an extremely powerful *Still Life with Three Skulls* (fig. 58) in 1945 which, as well as including conventional articles like a candle and playing cards, inevitably recalls the emblems of the Waffen SS. From the same year, with his usual sense of humour, Picasso sends up the tradition, including sprouting leeks, which recalls the way death gives way to new life in normal organic processes.[50] More recently Andy Warhol and Gerhard Richter have both returned to the theme.[51]

The so-called *pronkstilleven* (*'pronk'* means 'opulent'), in which precious objects are beautifully displayed, can also sometimes function as a vanitas painting. A breakfast piece in Dresden by Willem Heda, for example, shows half-eaten pies, the sugar miraculously suggested on the rim of the spoon, a broken glass, an overturned goblet, and a watch ready for winding. It is certainly intended to suggest excess and the waste of time (fig. 59). Many of these paintings are like Baroque architecture, which sought to glorify human achievement but in fact dwarfed it: 'Divorced from use, things revert to absurdity; anticipating nothing from human attention, they seem to have dispensed with human attention, whose purpose and even existence they challenge.'[52] The celebration of consumption turns back on itself.

The third form of still life which recognises the shadowside of creation is found in the expressionist still lifes of Goya and Van Gogh. Goya did

59 Willem Claesz Heda, *Breakfast Piece*, 1631(?), Gemäldegalerie, Dresden

157

not tackle this genre until he was in his sixties, during the Peninsular war. Dead game was a familiar subject for still life painting, but Goya seems to use them as a metaphor for the cruelty of the world. It is as if he has revoked the 'permission to kill' of Genesis 9. His *Still Life with Dead Turkey* is not about preparing for Christmas dinner, but about death, evoked by his use of black and earth tones (fig. 60). If there is grace in this it is the grace of facing reality without illusion. Goya is illustrating what Maritain calls 'the woundedness of the world'.[53] Similarly the *Still Life with Pieces of Rib, Loin and a Head of Mutton* (fig. 61), which recalls Rembrandt's *Flayed Ox*, seems to be about life without compassion, where the creaturely world is simply reduced to 'dead meat'. The comparison with his *Disasters of War* etchings, where severed limbs and heads are displayed, is inevitable. 'In the bitter years of the Peninsular war, preoccupied with death and violence, he seized on still life as something relevant to his larger concerns. He made the still life respectable again by elevating it to a level of seriousness not to be found in the pretty, bourgeois works of his contemporaries.'[54] These expressionist still lifes are only matched by some of Van Gogh's later works, such as the study of *Peasant Shoes* (fig. 62). 'Scuffed and worn down at heel, battered and crumpled, they sum up a whole world of distress and destitution; they vouch for the implacable daily round of exertion and fatigue which is the poor man's lot.'[55]

REAL PRESENCE

Since the ninth century at least, Christianity has been exercised by the idea of 'real presence' – polemically defined by contrasting it with 'mere signs'. At the heart of the debate is the question of the nature of the real, and of divine engagement with the material world. Zwingli, in denying transubstantiation, still believed Christ was 'really present' in the eucharist, but appealed to God's nature as Spirit. Spiritual presence *was* real presence. Luther's ill-tempered, and philosophically unsophisticated, appeal to the literal sense of 'is' ('hoc *est* corpus meum') preserved by contrast a sense that the world was 'charged with the glory of God'. His understanding of

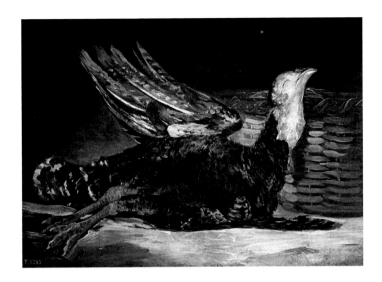

60 Francisco Goya, *Still Life with Dead Turkey*, 1808–12, Museo del Prado, Madrid

61 Francisco Goya, *Still Life with Pieces of Rib, Loin and a Head of Mutton*, 1808–12, Museo del Prado, Madrid

62 Vincent van Gogh, *Peasant Shoes*, 1886, Van Gogh Museum, Amsterdam

the incarnation led him to insist that the material was patent of divinity. Echoes of this conflict can be found in the understanding of still life painting. Thus, writing of modern still lifes, Margit Rowell says, 'their precise iconography, their reality, is less appealing and magnetic than their status as a sign, its significance elusive and contradictory, and its distance from what it pretends to but does not directly signify sustaining the tension and sensation of unfulfilled desire'.[56] Like Zwingli, and like idealists through the ages, she wants to drive a wedge between 'est' and 'significat'. Of course, Magritte's still lifes exist to do precisely this: they wittily challenge our understanding of everyday objects and remind us of the way we confuse

63 René Magritte, *Portrait*,
1935, Gift of Kay Sage
Tanguy, MoMA, New York

reality and representation. His *Portrait* (1935) (fig. 63) tells us 'You are what you eat' at the same time reminding us of the life denied which is involved in life sustained. Contemporary work has satirised consumerism and (for example in Warhol's *100 Cans*) highlighted the inanity of mass-produced life. On the other hand, much still life painting is susceptible to a very different reading. Paintings are, of course, signs but perhaps, as in the doctrine of the real presence, signification really is presence.

Sterling suggests that the reason still lifes appeal as they do and have this presence is 'because inanimate things, so closely bound up with daily life, represent man's most immediate commerce with matter. They afforded

each of us – when we were babes in the cradle, toying with objects for hours – our first contact with the world, and by the way of these things the artist revives our maiden sense of wonder and our first dreams.'[57] Paradoxically the sense of real presence is suggested precisely by defamiliarising, by helping us get beyond the taken for granted.[58] In this way painting can intensify the sense of reality, can suggest an aura in relation to the material. A famous example of this is suggested by Goethe's remark on a painting by Kalf in Cologne: 'One must see this picture in order to understand in what sense art is superior to nature and what the spirit of mankind imparts to objects, which it views with creative eyes. For me, at least, there is no question but that should I have a choice of the golden vessels or the picture, I would choose the picture.'[59] Art, we can say, reveals the true magnificence, the true being of objects. Something similar has been said about Heda's breakfast pieces. Sterling writes:

> With unerring taste and finesse he multiplied his modulations of grays tinged with green, beige and white, which he discreetly toned up with pink or brown. Gray, the most philosophic of colours, the colour of meditation, must have suited the moods of the Puritan mind. The mists of Holland, moreover, trained the eyes of Dutch painters to discern the faintest gradations of values – and values are the very basis of monochrome painting. Round his objects Heda succeeds in throwing a suggestion of boundless space: there they stand, charged with quiet gravity. Thus isolated in a transparent void, they represent the solid durability of matter which reassures the mind.[60]

Art displays objects as produced by the spirit, wrote Hegel. Instead of real wool, silk, real hair, glass, flesh and metal, we see only colours. 'In contrast to the prosaic reality confronting us, this pure appearance, produced by the spirit, is therefore the marvel of ideality, a mockery, if you like, and an ironical attitude to what exists eternally and in nature.'[61]

This sense of presence is found also especially in Cézanne, who sought to make the ordinary strange by breaking with perspective and by moulding his objects in colour. 'With an apple', he said, 'I want to astonish Paris'. D. H. Lawrence wrote that 'the actual fact is that in Cézanne modern

64 Paul Cézanne, *Still Life with Onions*, 1896, Musée D'Orsay, Paris

French art made its first step back to real substance, to objective substance, if we may call it so. Van Gogh's earth was still subjective earth, himself projected into the earth. But Cézanne's apples are a real attempt to let the apple exist in its own separate entity, without transfusing it with personal emotion. Cézanne's great effort was, as it were, to shove the apple away from him, and let it live of itself.'[62] Kandinsky agreed: 'Cézanne made a living thing out of a teacup, or rather in a teacup he realized the existence of something alive. He raised still life to such a point that it ceased to be inanimate.' For him Cézanne saw 'the inner life in everything'.[63] His *Still Life with Onions*, of 1896 (fig. 64), pays homage to the older tradition

with its crumpled tablecloth, and the knife overhanging the table, but there the similarity ends. Russets, pinks and pale blues are the predominant colours, 'a harmony of sadness and disenchantment'.[64] In his famous letter to Emile Bernard in which he said that nature should be treated 'by means of the cylinder, the sphere, the cone', Cézanne goes on, 'nature for us men is more depth than surface, whence the need to introduce into our light vibrations, represented by the reds and yellows, a sufficient amount of blueness to give the feel of air'.[65] This is what he tries to do here. In marked contrast to Heda and Kalf we are given simple peasant fare, and a peasant kitchen. Cézanne modulates his objects in colour, rather than using an outline, to try to convey the texture, depth and even the smell of objects: 'the arrangement of his colours must carry with it this indivisible whole, or else his picture will only hint at things and will not give them in the imperious unity, the presence, the insurpassable plenitude which is for us the definition of the real . . . Expressing what *exists* is an endless task.'[66] Some believe that Cézanne's breaking with perspective meant that his attention to nature found that 'nothing there is stable or still' and that what he captures is 'an elusive instability'.[67] Perhaps, however, what he captures is not instability but what his contemporary Henri Bergson, so important to Matisse, spoke of as the *élan vital* of things, the livingness of supposedly inert objects. In a sense Cézanne is attempting to go beyond the appearances to the nooumenon, the essence, beneath. 'Nature is not on the surface, it is in the depths. Colours are an expression of these depths on the surface. They rise from the roots of the world.'[68]

FORMS OF THE IMPLICIT LOVE OF GOD

'Attention', wrote Simone Weil, 'consists of suspending our thought, leaving it detached, empty and ready to be penetrated by the object'. For her, such attention was both the heart of prayer and of ethics, manifested in attention to others, but also to the beauty of the world. 'Art', she wrote, 'is an attempt to transport into a limited quantity of matter, modelled by man, an image of infinite beauty of the entire universe. If the attempt succeeds, this portion of matter should not hide the universe, but on the con-

trary it should reveal its reality to all around.'[69] Still life painting is a paradigm of this form of attention and of this form of art.

For many the sense has been that in the contemporary world the particularity of things is lost in the processes of global homogenisation. A prevailing hedonism teeters on the edge of a nihilism which finds no meaning in reality whatsoever. As in the second century the temptation would be to despair of the physical and, whether by way of denial or by excess, to deny it. By contrast, I have argued, a principal meaning of the still life tradition since it re-emerged at the end of the fifteenth century has been to set before us a vision of creation as benefit, as grace, charged with a grandeur which invests our ordinary mundane lives and mediating the presence of God.

65　Wassily Kandinsky, *Composition VII*, 1913,
The State Tretyakov Gallery, Moscow

7

BEYOND THE
APPEARANCES

God is 'beyond being', not a member of this or any universe. When Thomas Aquinas says that we do not know what God is, but only what God is not, he is stating this truth, in this respect as a representative of the entire Christian tradition. A God who could be comprehended in concepts would not be God. At the same time, God gives Godself to be known. Around this paradox the iconoclast controversy of the eighth century revolved. The iconoclasts insisted that a proper respect for the divine mystery meant that sacred images were illegitimate; the iconodules argued that in the flesh-taking God had sanctified matter and thus legitimated art. They eventually won the day and in both East and West icons, not only of God in the flesh, but of the Trinity, God in Godself, were accepted as legitimate foci of contemplation. But might one, by art, point to, or allude to, the ineffable nature of God? Or ought one to take the Jewish and Muslim route, and insist on an art of decoration which does not try to represent the divine in any way whatever? If painting may be parable, can it be a parable of the divine nature which we cannot conceive? This is one of the questions which are put to us by the rise of abstract art in the twentieth century.

THE MAELSTROM OF MODERNITY

'Constant revolutionizing of production', wrote Marx in a celebrated passage, 'uninterrupted disturbance of all social relations, everlasting uncertainty and agitation, distinguish the bourgeois epoch from all earlier ones. All fixed, fast frozen relations, with their train of ancient and venerable prejudices and opinions, are swept away, all new formed ones become antiquated before they can ossify. All that is solid melts into air, all that is holy profaned, and men at last are forced to face ... the real conditions of their lives and their relations with their fellow men.' The year that he wrote this, ironically, Millet successfully exhibited *The Winnower* in Paris. For twenty years after the Communist Manifesto, realism was the heart of European art. Courbet, in 1852, said, 'Painting is an essentially concrete art and can consist only of the representation of real and existing things; an invisible non existent abstract object does not belong to the sphere of painting.'[1] 'He did not suspect', commented the cubist painters Gleizes and Metzinger sixty years later, 'that the visible world only becomes the real world by the operation of thought, and that the objects which strike us with the greatest force are not always those whose existence is richest in plastic truths'.[2] Courbet, they said, was like someone who, looking at the ocean, is fascinated by the waves and does not think of the depths. By 1870 realism was almost universally found inadequate as a way of responding to the maelstrom Marx describes and indeed a question mark was put against the very notion. In a very Kantian way it was implied that there was no way beyond the appearances. But although all the artists we now take seriously had abandoned realism they stayed, more or less, with representation.

In 1906, the year before Picasso painted *Les Demoiselles d'Avignon*, Wilhelm Worringer published his doctoral thesis, *Abstraction and Empathy*, at his own expense. It was so well received that it found a commercial publisher two years later and has been in print ever since. Seeking to make a contribution to aesthetics Worringer turned the artistic theory of the previous four hundred years on its head. Since the Renaissance both artists and art lovers had gloried in illusionism, and extolled the break-

through moment when Giotto led the way out of medieval darkness to the full realism which was made possible by the discovery of linear perspective. Prior to that, art had been crude and primitive. Not so, said Worringer. In fact the skills of Egyptian sculptors had never been surpassed. They had not sculpted non-realistically because they could not but because they did not want to. The same applied to Byzantine and early medieval art. Worringer argued that there were two basic impulses in art, an organic or realistic, which sprang from empathy, and an inorganic or abstract. The latter was the origin of all art. It was primitive and in fact purer and better than the organic art which followed it because it was non-imitative and fully autonomous. 'Our investigations proceed', he wrote on his opening page, 'from the presupposition that the work of art, as an autonomous organism, stands beside nature on equal terms and, in its deepest and innermost essence, devoid of any connection with it, in so far as by nature is understood the visible surface of things. Natural beauty is on no account to be regarded as a condition of the work of art, despite the fact that in the course of evolution it seems to have become a valuable element in the work of art, and to some extent indeed positively identical with it.'[3] Abstraction arises from the need to bring order to the chaos of our experience: 'The simple line and its development in purely geometrical regularity was bound to offer the greatest possibility of happiness to the man disquieted by the obscurity and entanglement of phenomena. For here the last trace of connection with, and dependence on, life has been effaced, here the highest absolute form, the purest abstraction has been achieved; here is law, here is necessity, while everywhere else the caprice of the organic prevails.'[4] Inextricably drawn into the vicissitudes of ephemeral appearances, the soul knows here only one possibility of happiness, that of creating a world beyond appearance, an absolute, in which it may rest from the agony of the relative. 'Only where the deceptions of appearance and the efflorescent caprice of the organic have been silenced, does redemption wait.'[5] It looks, in other words, as if, for Worringer, abstract art represented rescue from the maelstrom of modernity, and he uses theological language to describe this. The soul is redeemed from the agony of the relative by the creation of a world beyond the appearances: it is a Platonic

theme which had found an echo throughout most of Christian history. For Worringer, here expressing the romanticism he was heir to, art was a way to realise this redemption.

The year after Worringer's book appeared was 'the moment of cubism', which had a colossal impact on the whole European art scene.[6] This was an optimistic moment, embodying an enthusiasm for modernity which, in the case of the abstractionists, survived the First World War.[7] 'The new life of iron and the machine', said Malevich, 'the roar of automobiles, the glitter of electric lights, the whirring of propellers, have awoken the soul, which was stifling in the catacombs of ancient reason and has emerged on the roads woven between earth and sky'.[8] 'Painting is a thundering colli-sion of different worlds', said Kandinsky, 'intended to create a new world in, and from, the struggle with one another, a new world which is the work of art. Each work originates just as does the cosmos – through catastro-phes which out of the chaotic din of instruments ultimately create a sym-phony, the music of the spheres. The creation of works of art is the creation of the world.'[9] Kandinsky was a friend of Schoenberg, and we hear in these views the excitement at the possibility of the emergence of a decisively new world. 'The machine is increasingly replacing natural forces', wrote Mon-drian. The clearest sign of this is in the metropolis. 'The truly modern artist regards the metropolis as an embodiment of abstract life; it is closer to him than nature is, and gives him a greater feeling of beauty. For in the metropolis, nature has already been straightened out and regulated by the human spirit . . . In the metropolis, beauty expresses itself more math-ematically; therefore it is the place out of which the mathematically artis-tic temperament of the future must develop, the place out of which the New Style must emerge.'[10] Le Corbusier spoke exactly this language. There was a sense both that the modern world was simply too complex for the resources of representational art and that abstract art represented the new world *in nuce*. Ironically, given the scepticism, if not downright atheism, which accompanied the emergence of modernity, all these artists shared with Worringer a strong spiritual sense. The new world may not have been theistic, but, even in Russia, it spoke the language of spirit. Kandinsky believed that the emergence of abstract art was the harbinger of a new age

when people would be able to experience the spirit of things unconsciously. 'Thus will mankind be enabled to experience first the spiritual in material objects and later the spiritual in abstract forms. And through this new capacity, which will be in the sign of the 'spirit', the enjoyment of abstract = absolute art comes into being'.[11]

THE 'THIRD AGE'

At the end of the twelfth century a Cistercian abbot in Calabria, Joachim of Fiore, had set Europe alight with prophecies of a third age. Conventionally Christians had divided time into two: the age of the Father, up to the coming of Christ, and then the age of the Son. Joachim announced the coming of a new age, the age of the Spirit, in which the messianic conditions would be realised. He believed it was just around the corner. Despite its non-arrival this idea entered the European bloodstream. It re-appeared in the philosophy of Hegel and, in a sinister and parodic way, in the idea of the 'Third Reich'. Some of this millenarian enthusiasm can be found in the emergence of abstract art.

It was in Munich, where both Worringer's book and cubism were enthusiastically discussed, that Kandinsky painted what he called 'the first abstract watercolour' in 1912. He categorised his work in order of complexity as either impressions, improvisations or compositions, the latter of which was 'An expression of a slowly formed inner feeling, which comes to utterance only after long maturing'.[12] The word 'composition', he wrote in his Reminiscences, 'moved me spiritually . . . [it] affected me like a prayer. It filled me with awe'.[13] He characterised the move to abstraction in theological terms, as an outworking of the interiorisation of the law in the Sermon on the Mount:

Gradually I became conscious of my earlier feelings of freedom, and the secondary demands that I made of art eventually disappeared. They disappeared in favour of a single demand: the demand of inner life in painting. To my astonishment I realized that this demand grew on the

foundation which Christ set forth as the foundation for moral qualification. I realized that this view of art is Christian and that at the same time it shelters within itself the necessary elements for the reception of the 'third' revelation, the revelation of the Holy Spirit.[14]

Compositions V and *VI* he called *Deluge* and *Resurrection*, but he left *Composition VII* untitled (fig. 65). How do we read it? Kandinsky was a first-rate musician and could have had a musical career. In *Concerning the Spiritual in Art*, written in 1911, he sought to apply 'the methods of music to art'.[15] 'And from this results the modern desire for rhythm in painting, for mathematical, abstract construction, for repeated notes of colour, for setting colour in motion.'[16] He argued that 'Colour is the keyboard, the eyes are the hammers, the soul is the piano with many strings. The artist is the hand which plays, touching one key or another, to cause vibrations in the soul.'[17] Each colour had its own emotional tone: 'Blue is the typical heavenly colour. The ultimate feeling it creates is one of rest. When it sinks almost to black, it echoes a grief that is hardly human. When it rises towards white, a movement little suited to it, its appeal to men grows weaker and more distant. In music a light blue is like a flute, a darker blue a cello; a still darker a thunderous double bass; and the darkest blue of all – an organ.'[18] Yellow, he believed, is insistent and aggressive, 'the typically earthly colour'. White speaks of a world 'too far above us for its harmony to touch our souls'. Black is 'something burnt out, like the ashes of a funeral pyre'. Red 'rings inwardly with a determined and powerful intensity. It glows in itself, maturely, and does not distribute its vigour aimlessly.'

This picture, then, is intended to play on our emotions. It gives an impression of great energy. It is playful and allusive and the eye cannot come to rest anywhere. It can be read figuratively, in that some interpreters see references to the garden of Paradise and understand it through the affair Kandinsky was then engaged in with Gabriele Münter.[19] This, however, seems contrary to Kandinsky's express intentions. At this stage, engaged with theosophy, Kandinsky believed that he could create an aura to which people appropriately spiritually attuned could respond.[20] He would do this absolutely independently of representation because the 'organic law of con-

struction', by which, I suppose, we must understand the traditional rules of composition, were 'walls around art'. Only by breaking them, he believed, was he able to enter the autonomous realm of art:

Today is the great day of one of the revelations of the world. The inter-relationships of these individual realms were illumined as by a flash of lightning; they burst unexpected, frightening, and joyous out of the darkness. Never were they so strongly tied together and never so sharply divided. The lightning is the child of the darkening of the spiritual heaven which hung over us, black, suffocating, and dead. Here begins the great epoch of the spiritual, the revelation of the spirit. Father-Son-Holy Spirit.[21]

As we see, Kandinsky understands the move to abstraction in a thoroughly Joachite way. We can see why one critic understands *Composition VII* as an apotheosis, full of 'optimistic radiance' emerging out of strife and chaos, a painting which 'envelops and enfolds the viewer'.[22] Much later, and responding to another form of abstraction, an American commentator likewise understood abstract art in apocalyptic terms:

The visionary need for a new kind of social and artistic authority necessarily formulates itself in abstract terms, for it involves a modal logic, not simply the logic of the given. The abstract is the necessary vehicle of the apocalyptic, which carries with it a new sense of necessity and possibility and the abandonment of an old actuality. The apocalyptic represents the overthrowal of the shallow surface of life by the depths of possibility, struggling for a wider vision than can be contained on the surface and so unsettling and finally disrupting it altogether . . . [the apocalyptic vision] displays itself as the fullness and energy that is in the depths, periodically announcing to life and society and art the necessity for and possibility of their own renewal.[23]

For Kandinsky, and for some other commentators, therefore, abstract art was a kind of harbinger of the third age, the John the Baptist of the emergence of a new society. For them it expressed some of the reckless, iconoclastic excitement which has always characterised third age movements.

BEYOND THE APPEARANCES

If the immediate determinant of the move to abstraction was the mael-
strom of modernity, there were also ancient philosophical or theological
views which prepared the way and which understood abstraction rather
differently. Both Mondrian and Rothko, for example, frequently cite Plato
and speak of the need to go beyond the appearances. The philosopher does
this in one way, says Rothko, but the artist does it on the level of the
sensual. What both do is to get beyond the appearances to the unity which
lies beneath them. Plato, he said, had to place the painter in a very un-
desirable position because he had to objectify reality through appearances.
'He could not foresee the development of the twentieth century method
for the representation of the essence of appearances through the abstrac-
tion of both shapes and senses.'[24] 'The art of today, which can in fact
portray our notions of reality, must be the exemplification of this prin-
ciple of Plato's ideals, and the compromises inherent in the world of
appearances can in fact demonstrate the abstractness of those appearances.
That is why, in the significant paintings of today, the subject matter is con-
stituted either of ideological abstraction or appearances abstracted into the
world of ideals by being frankly employed as a foil or vehicle for demon-
stration of these ideals'.[25] Plato contrasts being, which is true reality, with
becoming, which is bound to transcience and decay. Since the representa-
tion of anything created is a representation of something bound to decay,
abstract shapes are in that sense closer to being. The more metaphysical
of the abstract painters wanted thus to get beyond the appearances.

In an article in *De Stijl* Mondrian quoted Plotinus: 'art is above nature,
because it expresses ideas of which the objects of nature are the defective
likeness'. The artist, relying only on his own resources, rises above capri-
cious reality towards reason, by which, and according to which, nature
itself also creates. Hans Jaffé comments that Mondrian's entire evolution
as a painter is aimed at visually interpreting the general laws that under-
lie every phenomenon and that are to the wealth of natural forms as a
theme is to its variations.[26] Painting as a self-sufficient world comes to take
over from the naturalistic appearances that Mondrian began by painting.[27]

Mondrian sought 'the universals of basic form – the factor which governs the relationships of part to part, of part to whole, and of the whole form to the universal environment of which it forms a part'. He went on, 'Any person living in the twentieth century should know by now that physical perfection is an illusion, that quantitative or scientific knowledge is merely information or an absolute of perpetual incompletion, and that aesthetics is as near to completion or perfection as we can come, being the only qualitative form of knowledge which we possess.'[28] Louis Dupré argues that realist painting emerged at the end of the thirteenth century in order to convey the new sense of nature, both cosmic and human.[29] By the same token abstract art conveyed another shift in the understanding of nature, one in which reality was conceived not in three dimensions but in terms of pure relationships.[30]

As an example we can take *Composition with Red, Blue, Yellow and Black, 1929* (fig. 66). Only one pure colour is used and like most of Mondrian's paintings at this period it is based on the square. Where this is incomplete we are supposed to complete it by our imagination. The symmetry of the lines creates a sense of equilibrium. As far as possible Mondrian has worked away all signs of his brushwork to minimise the subjective element which would disturb the universal harmony. The use of the 'geometrical method' was supposed to give his work universal validity.[31]

Mondrian believed that the aim of life was to overcome the tragedy which resulted from human individualism. Only art could do this, precisely in virtue of its abstraction from the world in which tragedy reigned. Like Plato he sought the immutable beyond the flux of the present. What he called neo-plastic painting he saw not only as a new art but as a harbinger of a new world in which the laws of universal harmony are realised and human beings brought into consonance with the universe, in which the material and the spiritual were reconciled and society composed of balanced relationships.[32] The more the tragic diminishes, the more art gains in purity.[33] 'Tragedy is abolished only by the creation of (final) unity; in external life this is far less possible than in abstract life. In art the unity of the one and the other can be realized abstractly: therefore art is ahead

66 Piet Mondrian, *Composition with Red, Blue, Yellow and Black, 1929.*
Solomon R. Guggenheim Museum, New York. © 2011 Mondrian/Holtzman Trust
c/o HCR International Virginia

of life.'[34] Art is the vanguard of utopia. Jaffé comments, 'The earnest certainty and calm with which Mondrian speaks of the future make this utopia seem closely related to the Heavenly Jerusalem and the theological, eschatological implications point to parallels with St Augustine's City of God.'[35]

ART AND THE ANICONIC

A second importance of Plato derives from a well-known passage in the *Philebus*, where Plato considers the nature of pleasure and its role in human life. After some rather trivial examples of pleasure he instances the beauty of figures, as opposed to the beauty of living creatures:

> What I mean, what the argument points to, is something straight, or round, and the surfaces and solids which a lathe, or a carpenter's rule and square, produces from the straight and the round ... Things like that, I maintain, are beautiful not, like most things, in a relative sense; they are always beautiful in their very nature, and they carry pleasures peculiar to themselves ... And there are colours too which have this characteristic.[36]

This argument about purity of form has wide currency in twentieth-century abstract art. For Kandinsky, 'A triangle has a spiritual value of its own ... The case is similar with a circle, a square, or any conceivable geometrical figure.'[37] 'The more abstract is form, the more clear and direct its appeal. In any composition the material side may be more or less omitted in proportion as the forms are more or less material, and for them substituted pure abstractions, or largely dematerialized objects.'[38] Later champions, like Herbert Read, argued that all art was primarily abstract. 'For what is aesthetic experience, deprived of its incidental trappings and associations, but a response of the body and mind of man to invented or isolated harmonies?'[39] Similarly, Bridget Riley argued that all painting began with abstraction in the sense that it began with lines, colours and forms. In this sense 'Abstraction has always been at the root of painting. Vermeer is more of an abstract painter than many avowed "abstractionists".'[40]

The preference for pure shapes and colours in art naturally related to the aniconic tradition represented best by the art of Judaism and of Islam. Franz Marc wrote, 'It is a pity that one cannot hang Kandinsky's large composition and some others beside the Mohammedan carpets in the Exhibition Park. A comparison would be inevitable and how instructive for us all! ... The grand consequence of his colours holds the balance of his

graphic freedom – is that not at the same time a definition of painting?'[41] One Jewish commentator has noted that it is with Picasso that the Jews can really celebrate painting, which otherwise the aniconic tradition has made difficult.[42] Equally we can find a correspondence between Mondrian's aniconicity and that of his Calvinist tradition. Mondrian, like his Calvinist ancestors, was called an iconoclast. 'To Mondrian', comments Hans Jaffé, 'reproduction of the phenomenal form of things was just as much a profanation, a corruption of the absolute, universal harmony, as, to the sixteenth century Dutch reformers, the statues and images of saints were a desecration of God's absolute and invisible majesty. He wrote: "Precisely on account of its profound love for things, non figurative art does not aim at rendering them in their particular appearance." '[43]

The preference for the aniconic relates closely to the increased priority given to the decorative over representational art. For four centuries history painting, which depicted grand historical or mythological themes, had been hailed as the highest form of art. This increasingly came to seem emptily grandiloquent. Matisse's celebrated *Notes of a Painter*, published in 1904, make the point. Composition, he argued, was the art of arranging in a decorative manner the diverse elements at the painter's command to express his feelings. 'What I dream of', he wrote, 'is an art of balance, of purity and serenity, devoid of troubling or depressing subject matter, an art which could be for every mental worker, for the businessman as well as for the man of letters, for example, a soothing calming influence of the mind, something like a good armchair which provides relaxation from physical fatigue'.[44] Patrick Heron, for whom Matisse was master, wrote that 'Even in the most highly figurative of masterpieces the painter knows that it is not Rembrandt's mother's nose he is looking at, but a miraculously ordered mosaic of interleaved, overlapped, opaque, transparent, soft-edged, sharp-edged, rounded or squared, separate brush-touches . . . A painting's greatness . . . depends upon the organisational significance, satisfaction, harmony, architectonic coherence – or whatever else you like to call it that those paint marks across that flat surface evoke.'[45] In other words, all painting is primarily decorative.[46] For the artist Karen Stone decorative art does not so much communicate ideas or feelings as combat

joylessness. 'It serves as an antidote to boredom and difficulty, the uncomeliness and bareness of our existence.'[47]

This gives us a theological basis for decorative art: it contributes to shalom, to fullness of life. The architect Christopher Alexander, who frequently instances Matisse in his work, has tried to elaborate an understanding of the order of things which is both an ethics and an aesthetics. Good architecture, and by analogy good painting, he argues, resembles the healthy human self. 'When we experience something which has deep wholeness, it increases our own wholesomeness. The deeper the wholeness or life which we meet in the world, the more deeply it affects our own personal feeling.'[48] Like Franz Marc he is an enthusiast for ancient Turkish rugs, and finds them paradigms of beauty and order, an order and beauty he finds in Matisse's designs. On this account, abstract design has what can be called a truly metaphysical significance.[49]

The decorative is not, Matisse and others want to say, the superficial and inconsequential. This was argued with great vigour in relation to the work of Jackson Pollock. Harold Rosenberg described two of Pollock's most celebrated works, *Full Fathom Five* and *Lavender Mist* (fig. 67), as 'master works' which 'transform themselves from sheer sensuous revels in paint into visionary landscapes, then back again into contentless agitations of materials'.[50] For David Sylvester, Pollock's handling of paint and organisation is 'as subtle, as magisterial, as Matisse's or Bonnard's'.[51] Werner Haftmann discerned in Pollock a return to the tragic vision, which became the sole justification of painting. 'Since psychographic expression could be sustained only by the most intense life feeling, the authentic artist was constrained to live at the highest emotional pitch.'[52] Like many of Pollock's contemporaries he read Pollock as the existentialist artist par excellence.

Based on his reading of, mainly Jungian, psychology, Pollock was committed to automatism. He said in 1947, 'When I am in my painting I'm not aware of what I'm doing. It is only after a sort of "get acquainted" period that I see what I have been about. I have no fears about making changes, destroying the image etc, because the painting has a life of its own. I try to let it come through. It is only when I lose contact with the

67 Jackson Pollock, *Lavender Mist*, 1950, National Gallery of Art, Washington

painting that the result is a mess. Otherwise there is pure harmony, an easy give and take, and the painting comes out well. The source of my painting is the unconscious. I approach painting the same way I approach drawing. That is direct – with no preliminary studies. The drawings I do are relative to my painting but not for it.'[53] John Golding comments that the tone is matter of fact but the underlying assumptions are metaphysical 'and amount to an almost mystical view of painting as a rite or act of magic'.[54] For other critics Pollock's art is at last an art of the ineffable. Gadamer said that being that can be understood is language. Donald Kuspit commented, 'Pollock's art reminds us that all art, all being, tends to transcend itself if it is to be. This is why true art makes us nervous.'[55]

It is almost as if such art brings us face to face with the numinous and requires us to remove our shoes.

Do Pollock's paintings go beyond the decorative, however? Do they have any content? An unsigned review in 1950 said, 'His best designs manage to achieve an amazing, unhackneyed, luminous surface decorativeness. The successful ones speak to the eye of dazzling mosaic texture, a whirlpool of furious movement, a rousing , reckless bravado. They are a complete surrender to the enchanting sensuousness of colour and line as an art in itself.' The reviewer went on, however, 'This form of abstract art carries within it deadly limitations. By restricting itself so severely to an intense emotion through design and pattern, it creates designs for the eye to explore, but frustrates the mind. It seems to lead to a blind alley.'[56] An Italian reviewer in 1958 wrote, 'Pollock's own experience can teach one thing . . . and that is that this experience ends with itself and cannot have followers . . . It is the conquest of a desert by a man who has turned off the light of reason in himself and in his work . . . the big painting One . . . is the most dramatic and tormented painting, not in the least casual or decorative . . . It is the clear mirror of a temperament that unites, in a protest of anarchic origin, good and evil, harmonic and irrational forms with a universal result. The painting is a warning, a message, an irreducible and candid way of looking at the world.'[57] Hilton Kramer wrote the previous year, 'all one can feel in its presence is a suggestion of the pleasure the artist must have felt in the physical act of painting, and even that is of short duration and, at best, a vicarious satisfaction, really a secondhand emotion of the spectator. One's initial delight in the picture turns out to be one's whole experience of it . . . Instead of an infinitude of sensation there is ultimately only a closed world of tedium.'[58] For Francis Bacon abstract art always remained on one level and never got beyond the beauty of patterns or shapes. 'We know that most people, especially artists, have large areas of undisciplined emotion, and I think that abstract artists believe that in these marks that they're making they are catching all these sorts of emotions. But I think that caught in that way they're too weak to convey anything. I think that great art is deeply ordered.'[59]

POINTING BEYOND BEING

Matisse was not, of course, an abstract painter, and many abstractionists were decidedly not interested in a decorative art. Writing to the *New York Times* in 1943 Rothko and Gottlieb argued, 'There is no such thing as good painting about nothing. We assert that the subject is crucial and only that subject matter is valid which is tragic and timeless. That is why we profess spiritual kinship with primitive and archaic art.'[60] The idea of these artists was to transpose the meaning which, since the Renaissance, people had found in historical painting, into metaphysical depth and they felt they could do this through abstraction.

Many abstract artists were both interested in mysticism and sometimes described as mystics, and this has endeared them to religious people (not just Christians) interested in the apophatic tradition. To name and to know God is to know an idol. 'Every thing in the world gains by being known – but God, who is not of the world, gains by not being known conceptually. The idolatry of the concept is the same as that of the gaze: imagining oneself to have attained and to be capable of maintaining God under our gaze, like a thing of the world. And the Revelation of God consists first of all in cleaning the slate of this illusion and this blasphemy.'[61] The art of Mark Rothko, Barnet Newman and Clyfford Still has some affinities with this tradition. Their contemporary Robert Motherwell recognised this. For him abstract painting represented a spiritual striving to achieve the universal and so to become one again with the world. 'Abstract art is an effort to close the void that modern men feel . . . a form of mysticism.'[62] Mysticism involves renunciation, silence, the way of quietude. 'The mystic will give prominence to the fact, and emphasise it, that everything external is only a form and picture, that the transitory is only a parable, that its truth is only in its relation to the inexpressible, because undirected essence from which it proceeded and to which it must also revert.'[63] Diane Waldman comments that Rothko, Newman and Still empty their paintings of the superfluous and are thus able to express both the material reality of abstract painting and the incorporeal reality of the sublime. 'Art for all of them becomes an act of revelation, of exaltation, an embodiment of universal truth.'[64]

68 Mark Rothko, *Light Red Over Black*, 1957, Tate Modern, London

Rothko's trademark images, such as *Light Red over Black* of 1957 (fig. 68), are horizontal bands of colour which leach into one another. 'Each colour . . . supports its own form freely, as if it were spontaneously delimiting its respective area following its intimate forces of expansion, without encroachment, contact, or rivalry with the other colours . . . This fragile peace, where the frontiers are sketched less by a common accord than by a miraculous and simultaneous exhaustion of their rival tides, presents a miraculous equilibrium, so supple that it seems at the same time almost indestructible.'[65] Rothko stained his canvases, using layers of thin wash to

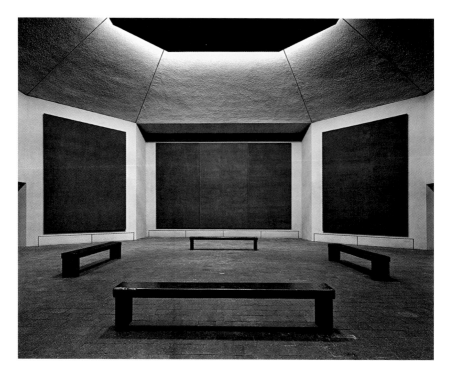

69 Mark Rothko, Rothko Chapel, Houston, Texas

give the sense of light welling up from the depths of the painting.[66] He believed that 'Paintings have their own inner light'.[67] The very form of his paintings is intended to be revelational. They were intended to be intimate and intense, the opposite of decorative. 'In saturating the room with the feeling of the work, the walls are overcome and the poignant impact of each work becomes for me more visible.'[68] Though Rothko painted many bright canvases it is with sombre colours that he is usually associated. His patron for the Houston chapel (fig. 69) wrote, 'As he worked on the chapel, his colours became darker and darker, as if he were bringing us on the threshold of transcendence the mystery of the cosmos, the tragic silence of our perishable condition, The Silence of God.'[69] Rothko, Diane

70 Barnett Newman, *Vir Heroicus Sublimis*, 1950–1, MoMA, New York

Waldman believes, attained a harmony, an equilibrium, a wholeness in the Jungian sense that enabled him to express universal truths in his breakthrough works, 'fusing the conscious and the unconscious, the finite and the infinite, the equivocal and the unequivocal, the sensuous and the spiritual'.[70] Robert Hughes remarks that Rothko was obsessed with the moral possibility that his art could go beyond pleasure and carry the full burden of religious meanings. 'He expected it to do it at the high tide of American materialism, when all the agreements about doctrine and symbol that had given the religious artists of the past their subjects had been cancelled.'[71] Perhaps the comment that Rothko is the Andrei Rublev of high capitalism is saying much the same thing.[72]

Barnet Newman, another Jew, with a real knowledge of the Talmudic tradition, was the most explicitly theological of the abstract expressionists, and deliberately painted huge canvases (often eighteen feet long because of the importance of the number eighteen in the Jewish liturgy) because he believed that 'scale equals feeling'.[73] His trade mark was the use of thin stripes ('zips') to divide the space of his canvases. His pair *Vir Heroicus Sublimis* (fig. 70) and *Cathedra* (fig. 71) oppose the hubristic human being

71 Barnett Newman, *Cathedra*, 1951, The Stedelijk Museum, Amsterdam

on the one hand to the presence of deity on the other. In painting the latter he had the vision of Isaiah (Isa 6) specifically in mind. He believed his canvases were self-evidently revelatory and could be understood 'by anyone who will look at [them] without the nostalgic glasses of history'.[74] For others, however, 'The polemical numbness of Minimalism is prefigured in Newman's paintings. Their simple, assertive fields of colour hit the eye with a curiously anaesthetic shock. They do not seem sensuous: sensuality is all relationships. Rather, they appear abolitionist, fierce, and mute.'[75]

Whether or not they are successful these two artists attempt an art of the ineffable more than any other artists in the Western tradition. The canvases in the Houston chapel, comments Hughes, have all the world drained out of them, leaving only a void. 'Whether it is The Void, as glimpsed by mystics, or simply an impressively theatrical emptiness, is not easily determined, and one's guess depends on one's expectation. In effect, the Rothko Chapel is the last silence of Romanticism.'[76] That ambiguity surely applies to the work of both these painters.

ABSTRACT ART AND THE KINGDOM

To talk of an art of the ineffable raises all the problems and questions of the original iconoclast controversy. During the Renaissance, art theorists argued that it was precisely the incarnation which allowed for a figurative or representational art. History painting was the highest genre of art because it conveyed a moral meaning. Is the purpose of abstract art, by contrast, simply to reduce us to silence? Does it illustrate the final sentence of the *Tractatus*: Whereof we cannot speak, thereof we must be silent? For some, abstract art is an invitation to 'visual ecstasy'. Precisely in its apophatic nature it invites us into the world to come.[77] Others are less sanguine. Gregory Battcock, for instance, reads abstract expressionism as 'an outrageous abdication, by the artist, of his traditional commitments'. 'It is an art style of extravagance: of waste, emptiness and exquisite sensual stimulation. It has little to do with anything of consequence and, amazingly, is all the more impressive because of its vacuity.'[78] For George Grosz, writing in Germany in 1925, abstract artists were 'wanderers in the void', who stood 'silent and indifferent, that is irresponsibly, in relation to social occurrence'.[79] Paul Evdokimov, from the Orthodox standpoint, speaks of it as coming from an emptied Sophia, diverted from its destination. 'Abstract art works on the rainbow which has been removed from its cosmic context. We can admire its solar spectrum, analyze it, and play with its colors for ever, but it no longer unites heaven and earth and says nothing essential about man.'[80]

Abstract art, as we have seen, is sometimes spoken of as 'mystical'. For Barth, as for many Protestant critics, mysticism was esoteric atheism, part of that world of religion which had to be denied in order that true religion could be affirmed.[81] True religion, for him, had a narrative structure. Ernst Gombrich, reflecting on abstract art, turned to 1 Cor. 14, and suggested that words which could be understood were more valuable than those in an unknown tongue. 'How reactionary these words must have sounded', he mused, 'to the fervent enthusiasts who had at last got rid of the deadweight of conventional speech! But would Western civilization have survived at all, one wonders, if this dyke had not been erected against

the tide of unreason, enabling the Church to use and preserve the texts and disciplines on which a revival of rationality could ultimately be based?'[82] We might say, then, that if we are looking for secular parables, we have to look to representational art, to an art which saves the appearances and which does not abstract from them. An insistence on the primacy of appearances, framed in a secular guise, was the justification for socialist realism, and a more hollow and untruthful art it would be hard to find. There is no doubt that the almost universal abandonment of realism in twentieth-century art did represent a profound sense that such realism was incapable of expressing the new social and spiritual realities with which human beings were faced. Not all abstract art was disengaged, but the utopianism of both Mondrian and Malevich was tied up with a faith in the possibilities of technology, of what the right angle could do for us, which now looks absurd and even dangerous. It illustrates the danger of going beyond the appearances and the ease with which idealism, in both senses, can represent flight from reality.

The fourth-century theologians known as the Cappadocians had an apophatic theology, but for that very reason thought that it was necessary to use the most vivid metaphors to speak of God. Kandinsky's art might represent this response to the darkness of God: a dazzling darkness of brilliant colours and allusions. Rothko, Newman and Still, on the other hand, express something like the unity of being beyond appearance. They allude to that which is otherwise than being. Their art expresses the necessary reminder of all theology that God is not a member of this or any universe. But the question of the iconodules, whether the incarnation does not return us vigorously to the appearances, remains. Granted, God is ineffable, but God gives God's self to be known in the appearances, supremely in the incarnation, but in the epiphany of the face, and of other created reality. Those who have objected to the apophatic tradition, for whom God speaks through the pots and pans of Chardin, the market stalls of Beuckelaer or Le Nain's peasants, appeal to this understanding. For this mainstream tradition, apophaticism cannot be the normative representative of the perception of the divine in reality. Contrasting the painting of Vermeer and Titian with that of abstract expressionism, David Hart wonders whether 'the true

sublime is endless mediacy, endless and beautiful deferral'. For him abstract expressionism is a form of romanticism, attempting to 'express' the artist's creative temper as an immediate presence, an immediate communication of a certain inchoate pathos, energy or ferment.[83] It becomes then a visual expression of adolescent angst.

Tate Modern is the most visited art gallery in the world, and the crowds who come day by day surely find, or hope to find, their world interpreted for them. Of course there is much more than abstract art in the Tate Modern: pop art, installation art, *arte povera*, conceptual art to name just some of the genres. The Rothko room is, however, one of the most popular. Perhaps this is because we live in a world where the koan is the most accessible spiritual icon. Perhaps abstract paintings successfully point to that world which is 'otherwise than being', for which there is clearly a spiritual hunger no matter what the statistics on church attendance indicate. Perhaps, on the other hand, what the abstract artists have left us with, despite their best intentions, is an art of inward emigration, which refuses to face up to the critical issues of the day and has nothing of any consequence to say. And is it in that sense a truly contemporary art?

PICTURES AS PARABLE

Perhaps the prohibition of images in the Hebrew bible was already a response to the immense difficulty of talking about God, and the consequent flight to easier options to which that led. Perhaps the prohibition expressed the worry that images made the knowledge of God all too easy, and misled people for that reason. Problems in articulating our sense of the presence of God did not start with the receding of the sea of faith. I have presupposed in this book that thinking of the presence and reality of God in and through the purely secular is not a retreat but a recognition of what the gospel properly teaches. At the same time it is, of course, true that, for all the contemporary concern about the clash of civilisations and religions, the Western world is deeply secularised and an increasing proportion of people have no need of the hypothesis of God. The rise and rise of secular art can be read as a marker of this phenomenon. To the eyes of faith, however, 'the earth is the Lord's and all that is in it': there is no purely secular reality. Protestantism in particular has been deeply suspicious of the idea that we need sacred spaces, music or art forms in order to worship God. What I hope to have shown is the way in which some of the greatest secular art of the past four hundred years can be understood to speak of the presence and reality of God in ways which do not compromise its integrity. The great English Dominican, Herbert McCabe, used

Facing page: detail of fig. 64

to say that Thomas Aquinas' famous 'five ways' were not lame attempts to prove the existence of God but different ways of putting the question, 'Why is there anything at all?', 'Why anything rather than nothing?'. To read secular art theologically is to insist on questioning, on the dimension of depth, to resist premature attempts at the closure of meaning. It is to situate art within such a tradition of questioning and reflection. Painting itself, obstinately non-verbal, already in its own way represents that resistance, inviting a continually refreshed questioning and celebration of the material world which, through canvas, board and paint, it represents. It invites us to consider both that which is beyond being and also, from the Christian perspective, the God who takes flesh in love and affirmation of the material. It invites us to reflect more deeply on the mystery of existence. It speaks obliquely, and through images, as do parables. One or two of its practitioners, and far more admirers, find it straightforwardly revelatory of the divine. For theologians, and for most artists, there is nothing straightforward about the divine and we are left to make do with an absence which is also a presence, or a presence which is an absence, with hints and allusions, with rumours of angels. The crowds that throng to art galleries and exhibitions go, I suspect, not just in search of a meaning which they do not find elsewhere in society, and which the church no longer conveys for them, but because they are interested in these rumours, because there are parables which still speak of the elusive but pressing mystery of the world.

For the past fifty years most theologians who have wanted to reflect on art have done so in the shadow of Paul Tillich, whose claim that 'Being' or 'ultimate concern' was manifested in all existence was an easy way to find the divine in the secular. Art – even Dada – expresses meaning and this revelation of ultimate reality 'can point to and be experienced as moments of divine self communication'.[1] Art according to this perception is itself revelatory. While I agree that pictures (like music) can be *loci theologici* I think the issue is more complex. The presupposition of Jesus' parables seems to me to be that the God Jesus calls Father is visible in all God's works. The whole world is, as George Macleod liked to say of Iona, 'a thin place'. All that is, is the product of the divine Word, which is to say

the divine imagination and joy, loving reality into being. To be sure sin warps our perception of that, and mis-shapes the world we are given. A truthful art cannot help but discern that as well. But the emphasis in the parables is not on this mis-shaping but on the joy and beauty of a world in which God is profoundly engaged. The parables are the product of a mind which knows God everywhere. In developing the doctrine of the incarnation theology attempted to reflect on the depths of that engagement. The theology of the Holy Spirit wanted to say that 'where charity and love are, there is God'. And not simply charity and love, but radiance, imagination, mystery, and passion, compassion and forgiveness in the face of darkness, cruelty and terror. Just as great composers hear more profoundly than the rest of us, but enable others to hear, so, I have argued, great artists see more clearly and enable others to see. To do this they do not have to be believers but they do need to be truthful. In his great essay on art Collingwood argued that all art represents a struggle for the truth, and that every artist is engaged in a perpetual struggle against corruption of consciousness. Such corruption affects everyone, and everyone has to struggle against it, but the artist does so paradigmatically. 'In so far as consciousness is corrupted, the very wells of truth are poisoned. Intellect can build nothing firm. Moral ideals are castles in the air. Political and economic systems are mere cobwebs. Even common sanity and bodily health are no longer secure. But corruption of consciousness is the same thing as bad art.'[2] Because this is the case art is not a luxury. Great art requires great talent but it requires truthfulness as well – mere talent is not enough, which is why John Berger is right to speak of both the success and failure of Picasso whose gifts, paradoxically, could make things too easy for him. There is no redemption through form, though if Christians are right in their claims about the incarnation there is no redemption without it either.[3] What we have instead are questions and rumours, perceptions which put questions, which challenge the easy supposition that we are nothing but an evolutionary accident on a cooling cinder and which, in both light and darkness, provoke us to thought, to wonder and sometimes even to worship.

NOTES

1 SECULAR PARABLES

1 This was not lost on earlier commentators. In the eighteenth century John Loveday of Caversham was led by this voluptuousness to suggest that Bacon had fallen in love with his cook and therefore painted her (Karen Hearn, *Nathaniel Bacon: Artist Gentleman and Gardner*, London: Tate Publishing, 2005, p. 2). The dignity of the girl seems to me to suggest otherwise.

2 Margaret Sullivan believes that pumpkins, melons, gourds and cucumbers are all sexual metaphors, as, more remarkably, are cabbages, a symbol of luxury for Pliny because of the difficulty of their cultivation. She understands such paintings as an attempt to get viewers to reflect on the craving for luxuries and the ease with which spiritual values are corrupted in the drive to acquire more material possessions (Margaret Sullivan, 'Aertsen's kitchen and market scenes: audience and innovation in northern art', *Art Bulletin*, vol. 81, no. 2, June 1999, pp. 236–66). Kenneth Craig notes that Calvin's successor, Theodore Beza, published an emblem in 1580 which shows a man behind a table laden with food. There are two fishes on a platter, a dressed chicken, some vegetables, a goblet of wine and a loaf of bread. The Latin explication reads: 'What you eat and what you drink has to die to sustain life: And we obtain life from the death of Christ. Do you laugh at this impious Philosopher?' The thrust of the emblem is that the dead food sustains our temporal lives just as the sacrifice of Christ sustains our spiritual lives (Kenneth M. Craig, 'Pieter Aertsen and *The Meat Stall*', *Oud Holland*, vol. 96, no. 1, 1982, pp. 1–15; here p. 6).

3 Shakespeare, *The Tempest*, act 4, sc. 1.
4 David Bentley Hart, *The Beauty of the Infinite*, Grand Rapids: Eerdmans, 2004, p. 270.
5 Shakespeare, *The Winter's Tale*, act 4, sc. 4.
6 Hearn, *Nathaniel Bacon*, p. 7. The younger Bacon developed his garden at Culford Hall in Suffolk.
7 Francis Bacon, *Essays*, London: Dent, 1968, p. 137.
8 Lorne Campbell considers Beuckelaer greater than Aertsen ('Beuckelaer's *The Four Elements*: four masterpieces by a neglected genius', *Apollo*, February 2002, pp. 40–5).
9 William Jordan and Peter Cherry, *Spanish Still Life from Velázquez to Goya*, London: National Gallery, 1995, p. 16.
10 Pamela Jones, 'Federico Borromeo as a patron of landscapes and still lifes: Christian optimism in Italy ca 1600', *Art Bulletin*, June 1988, vol. 70, no. 2, pp. 261–72.
11 Campbell comments, 'By such means, a complex series of repeating and echoing motifs make interlinking relationships among all four compositions' (Campbell, *Apollo*, p. 43). A contemporary basket maker who looked at these pictures commented that the artist must have made baskets himself, so well does he understand their construction.
12 Sullivan notes that Aertsen endowed the denizens of the market place with faces that 'would not look out of place in a laudatory portrait' (Sullivan, 'Aertsen's kitchen and market scenes', p. 260). The same can be said for Beuckelaer and Bacon. Günther Irmscher argues that Renaissance moralists drew on Cicero, for whom trades which cater to sensual pleasures such as fishmongers, butchers, cooks, poulterers and fishermen were the least respectable. If that is the case we can only say that they draw on it by contradicting it (Günther Irmscher, 'Ministrae voluptatum: stoicizing ethics in the market and kitchen scenes of Pieter Aertsen and Joachim Beuckelaer', *Simiolus*, vol. 16, no. 4, 1986, pp. 219–32).
13 See Kenneth M. Craig, 'Pars ergo Marthae transit: Pieter Aertsen's "inverted" paintings of Christ in the house of Martha and Mary', *Oud Holland*, vol. 97, 1983, pp. 25–39. He writes, 'Aertsen in paint does what Augustine does in words. The painting in its own way is as much a sermon as was ever delivered by priest from pulpit, for the juxtaposition of the great still life with the small biblical scene is nothing less than a rhetorical device employed to moralize on man's concern for his physical comforts; at the same time it presents subtly but firmly the proposition that spiritual values are preferable to temporal ones' (p. 29).
14 This is even more likely if, as Campbell argues, the pun on the Dutch word

for birds, *vogelen*, which can also mean to have intercourse, is intended. He points out that one of the women buyers seems to be eyeing up the male seller (Campbell, *Apollo*, p. 43).

15 Campbell, *Apollo*, p. 43.

16 Raimonde van Marle, *Iconographie de l'art profane au moyen-âge et à la Renaissance*, 2 vols, New York: Hacker, 1971; Hugo Buchthal, *Historia Troiana: Studies in the History of Medieval Secular Illustration*, London: Warburg Institute, 1978.

17 Otto Pächt shows how detailed nature studies are already to be found in the late thirteenth and early fourteenth centuries in Italy. These constitute the essential preparation for both independent landscape and still life painting (Otto Pächt, 'Early Italian nature studies and the early calendar landscape', *Journal of the Warburg and Courtauld Institutes*, vol. 13, nos 1/2, 1950, pp. 13–47). The Emperor Frederick II (1194–1250) already showed many 'secular' traits, insisting on the need for empirical proof, rejecting *fides ex auditu*, and authoring 'the first zoological treatise written in the critical spirit of modern science' (Pächt, 'Early Italian nature studies', p. 23). Huizinga argues that many of the secular paintings of the fifteenth century have probably disappeared, giving us a rather false impression of the sacred – secular balance in that century (J. Huizinga, *The Waning of the Middle Ages*, Harmondsworth: Penguin, 1965, p. 236).

18 J. Burckhardt, *The Civilization of the Renaissance in Italy*, London: Phaidon, 1965, pp. 303ff.

19 Richard Kearney, *The Wake of Imagination: Toward a Postmodern Culture*, London: Routledge, 1994, p. 136.

20 Roger Hinks, *Michelangelo Merisi da Caravaggio: His Life, His Legend, His Works*, London: Faber and Faber, 1953.

21 So, for example, O. R. Kristeller, 'Marsilio Ficino and his circle' and 'Humanism and scholasticism in the Italian Renaissance', *Studies in Renaissance Thought and Letters*, Rome: Edizione di Storia e Letteratura, 1956. Kristeller's judgement is that humanism and scholasticism arose at the same time, about the end of the thirteenth century and coexisted as separate branches of learning, competing as rival branches of the arts. It was with the rise of modern science that scholasticism got displaced (p. 580).

22 Keith Moxey, *Pieter Aertsen, Joachim Beuckelaer and the Rise of Secular Painting in the Context of the Reformation*, London: Garland, 1977.

23 At the same Calvin agreed that 'the arts of painting and carving are gifts of God'. Like other gifts they had to be used for what was 'pure and clean'. This comprised two categories: 'The first consists of histories, and the second of trees, mountains, rivers and persons that one paints without any meaningful

intention. The first kind provides instruction, the second exists only to afford us pleasure' (J. Calvin, *Institutes of the Christian Religion*, trans. H. Beveridge, Grand Rapids: Eerdmans, 1975, p. 135). William Perkins made the distinction between secular and religious painting, art that was purely commemorative and served civic uses and art that might be religiously misused. Imagery that was historical, recording human or divine history, was legitimate, with the important proviso that scriptural representations were kept out of church. But there was nothing wrong with images 'made for the beautifying of houses, either public or private, that serve only for civil meetings' and these included portraits. 'The image of a man may be painted for civil or historical use' but not to represent God or 'in use of religion' (Margaret Aston, 'God's saints and reformers: portraiture and Protestant England' in Lucy Gent (ed.), *Albion's Classicism: The Visual Arts in Britain 1550–1660*, New Haven and London: Yale University Press, 1995, pp. 181–220; here p. 179).

24 Etienne Gilson argues that the adoption of a Raphaelesque formula as the official aesthetic of the Roman Church had the effect of promoting a decorative art rather than a specifically religious one which points beyond itself to the divine mystery. This diminished its sacramental potential (Etienne Gilson, *Elements in Christian Philosophy*, New York: Mentor, 1960, p. 120).

25 Cited in Ingvar Bergström, *Dutch Still Life Painting in the Seventeenth Century*, London: Faber and Faber, 1956, p. 2.

26 W. Dyrness, *Reformed Theology and Visual Culture: The Protestant Imagination from Calvin to Edwards*, Cambridge: Cambridge University Press, 2004, pp. 76, 92; here drawing on the work of Peter Matheson.

27 Auerbach, Erich, *Mimesis: The Representation of Reality in Western Literature*, Princeton: Princeton University Press, 1968, p. 72.

28 Karl Barth, *Church Dogmatics*, Edinburgh: T. & T. Clark, vol. 3, pt 1, 1958, pp. 330–1 (henceforward *CD*).

29 Barth, *CD*, vol. 3, pt 1, p. 362.

30 Barth, *CD*, vol. 3, pt 3, p. 184. Jacques Maritain seems to have believed the same thing. Summarising his view Rowan Williams writes, 'God makes a world in which created processes have their own integrity, so that they do not need God's constant direct intervention to be themselves. At a deeper level, it assumes a unity between grace and nature: the integrity of a created process will, if pursued honestly and systematically, be open to God's purposes' (Rowan Williams, *Grace and Necessity*, London: Continuum, 2005, p. 9).

31 Barth, *CD*, vol. 3, pt 1, p. 474.

32 The phrase is used by Hans Frei about Barth. Cited in Paul Metzger, *The Word of Christ and the Word of Culture*, Grand Rapids: Eerdmans, 2003, p. 231.

33 Barth, *CD*, vol. 3, pt 1, p. 199. For Barth creation glorifies God by being

what it is in the freedom of its limits. When the artist or carpenter or nursing mother (Barth's examples) revels in his or her work, content with it, and not wishing to go beyond it, it is then that even non-Christian cultural existence finds affirmation.

34 Karl Barth, *Wolfgang Amadeus Mozart*, Grand Rapids: Eerdmans, 1986, pp. 37–8. From a very different theological perspective Etienne Gilson expressed something very similar: 'In a created universe whatever exists is religious because it imitates God in its operations as well as in its being. If what precedes is true, art, too, is religious in its very essence, because to be creative is to imitate, in a finite and analogical way, the divine prerogative, exclusively reserved for HE WHO IS, of making things to be' (Etienne Gilson, *Painting and Reality*, New York: Meridian, 1959, p. 271. See also John Ruskin who argued that 'the works of God in creation provide a timeless and universally accessible testimony to their divine origin. The artist is gifted with the ability to see and represent in his work a truthful image of that testimony and so to be able to direct the less perceptive to see it for themselves' (cited in George Pattison, *Art, Modernity and Faith*, 2nd edn, London: SCM, 1998, p. 54).

35 Norman Bryson, *Looking at the Overlooked: Four Essays on Still Life Painting*, London: Reaktion, 1990, p. 150.

36 I accept the argument of Kenneth Craig that 'There is no condemnation of the material world. Rather, such lowly things as vegetables and meats, while intended to represent the temporal aspects of human concern, are yet considered to be sufficiently worthy to be the symbols which lead the viewer to reflect on the profound spiritual truth that exist behind them on another level. Like the pictures of van Eyck these pictures draw us to contemplation of the spiritual world by a rich version of the natural one' (Craig, 'Pars Ergo Marthae Transit', p. 36). Unlike him I do not think this truth is established merely by way of contrast. Tillich likewise believes that the rise of a secular art does not mean that the religious or theological dimension is lost (Paul Tillich, *On Art and Architecture*, New York: Crossroad, 1989, p. 172).

37 The term 'secular parable' comes from Karl Barth. For Tillich all art is religious because it 'expresses a depth content, a position towards the Unconditional'. In it, 'being' manifests itself. My adoption of the secular parable notion is intended to distinguish my position from that of Tillich, with whose views on secularity I largely agree. His way of understanding art both presupposes the analogia entis and requires copious use of the abstract language of being which the language of parables does not require (Tillich, *On Art and Architecture*, p. 52).

38 *CD*, vol. 4, pt 3, 1, 1961, p. 117.

39 *CD*, vol. 4, pt 3, 1, p. 139.

40 *CD*, vol. 4, pt 3, 1, p. 115, my italics.

41 *CD*, vol. 4, pt 3, 1, p. 122.

42 Jean Luc Marion writes, 'In order to see, it is enough to have eyes. To look demands much more: one must discern the visible from itself, distinguishing surfaces there in depth and breadth, delimiting forms, little by little, marking changes, and pursuing movements' (Jean-Luc Marion, *In Excess: Studies of Saturated Phenomena*, New York: Fordham, 2002, p. 55).

43 Marion, *In Excess*, p. 51.

44 Among the many who have argued this case are: Sullivan, 'Aertsen's kitchen and market scenes'; Irmscher, 'Ministrae voluptatum'; and Craig, 'Pieter Aertsen and *The Meat Stall*'.

45 Keith Moxey has argued that the pictures represent a wholly new attitude towards pictorial subject matter. For him the presence of religious themes in secular subjects cannot be viewed as providing a justification for those subjects since autonomous secular subjects were already present in Aertsen's work and Aertsen is at least as concerned with the direct representation of coarse peasant sensuality as with moralisation. He considers this to be the content of peasant life but we would rather say, on the evidence of the pictures, the Georgic world, the world of agricultural and marine labour, that which sustains us and without which we cannot live (Moxey, *Pieter Aertsen*, p. 33).

46 So David Brown, *God and Enchantment of Place*, Oxford: Oxford University Press, 2004, pp. 7, 33.

47 Aidan Nichols cites H. D. Lewis's view that the more the artist invests the commonplace realities of ordinary experience with his peculiar individual impression of them, the more starkly do they present to him an irreducibly other nature. 'The closer the artist moves towards reality in his art the more is it alarmingly aloof. Paradoxically but unmistakeably, there is in art an unveiling which is at the same time a concealment. In the very process of clarification there is also a deepening of mystery. Mystery that is not in the sense that there is a mystery at the end of every scientific truth . . . but in a more absolute and immediate sense that that which is made peculiarly plain to us is itself proportionately more enigmatic. Mystery and illumination are one in art' (Aidan Nichols, *The Art of God Incarnate*, London: Darton, Longman and Todd, 1980, p. 117).

48 As Aquinas notes at the beginning of the *Summa theologiae*, 1a.1.2.

49 The comparison is Barth's.

50 Maurice Merleau-Ponty, 'Cézanne's doubt', in *Sense and Non-Sense Studies in Phenomenology and Existential Philosophy*, Evanston, Ill.: Northwestern University Press, 1964, p. 20.

51 Barth, *CD*, vol. 4, pt 3, pp. 112–13.

52 Barth, *CD*, vol. 4, pt 3, 1, p. 113.

53 True words spoken outside of the church may speak of the goodness of the original creation, of its jeopardising, of its liberation or of the future revelation of its glory (all of these aspects, of course, have their analogy in painting). They may speak of the psychophysical or social determination of human beings, of their defects, rights or dignity, of the forgiveness of sins, of the marching orders they are given, of the shadow of death under which they live, or the joy in which they may live even under this shadow. 'Each true word points in its own way to Jesus Christ the true Son of Man, the centre and totality of human life, and therefore to the true humanity of God' (Barth, *CD*, vol. 4, pt 3, 1, p. 123).

54 Marion, *In Excess*, p. 58. Marion speaks of art displacing reality in the intensity of its vision, stealing admiration from its original, as in the famous remark of Goethe on a painting by Willem Kalf. He speaks of it therefore as 'an idol'. Art 'annuls the prestige of the visibility of the world and, in this sense, dismisses the physical from all primacy' (p. 61). The idea of art catching an aspect of reality in such a way as to go beyond it, charge it with glory, and thus transcend it, is helpful. The idea of saturated being, which may derive from Rothko, aptly catches this fullness of artistic presence. But with landscapes and portraits, above all, does art not send us back to reality with new eyes? This seems to be the basis of the very idea of the picturesque. Drawing on the aesthetics of Jacques Maritain, Rowan Williams argues something similar. The world, he says, cannot be captured by perception. There is always an excess. 'Re-presentation assumes that there is an excess in what presents itself for knowing, and that neither the initial cluster of perceptions nor any one set of responses will finally succeed in containing what is known' (Williams, *Grace and Necessity*, p. 139).

55 Christopher Rowland, *Revelation*, London: Epworth, 1993, p. 21.

56 We could ask where this leaves God's lordship in revelation? Mozart is able to do this, argues Barth, because, in his humility, he simply channels what he hears of the goodness of creation. Simply to respond to creation in this way was the goal of many painters (Constable, or Monet, for example) but, of course, everything is channelled through their particular sensibilities, including their limitations (exactly as with Scripture). We could argue that Barth simply gives rein here to his enthusiasm for Mozart and does not think this through in relation to his fundamental theological system. Or we could argue that the fact that the peace which passes understanding is discerned only by those with ears to hear, or, analogously, with eyes to see, means that the freedom of the divine revelation is maintained. The British Congregationalist theologian P. T. Forsyth, often spoken of as an early anticipation of Barth,

gave his own account of the way painting might function as a secular parable in arguing that the religious artist is not to be confined to religious subjects, nor even to distinctly religious ideas. For him the National Gallery in London represented an interest 'as integral to the Church in its own way as the national Parliament'. Thinking especially of the impressionists, he argued that whereas painters used to paint the beauty of holiness they now paint the holiness of beauty. Having begun (on his account) with the soul as the realm of God it ended with the universe as the realm of power and law, beauty and order (P. T. Forsyth, *Christ on Parnassus*, London: Independent Press, 1959, pp. 255, x, 128).

57 There are, of course, criteria to recognise the 'words' which count as secular parables. They agree with Scripture and the confessions of the church, and the fruits to which such words give rise. They lead us more deeply into the given world of the Bible. They differ from the Word of Scripture in that they are limited to a specific time and situation and their reception is not an affair of the whole community but only of part of it. They do not express partial truths, for the one truth of Jesus Christ is indivisible, but they express the one and total truth from a particular angle, and to that extent only implicitly and not explicitly in its unity and totality (Barth, *CD*, vol. 4, pt 3, 1, pp. 123, 128).

58 Barth, *CD*, vol. 4, pt 3, 2, p. 737. Barth continues to insist that in speaking of true words outside the Christian sphere he is not speaking of natural theology. Natural theology, which appeals to a knowledge of God 'given in and with the natural force of reason' does not speak of the triune God but about a Supreme Being, or about providence, and these understandings of God, and the views of humankind which go with them, do not commit us in the way in which revelation does (*CD*, vol. 4, pt 3, 1, p. 117).

59 Amos Wilder, *Jesus' Parables and the War of Myths*, London: SPCK, 1982, p. 87.

60 Jordan and Cherry, *Spanish Still Life*, p. 42.

61 Wassily Kandinsky, *Concerning the Spiritual in Art*, New York: Dover, 1977, p. 9.

62 Michael Austin, *Explorations in Art, Theology and Imagination*, London: Equinox, 2005, p. 16.

63 Austin, *Explorations in Art*, p. 167.

64 Ernst Fischer, *The Necessity of Art*, Harmondsworth: Penguin, 1963, p. 42.

65 Ernst Fischer, *Necessity*, p. 46.

66 Ernst Fischer, *Necessity*, p. 42.

67 Nicholas Wolterstorff, *Art in Action: Toward a Christian Aesthetic*, Carlisle: Solway, 1997, p. 50.

68 Paul Ricoeur, *The Conflict of Interpretations*, Evanston, Ill.: Northwestern University Press, 1974, p. 158. Ricoeur remarks that Freud was only aware of art in its idealising form, 'its ability to muffle the forces of darkness through sweet incantation' (p. 158).

69 John Berger, *Ways of Seeing*, Harmondsworth: Penguin, 1972, p. 23.

70 Charles Pickstone and Graham Ward took up the issue of transcendence in art in two stimulating articles, the former arguing that Van Gogh's art lacked the 'vertical dimension' and the latter that a theology which paid inadequate attention to the cross collapsed the sacred into the secular, the religious into the aesthetic (Charles Pickstone, 'Much strife to be striven: the visual theology of Vincent Van Gogh', *Theology*, July/August 1990, pp. 283–91; G. Ward, 'Sacramental presence or neopaganism?', *Theology*, 1991, pp. 279–83). I am trying to preserve the aspect of transcendence by insisting on the freedom of God in revelation which is not implicit, per se, in any created reality.

71 Lionel Kochan argues this in *Beyond the Graven Image, A Jewish View*, Basingstoke: Macmillan, 1997. I take it that it is also the function of Kierkegaard's contrast between the aesthetic and the ethical in *Either/Or*.

72 Terry Eagleton, *The Idea of Culture*, Oxford: Blackwell, 2000, p. 130. P. T. Forsyth already argued this case, at the beginning of the twentieth century. Art is ethical in principle, he said, but not ethical in function. 'If Art is to be raised, it is the public that must be raised. And that Art cannot do. It is not an evangelist, or a prophet, or a moral reformer. It cannot start a moral regeneration in a people debased by money and uplifted by faith' (Forsyth, *Christ on Parnassus*, pp. 263, 290).

73 Walter Benjamin, *Illuminations*, London: Fontana, 1973, p. 248. At the same time Jean-Luc Marion is right, speaking of art galleries, that 'a remnant of veneration, even without assurance or lucidity, is worth more than blind barbarism' (Marion, *In Excess*, p. 70).

74 Kearney, *Wake of Imagination*, p. 198.

75 Barth was a keen student of Schiller, and Kearney mentions that Schiller argued that only by making a 'leap' out of the world of everyday reality is the imagination free to invent a world of pure illusion – the joyous kingdom of play. The messianic kingdom is no longer something to be revealed by God. It is an aesthetic project of man's imagination (Kearney, *Wake of Imagination*, p. 186).

76 Karl Barth, *Ethics*, Edinburgh, T. & T. Clark, 1981, p. 509. Commenting on the play paradigm in postmodern thought Richard Kearney argues that it may be construed as a token of the poetical power of imagination to transcend the limits of egocentric and indeed anthropocentric consciousness – thereby exploring different possibilities of existence. Without the poetical openness to

the pluridimensionality of meaning, he goes on, the ethical imagination might well shrink back into a cheerless moralising, an authoritarian and fearful censorship (Kearney, *Wake of Imagination*, p. 369). As in so many things, Barth agrees with St Thomas here. See A. Besançon, *L'image interdite. Une histoire intellectuelle de l'iconoclasme*, Paris: Gallimard, 1994, pp. 313–14. I owe this reference to Richard Viladesau. Tillich also understands art in terms of play (*On Art and Architecture*, p. 4).

77 See Kearney, *Wake of Imagination*, p. 369: 'The poetical readiness to tolerate the undecidability of play must be considered in relation to the ethical readiness to decide between different modes of response to the other . . . it is a matter of ascertaining the mutually enhancing virtues of both aspects of imagination. Each is indispensable to the other.'

78 Pattison points out that Victorian genre painting accords perfectly with Ruskin's and Arnold's belief in the moral and pedagogical responsibility of art and their faith that it could effect social changes for the better (Pattison, *Art*, p. 191).

79 'We need to recognise that the visual arts can and often do play a socially critical role. It is not only the word of the prophet and poet that challenges injustice, but also the work of the painter, sculptor and architect' (John de Gruchy, *Christianity, Art and Transformation*, Cambridge: Cambridge University Press, 2001, p. 52).

80 Robert Hughes, *The Shock of the New*, 2nd edn, London: Thames and Hudson, 1991, p. 111.

81 Barth, *Ethics*, p. 508.

82 Barth appeals to Isa 65.17. In this respect Barth explicitly contradicts what Pattison, like so many theological liberals, feels 'must' be the case for him.

83 Barth, *Ethics*, p. 510.

84 Walter Benjamin, cited in Ernst Fischer, *Necessity*, p. 203, and Pattison, *Art*, p. 99, who hopes that art and religion might find common cause in the assault on all premature consolations and help chart that dark wasteland 'which is the new landscape of the human pilgrimage'. Fischer speaks of the permanent function of art as re-creating in every individual's experience 'the fullness of all that he is not, the fullness of humanity at large' (p. 223). John Berger comments that what makes Jack Yeats a great artist is that he had an awareness of the possibility of a world other than the one we know (John Berger, *Selected Essays and Articles*, Harmondsworth: Penguin, 1971, p. 59).

85 Wolterstorff, *Art in Action*, pp. 81, 169.

86 This is the view of the neo-Thomist Etienne Gilson, who has a very different standpoint from Wolterstorff (Gilson, *Painting and Reality*, p. 272).

87 Simone Weil is one of the seminal figures of the twentieth century; a Jew pro-

foundly attracted by Christianity; a radical independent thinker who could not sign up to any political orthodoxy; a realist who loved Plato. Her remarks on prayer as attention can be found in 'Reflections on the right use of school studies', in *Waiting on God*, London: Routledge & Kegan Paul, 1951.

88 David Ford, *Self and Salvation: Being Transformed*, Cambridge: Cambridge University Press, 1999, p. 21.

IMAGE

1 Kochan, *Beyond the Graven Image*, p. 55.

2 Plato, *Republic*, 605a.

3 Clement of Alexandria, *Exhortation to the Greeks*, 4.

4 John of Damascus, *De fide orthodoxa*, chap. 16.

5 So Philoxenes of Mabboug in Kearney, *Wake of Imagination*, pp. 133, 146–7.

6 Karen Stone, *Image and Spirit: Finding Meaning in Visual Art*, London: Darton, Longman and Todd, 2003, p. 10.

7 Cited in Nichols, *Art of God Incarnate*, p. 50.

8 Nichols, *Art of God Incarnate*, pp. 48, 49.

9 Stone, *Image and Spirit*, p. 9.

10 Stone, *Image and Spirit*, p. 29.

11 Stone, *Image and Spirit*, p. 43.

12 The film director Ken Loach, defending his use of long periods of dialogue in his films, says 'Certain things have to be expressed in language because only language can carry the nuances. Images are too ambiguous' (*Big Issue*, 19–25 June 2006).

13 Stone, *Image and Spirit*, p. 27.

14 Nichols, *Art of God Incarnate*, p. 93.

15 E. H. Gombrich, *Art and Illusion*, Oxford: Phaidon, 1986, p. 72.

16 Gombrich, *Art and Illusion*, p. 76.

17 E. H. Gombrich, 'Botticelli's symbolic mythologies', in *Symbolic Images: Studies in the Art of the Renaissance*, Oxford: Phaidon, 1972.

18 For the late nineteenth century he was quintessential Englishness. In the First World War his paintings were used to show what people were dying for in the trenches. In the mid war period they were used by the Campaign for the Protection of Rural England. He had been a forerunner of Cézanne, of the impressionist movement, and the whole modern movement. By 1965 he was an 'industrial landscape painter'; six years later he was concerned with the forces and relations of rural production, if only to subdue their impact. By 1981 the 'absolute despair' symbolised by Cruise missiles is contrasted with the 'aesthetic wholeness' of Constable, 'the fuller realization of human sensual

and perceptual potentialities within a world transformed'. Ten years later he had become a champion of conservation, which was a condition of the enterprise culture, not a barrier to it (Stephen Daniels, *Fields of Vision: Landscape Imagery and National Identity in England and the United States*, Cambridge: Polity, 1993).

19 Gombrich, *Art and Illusion*, p. 326.
20 Iris Murdoch, *The Sovereignty of Good*, London: Ark, 1970, p. 30.
21 Nichols, *Art of God Incarnate*, p. 103.

2 RADIANT HUMANISM

1 Herbert Horne, *Botticelli*, Princeton: Princeton University Press, 1980 (1908), p. 274.
2 Rab Hatfield, 'Botticelli's *Mystic Nativity*, Savonarola and the millennium', *Journal of the Warburg and Courtauld Institutes*, vol. 58, 1995, pp. 89–114.
3 Lightbown disputes this, though the available evidence peters out in 1505 (Ronald Lightbown, *Sandro Botticelli*, London: Elek, vol. 1, 1978, p. 154).
4 Lightbown writes of *The Birth of Venus*, 'There is no more radiant picture in European art than this' (*Sandro Botticelli*, p. 89). In Thomas Pynchon's 1960s novel *V* it is *The Birth of Venus* which is torn from its frame and mocked, presumably as a symbol of the humanism which Pynchon considers to be under threat.
5 Germaine Bazin, *Fra Angelico*, London: Heinemann, 1949. Bazin makes the mistake of describing the artist as a member of Ficino's circle, which is chronologically impossible, but he justifies the appellation 'humanist' by reference to Fra Angelico's coordination of the body with painted space and the intelligence of his faces.
6 Cited in Pasque Villari, *Life and Times of Girolamo Savonarola*, London: Fisher Unwin, vol. 2, 1890, p. 138.
7 Coulton tells how in the thirteenth century a Franciscan artist and the Guardian of the Franciscan house in Gloucester had both been disciplined because the one had painted and the other had allowed pictures on a pulpit (C. G. Coulton, *Art and the Reformation*, Oxford: Blackwell, 1928, p. 334).
8 Either Lucretius' *De rerum natura*, or the *Stanze* of Poliziano celebrating the joust of Giuliano de' Medici in the case of *The Birth of Venus*. See Horne, *Botticelli*; A. Warburg, 'Sandro Botticelli's Geburt der Venus und Frühling', *Gesammelte Schriften*, Leipzig and Berlin, vol. 1, 1932 (1893); here pp. 1–55. Panofsky assumes indebtedness to Poliziano (Erwin Panofsky, *Renaissance and Renascences in Western Art*, New York: Harper and Row, 1969, pp. 193ff).

9 Gombrich, 'Botticelli's symbolic mythologies', reprinted in *Symbolic Images*.

10 Cited in Gombrich, *Symbolic Images*, p. 42.

11 Lightbown, *Botticelli*, vol. 1, p. 81.

12 Lightbown, *Botticelli*, vol. 1, p. 89.

13 Charles Dempsey argues that the paintings are best understood as visualisations of idealised, courtly love (*The Portrayal of Love: Botticelli's 'Primavera' and Humanist Culture at the Time of Lorenzo the Magnificent*, Princeton: Princeton University Press, 1992). Sharon Fermor reads it in terms of the chivalry of the joust ('Botticelli and the Medici' in F. Ames-Lewis (ed.), *The Early Medici and their Artists*, London: Birkbeck, 1995, pp. 169–85).

14 Burckhardt, *Civilization*, p. 309.

15 Pico della Mirandola, *On the Dignity of Man*, New York: Macmillan, 1985, p. 32.

16 Later, in his *Apology*, he attacks him violently.

17 Marsilio Ficino, *The Letters of Marsilio Ficino*, London: Shepheard-Walwyn, vol. 3, 1981, p. 139.

18 Kristeller, 'Marsilio Ficino and his circle', in *Studies*, p. 39.

19 Marsilio Ficino, *Platonic Theology*, 13.3, ed. James Hankins, trans. Michael J. B. Allen, Cambridge, Mass.: Harvard University Press, vol. 4, 2001, pp. 171–5.

20 Marsilio Ficino, *Commentary on the Symposium*, trans. S. Jayne, Woodstock, Conn.: Spring Publications, 1985, p. 40.

21 Edgar Wind seems to me to establish this beyond a peradventure (*Pagan Mysteries of the Renaissance*, Harmondsworth: Penguin, 1967); Nesca Robb had argued for a Neoplatonic reading as early as 1935 in *Neoplatonism of the Italian Renaissance*, London: Allen & Unwin, 1935.

22 G. Vasari, *Lives of the Artist*, vol. 1, Harmondsworth: Penguin, 1965, trans. George Bull, p. 230.

23 Robb, *Neoplatonism*, p. 219.

24 Ficino, *Letters*, vol. 1, letter 47.

25 So M. Allen and J. Hankins in Ficino, *Platonic Theology*, 1, p. viii.

26 Ficino, *Platonic Theology*, 18.9, vol. 6, p. 179.

27 Ficino, *Platonic Theology*, 2.13, vol. 1, p. 199.

28 Gombrich, *Symbolic Images*, p. 64.

29 Gombrich, *Symbolic Images*, p. 76.

30 Mirella Levi D'Ancona (ed.), *Botticelli's Primavera*, Florence: Olschke, 1983, p. 19.

31 André Chastel, *Marseile Ficin et l'art*, Geneva: Droz, 1996, p. 150. The scheme is taken from *De Christiana religione*.

32 B. Gallati, 'An alchemical interpretation of the Marriage between Mercury and Venus', in D'Ancona, *Primavera*, pp. 99–121; here pp. 110, 119.

33 Gombrich, *Symbolic Images*, p. 63.

34 Panofsky, *Renaissance*, pp. 195–6.

35 Claudia Villa, 'Per una lettura della "primavera": Mercurio "retrograde" e la retorica nella bottega di Botticelli', *Strumenti critici*, vol. 13, no. 1, January 1998, pp. 1–28.

36 Panofsky, *Renaissance*, p. 199.

37 Charles Dempsey, 'Mercurius Ver: the sources of Botticelli's *Primavera*', *Journal of the Warburg and Courtauld Institutes*, vol. 31, 1968, pp. 251–73.

38 Panofsky, *Renaissance*, p. 200.

39 Nicolai Rubinstein, 'Youth and spring in Botticelli's *Primavera*', *Journal of the Warburg and Courtauld Institutes*, vol. 60, 1997, pp. 248–51.

40 Wind, *Pagan Mysteries*, pp. 125, 126.

41 Kenneth Clark, *The Nude*, Harmondsworth: Penguin, 1985, p. 98.

42 Panofsky, *Renaissance*, p. 198. He comments, '*Amor divinus* is the son of celestial Venus who had miraculously come into being... She has... no mother – which means, in view of the supposed connection between the words *mater* and *materia*, that she dwells in the sphere of Mind, utterly remote from Matter. The love engendered by her enables our contemplative powers to possess themselves of divine beauty in an act of pure cognition... *Amor humanus*, on the contrary is the son of ordinary or natural Venus... Both kinds of love are... "honourable and praiseworthy, albeit in different degrees", and each of the two Venuses "impels us to procreate beauty, but each in her own way"' (Ficino, *Commentary*, 6.4).

43 'God exists by the very essence of beauty and is alone truly beautiful' (Gregory of Nyssa, *On the Song of Songs*, 4); 'Compared with God nothing else is beautiful' (Augustine, *Confessions*, 11.4); 'The Good is called beauty because it imparts beauty to all things according to their natures. In itself and by itself it is the uniquely and eternally beautiful. It is the superabundant source in itself of the beauty of every beautiful thing' (Colm Luibheid (ed.), *Pseudo-Dionysius*, Mahwah, N. J.: Paulist, 1987, pp. 76–7).

44 Cited in Panofsky, *Renaissance*, p. 184.

45 Aquinas, *Commentary on the Divine Names*, cited in Umberto Eco, *The Aesthetics of Thomas Aquinas*, London: Radius, 1988, p. 27.

46 Panofsky, *Renaissance*, p. 184. The passage in the *Summa theologiae* is 1a.39.8.

47 Tillich, *On Art and Architecture*, p. 235.

48 John Berger, *The White Bird*, London: Hogarth, 1988, pp. 7–9.

49 Lionel Venturi, *Botticelli*, London: Phaidon, 1961, p. 7.

50 Robb, *Neoplatonism*, p. 220.

51 A. Hauser, *The Social History of Art*, London: Routledge, 1951, p. 304.

52 Rowan Williams insists, rightly in my view, that an artist cannot seek beauty in itself without losing integrity (*Grace and Necessity*, p. 168). Botticelli, in my view, is responding to an 'excess' which he has discerned in reality and which, as in the final book of Ficino's *Theologia Platonica*, potentially characterises all bodies, and perhaps all matter – the reflection by the created world of the Creator.

53 Predictably, suspicion fell on Ficino during the Counter-Reformation, and the third of his books, 'On Life', was placed on the Index (Jill Kraye, 'Ficino in the firing line: a Renaissance Neoplatonist and his critics' in M. Allen and V. Rees (eds), *Marsilio Ficino: His Theology, His Philosophy, His Legacy*, Leiden: Brill, 2002, pp. 377–98.

54 De Gruchy, *Christianity*, p. 107.

55 Hans Urs von Balthasar, *The Glory of the Lord*, Edinburgh: T. & T. Clark, 1982, p. 18. Tillich thought that no convincing representation of glory had ever been produced, but if it is anywhere, surely it is in Botticelli (*On Art and Architecture*, p. 138).

3 PIG EARTH

1 Keith Moxey argues that 'the Beham brothers in their account of the kermiss and of a church festival transformed a cultural stereotype associated with social satire and obscene humour into a visual vehicle for the expression of class ridicule' (*Peasants, Warriors and Wives: Popular Imagery in the Reformation*, Chicago: University of Chicago Press, 1989, p. 66).

2 Bryson, *Looking at the Overlooked*, p. 110.

3 Henry van de Velde, writing in 1899, acknowledged that Brueghel was the great exception among his peers, but even so felt that his depictions of peasants were no more than comic caricatures. The effect of this was to negate their subversive significance ('Du paysan en peinture', *L'avenir social*, August 1899, p. 283).

4 Margaret Sullivan, *Bruegel's Peasants: Art and Audience in the Northern Renaissance*, Cambridge: Cambridge University Press, 1994, p. 13.

5 Sullivan, *Bruegel's Peasants*, p. 91.

6 Sullivan, *Bruegel's Peasants*, p. 55. Dulle Griet, usually called 'Mad Meg' in English, is taken to be a satire of covetousness. Meg, already laden with objects, heads to the mouth of hell to get even more.

7 Sullivan, *Bruegel's Peasants*, p. 61.

8 Sullivan, *Bruegel's Peasants*, p. 78.

9 Sullivan, *Bruegel's Peasants*, p. 104.

10 Sullivan, *Bruegel's Peasants*, p. 126.

11 Hessel Miedema, 'Realism and comic mode: the peasant', *Simiolus*, vol. 9, no. 4, 1977, pp. 205–19; here p. 219.

12 G. W. F. Hegel, *Hegel's Aesthetics: Lectures on Fine Art*, trans. T. M. Knox, Oxford: Oxford University Press, vol. 2, 1975, p. 887.

13 Svetlana Alpers, 'Taking pictures seriously: a reply to Hessel Miedema', *Simiolus*, vol. 10, 1978–9, pp. 46–50.

14 Svetlana Alpers, 'Bruegel's festive peasants', *Simiolus*, vol. 6, nos 3–4, 1972–3, p. 167.

15 Stephen Greenblatt agrees, distinguishing between the laughter that levels and the laughter that sets out to inscribe differences (Stephen Greenblatt, 'Murdering peasants: status, genre and the representation of rebellion', *Representation*, vol. 1, no. 1, February 1983, pp. 1–29; here p. 17).

16 Kenneth Clark, *Landscape into Art*, 2nd edn, London: John Murray, 1976, p. 58.

17 Bryson, *Looking at the Overlooked*, p. 101.

18 Svetlana Alpers, 'Realism as a comic mode: low life painting seen through Bredero's eyes', *Simiolus*, vol. 8, no. 3, 1975–6, pp. 115–39.

19 Carel van Mander, *Dutch and Flemish Painters*, New York: Arno, 1969, p. 153.

20 Moxey, *Peasants*, p. 25.

21 Paul Freedman, *Images of the Medieval Peasant*, Stanford: Stanford University Press, 1999.

22 Freedman, *Images*, p. 155.

23 Freedman, *Images*, p. 213.

24 Freedman, *Images*, p. 15.

25 Freedman, *Images*, p. 214.

26 'Bruegel and the peasants: a problem of interpretation', in W. S. Gibson, *Pieter Bruegel the Elder: Two Studies*, Kansas: University of Kansas Press, 1991.

27 Robert Reyce, *Suffolk in the Seventeenth Century*, ed. Lord Francis Hervey, London, 1902 (1618), pp. 56, 57.

28 Freedman, *Images*, p. 218.

29 Freedman, *Images*, p. 231.

30 Freedman, *Images*, p. 232.

31 Ernst Fischer, *Necessity*, p. 135.

32 Ronald Paulson, *Literary Landscape: Turner and Constable*, New Haven and London: Yale University Press, 1982, p. 50.

33 Wayne Franits, *Dutch Seventeenth-Century Genre Painting*, New Haven and London: Yale University Press, 2004, p. 137.

34 Franits, *Dutch*, p. 138.

35 Tillich nevertheless found that the peasant scenes of Jan Steen had 'eternal

light and pointed to the nature of the divine ground out of which they came' (*On Art and Architecture*, p. 33).

36 Williams, *Grace and Necessity*, p. 14.

37 *The Complete Letters of Vincent Van Gogh*, 3 vols, London: Thames and Hudson, vol. 2, letter 402, 1959, p. 367.

38 Jean de la Bruyère, *Characters*, trans. Jean Stewart, Harmondsworth: Penguin, 1970, p. 210. See Johann Georg Sulzer a century later: 'What person of feeling can look upon the pleasures of simple shepherds in a rural scene marked by innocence and simplicity without experiencing the most joyful stirrings of the heart?' This is a little too close for comfort to Marie Antoinette's playing at shepherdesses. From his essay 'General theory of the fine arts' cited in C. Harrison, P. Wood and J. Gaiger (eds), *Art in Theory 1648–1815: An Anthology of Changing Ideas*, Oxford: Blackwell, 2000, p. 841.

39 Van de Velde, 'Du paysan', p. 329.

40 Christopher Parsons and Neil McWilliam, '"Le paysan de Paris": Alfred Sensier and the myth of rural France', *Oxford Art Journal*, vol. 6, no. 2, 1983, pp. 38–58. The authors argue that Sensier talked up Millet's reputation in order to make a profit on his holdings of Millet's art.

41 Julia Cartwright, *Jean François Millet*, 2nd edn, London: Swan Sonnenschein, 1902, p. 52.

42 The version in the Musée D'Orsay is later, between 1853 and 1857. The original is in a private collection in the United States. The first critics felt that Millet had overdone the impasto, and perhaps for that reason this is not evident in the Paris version.

43 Cited in Parsons and McWilliam, 'Le paysan', p. 44.

44 Cited in Robert L. Herbert, *Jean François Millet*, London: Arts Council of Great Britain, 1976, p. 62.

45 Cited in Herbert, *Jean François Millet*, p. 85.

46 Parsons and McWilliam, 'Le paysan', p. 47. A popular history of rural labour even spoke of peasants as 'the enemy within the gates'.

47 Cited in Herbert, *Jean François Millet*, p. 85.

48 Cartwright, *Jean François Millet*, p. 139. Van de Velde wrote, 'These simple ones are of the gods, and their grand silhouettes have a pure beauty, erected like bronzes to celebrate a humane and generous doctrine under harsh and corrosive skies' ('Du paysan', p. 330).

49 One of Ronald Blythe's interviewees in Akenfield noted that men deserted to fight in the First World War because the work was lighter: quite literally, he said, men were worked to death (*Akenfield*, Harmondsworth: Penguin, 1969, p. 41).

50 Herbert, *Jean François Millet*, p. 138.

51 Cited in Herbert, *Jean François Millet*, p. 137. See T. J. Clark's comment that 'Mental life in Millet was wholly defined by the fact of labour; and defined here meant stultified, externalized, and all but extinguished' (*Farewell to an Idea: Episodes from a History of Modernism*, New Haven and London: Yale University Press, 1999, p. 121).

52 Van de Velde, 'Du paysan', p. 333.

53 Jean Bouret, *The Barbizon School and Nineteenth-Century French Landscape Painting*, London: Thames and Hudson, 1973, p. 218.

54 Herbert, *Jean François Millet*, p. 138.

55 Van Gogh, *Letters*, vol. 2, letter 400, p. 362.

56 Ernst Fischer, *Necessity*, p. 136.

57 Van Gogh, *Letters*, vol. 2, letter 404, p. 370.

58 For the cult of the peasant see Parsons and McWilliam, 'Le paysan', p. 41, and T. J. Clark, *Farewell*, pp. 120ff. Van de Velde felt that Millet was compromised by theatricality, and that his idol, Pissarro, had given a truer and more sympathetic reading of the peasantry than he ('Du paysan', pp. 379ff). Clark agrees and argues the case in fascinating detail, showing Pissarro's sympathy for anarchist ideas, but I cannot see that Pissarro escapes the sentimentality which he himself knew was his besetting sin.

59 Gustavo Gutierrez, *The Power of the Poor in History*, London: SCM, 1983, p. 95.

4 CATCHING SHADOWS

1 Jonathan Richardson, *An Essay on the Theory of Painting*, Menston: Scolar Press, 1971 (1725), p. 226.

2 Cited in Dyrness, *Reformed Theology*, p. 108.

3 Aston, 'God's saints', p. 184.

4 Gary Schwartz, *Rembrandt: His Life, His Paintings*, Harmondsworth: Penguin, 1985, p. 57.

5 Cited in John House, *Landscapes of France: Impressionism and its Rivals*, London: Hayward Gallery, 1995, p. 40.

6 In David Sylvester, *The Brutality of Fact: Interviews with Francis Bacon*, London: Thames and Hudson, 1987, p. 63.

7 Hegel, *Lectures on Fine Art*, vol. 2, p. 866.

8 Emmanuel Levinas's reflections on 'the face' can be found in *Totality and Infinity*, The Hague: Nijhoff, 1979.

9 Ford, *Self and Salvation*, p. 24. David Hart rejects a constructive reading of Levinas in the most vehement terms. For him, with Levinas 'the God of glory is reduced to a provocative absence, creation to elemental flux, the liberty of

love to the bondage of singular obligation'. Levinas misses the love of being. David Bentley Hart, *The Beauty of the Infinite*, p. 92.

10 Ford, *Self and Salvation*, p. 25.

11 Shakespeare, Sonnet 53.

12 Edouard Pommier, *Théories du portrait de la Renaissance aux lumières*, Paris: Gallimard, 1998, pp. 20, 434.

13 Blaise Pascal, *Penseés*, Paris: Éditions du Seuil, 1963, para. 260, p. 253; my translation.

14 Kochan, *Beyond the Graven Image*, p. 128.

15 Rothko and Gottlieb, letter to the *New York Times*, 13 June 1943 cited in Nicholas Serota et al., *Mark Rothko: 1903–1970*, New York: Stewart, Tabori and Chang, 1987, p. 83. Jean-Luc Marion comments that Rothko had to forego portraiture 'in order not to make himself complicit with [the subject's] disfigurement, not to have to mutilate without respite the flesh and faces of people in order to make them enter by force into a flat visibility' (Marion, *In Excess*, p. 76).

16 Pommier, *Théories*, p. 434. Amerbach composed a distich which Holbein shows painted on a board attached to a tree. Amerbach wrote, 'Although a painted face, I do not differ from the living visage, but I have the same value as my Master, drawn with the help of exact lines. At the time when he had completed eight cycles of three years, the work of art represents in me, with all the exactitude that belongs to Nature'. Holbein then adds Amerbach's name and 'Holbein Dipingebat'. On Pommier's reading this qualifies the rather vainglorious view of his patron. Maritain, in Rowan Williams' exposition, says something similar; according to him art (and not just portraiture) has 'that kind of imperfection through which infinity wounds the finite'. This seems to me akin to the rabbinic principle (Williams, *Grace and Necessity*, p. 21).

17 Joanna Woodall suggests that fear of idolatry may have lain behind the absence of realistic portraiture in the Middle Ages (Woodall (ed.), *Portraiture: Facing the Subject*, Manchester: Manchester University Press, 1997, p. 17).

18 Van Mander, *Dutch and Flemish*, p. 352.

19 Van Mander, *Dutch and Flemish*, p. 352.

20 Cited in Joanna Woods-Marsden, *Renaissance Self-Portraiture*, New Haven and London: Yale University Press, 1998, p. 9. As Pommier notes, it is ironic that the most famous of all paintings (the Mona Lisa) is a portrait! (*Théories*, p. 79).

21 Cited in Shearer West, *Portraiture*, Oxford: Oxford University Press, 2004, p. 188.

22 Cited in Richard Brilliant, *Portraiture*, London: Reaktion, 1991, p. 32.

23 'There are multitudes of people, but there are many more faces, because each person has several of them. There are people who wear the same face for years: naturally it wears out, gets dirty, splits at the seams, stretches like a glove during a long journey. They are thrifty, uncomplicated people; they never change it, never even have it cleaned . . . Other people change faces incredibly fast, put on one after another, and wear them out . . . when they are barely forty years old they come to their last one . . . They are not accustomed to taking care of faces; their last one is worn through in a week, has holes in it, is in many places as thin as paper, and then, little by little, the lining shows through, the non-face, and they walk around with that on' (cited in Brilliant, *Portraiture*, p. 114).

24 John Berger, 'The changing view of man in the portrait', in *Selected Essays*, p. 35.

25 Berger, *Selected Essays*, p. 40.

26 Impossible because of its gendered language.

27 The first treatise on this theme was from Eucherius of Lyons at the beginning of the sixth century. Allusions to the transitoriness of earthly concerns continued right through the seventeenth century, in the Vanitas theme, and these were, indeed, picked up by twentieth-century artists like Picasso and Juan Gris.

28 Innocent III, 'De contemptu mundi', bk 1, chap. 1, in J. P. Migne, *Patrologia Latina*, 217, p. 702.

29 E. Cassirer, P. O. Kristeller and J. H. Randall (eds), *The Renaissance Philosophy of Man*, Chicago: University of Chicago Press, 1948, p. 392.

30 Woods-Marsden, *Renaissance*, p. 14. This is not to deny that the rise of the bourgeoisie may also be part of the story of the re-birth of the realistic portrait, as Burckhardt implied.

31 John Pope-Hennessy, *The Portrait in the Renaissance*, London: Phaidon, 1966, p. 114. Though Richard Viladesau points out that, influenced by Plotinian thought, Mirandola thought God was beyond both being and beauty (*The Triumph of the Cross: The Passion of Christ in Theology and the Arts–from the Renaissance to the Counter Reformation*, Oxford: Oxford University Press, 2008, p. 306).

32 In the North the canonical image of this vision of the human is probably Holbein's *Ambassadors*, in which the two young men, still in their twenties, are depicted as masters of all the Renaissance arts and of learning. The calendars and time keepers on display tell us that the painting was executed at 10.30 a.m. on 26 April 1533. It is also made clear that they lament recent divisions in the church. Where a century earlier patrons were depicted

adoring the Virgin or perhaps the cross, here the cross is pushed to the extreme left edge of the picture, visible only in profile. The anamorphic picture of the skull in the foreground is both a testament to painterly skill and at the same time a conventional *memento mori*. The dignity, intelligence and skill of the human is insisted on alongside a decent acknowledgement of mortality. In all their pomp these men know that death is their end.

33 Of course, as writers like Francisco de Holanda and Lomazzo made clear, only the elite qualified for these images (Woodall, 'Sovereign bodies: the reality of status in seventeenth-century Dutch portraiture', in *Portraiture*, pp. 75–100; here p. 77). This makes the work of Louis Le Nain, and the paintings of servants and dwarfs mentioned later, all the more astonishing.

34 Thomas More, *Utopia*, in *The Collected Works of Sir Thomas More*, ed. E. Surtz and J. Hexter, New Haven and London: Yale University Press, 1965, p. 193.

35 Aston, 'God's saints', p. 200.

36 Aston comments that 'For all Beza's disavowal there was a sense in which portraits of worthies and ancestors became for the reformed world what saints had been for the pre reformed' (Aston, 'God's saints', p. 194).

37 Aston, 'God's saints', p. 201. Jonathan Richardson, in the eighteenth century, felt that ''tis rational to believe that pictures of this kind are subservient to virtue; that men are excited to imitate the good actions, and persuaded to shun the vices of those whose examples are thus set before them' (Richardson, *An Essay*, pp. 13–14).

38 Leon Battista Alberti, *On Painting*, New Haven and London: Yale University Press, 1966, p. 92.

39 Pommier, *Théories*, p. 144.

40 Cited in Pommier, *Théories*, p. 422.

41 Erwin Panofsky, *Early Netherlandish Painting*, New York: Harper and Row, 1971, p. 195.

42 West, *Portraiture*, p. 150.

43 Hart, *Beauty of the Infinite*, p. 144.

44 Catholics also shared this view. Holbein doodled a caricature of someone adoring his own face in a mirror in the margin of Erasmus's *Encomium moriae* (Oscar Bätschmann and Pascal Griener, *Hans Holbein*, London: Reaktion, 1997, p. 151).

45 Lorne Campbell, *Renaissance Portraits: European Portrait-Painting in the Fourteenth, Fifteenth and Sixteenth Centuries*, New Haven and London: Yale University Press, 1990, p. 194.

46 Pommier, *Théories*, p. 273.

47 Aston, 'God's saints', p. 181.

48 H. Perry Chapman, *Rembrandt's Self-Portraits: A Study in Seventeenth Century Identity*, Princeton: Princeton University Press, 1999, p. 5. The Dürer self-portraits, with their allusions to Christ, and their implied comparison of the artist to an almost divine creativity, are hardly born of religious self-scrutiny. Brilliant as they are, they seem to be full of overweening conceit!

49 I have said 'Platonism' rather than Plato in view of the many different versions of the soul–body relation which had an impact on the church.

50 Xenophon, *Memorabilia*, 3.10.3.

51 Bätschmann and Griener, *Hans Holbein*, p. 31. Similarly Domenico Ghirlandaio's portrait of Giovanna Tornabuoni (in the Prado) includes a couplet from Martial which maintains that art could not possibly paint a soul so beautiful.

52 Aquinas, *Summa theologiae*, 1a.76.8. As I understand it this means that the question of individuality and identity cannot be the product of the seventeenth century as is often claimed. Of course, ideas of character and personality have developed and changed, but the idea that each person has a soul which shapes their individuality is ancient.

53 Ficino, *Platonic Theology*, 9.5.2, vol. 3, p. 59.

54 Aristotle, *Poetics*, 4.3; 4.8; 15.8. The word 'portrait' derives from the French '*trait pour trait*', meaning an accurate representation. I cannot follow Joanna Woodall's interesting contention that a gap between body and identity was opened up by the Reformation's putting a space between sign and prototype or that dualism became an increasingly contentious issue from the eighteenth century onwards. The evidence of the portraits themselves does not seem to support the contention that what was at stake was identification rather than representation of personal identity (Introduction to Woodall, *Portraiture*, pp. 10ff, p. 17.

55 Richardson, *An Essay*, pp. 21–2.

56 Campbell, *Renaissance Portraits*, p. 1.

57 David Ford remarks that 'Besides the "bright mystery" of the inexhaustibility of the face of the beloved and the infinity of hiddenness and revelation glimpsed through the amazement of adoration, there is the "dark mystery" of the lying face, deceptive communication. The possibility of this (and it is sometimes desirable) also says something important about the self in its capacities for differentiation, many levelled communication, ambiguity, ambivalence and contradiction . . . The notion that it is a presentation that corresponds to some internal state is inadequate – that oversimplifies the interplay of "inner" and "outer", "body" and "mind" . . . Once we have rejected a correspondence theory of face and self we can let it play its part in a more

adequate social, communicational and ethical understanding' (in Ford, *Self and Salvation*, p. 21).

58 Schwartz, *Rembrandt*, p. 97. He wrote, 'Between this portrait and de Gheyn there lies a gap/No larger than the one that sunders fact from fiction.'

59 Cited in Brilliant, *Portraiture*, p. 10. The remark was recalled by Bernini's son.

60 Ernst van Alphen, 'The portrait's dispersal: concepts of representation and subjectivity in contemporary portraiture', in Woodall, *Portraiture*, pp. 239–56; here p. 246. Van Alphen notes the allusion to the crucifixion and writes: 'Within Bacon's consistent reflection on the effects of representation the crucifixion betokens the inevitable consequence of representation, the tearing apart of the subject, the destructive effect of reproductive mimesis . . . As indexes of the immense suffering and the total mortification of the body, the nails suggest that any attempt to represent mimetically may be regarded literally as an attempt to *nail the subject down*' (my italics).

61 Sylvester, *Brutality of Fact*, pp. 174–5.

62 Brilliant, *Portraiture*, p. 11.

63 Brilliant comments, 'Portraiture is such a calculating art of (mis)representation that no beholder can be completely innocent' (*Portraiture*, p. 35).

64 Bernard Berenson, *Aesthetics and History in the Visual Arts*, London: Constable, 1950, pp. 199–200.

65 In 1534 Vasari painted a full-length portrait of Alessandro de' Medici and sent a letter to Ottaviano de' Medici explaining its meaning: 'The duke's armour is the prince's mirror, such that his people may be able, in the actions of their lives, to reflect themselves in him; he is fully armed to show that he is prepared to defend his country; he is seated to show that he has taken possession of his duchy, and holds the golden baton of power to rule as prince and to command as captain. The ruins behind refer to the siege of Florence in 1530 while he faces a view of the city in serene prosperity. The round seat, without beginning or end, shows that his reign is perpetual. It has three legs, three being the perfect number, and they are his people, who have no limbs: they need none, as they are guided by their ruler. The chair legs end in lions' paws referring to the lion of Florence. The mask, bridled by bands, stands for Volubility, and show that the unstable populace is kept under control from the fortress and by the love that the people bear to the duke . . . the flaming helmet, placed on the ground, is eternal peace, proceeding from the Prince's head by his good government and overwhelming his people with joy and love' (cited in Campbell, *Renaissance Portraits*, p. 130).

66 Cited in West, *Portraiture*, p. 182.

67 Brilliant, *Portraiture*, p. 49.

68 Merleau-Ponty is a good example. He describes Leonardo as 'Indifferent,

incapable of any strong indignation, love or hate, he left his paintings unfinished to devote his time to bizarre experiments' (*Sense and Non-Sense in Phenomenology and Existential Philosophy*, Evanston, Ill.: Northwestern University Press, 1964, p. 23.

69 Kenneth Clark, *Leonardo da Vinci*, Harmondsworth: Penguin, 1959, p. 29.
70 Sr Wendy Beckett, *The Story of Painting*, London: Dorling Kindersley, 1994, p. 118.
71 All Leonardo's greatest portraits are of women and in all of them he is able to suggest intelligence. None of his women subjects are simply 'trophies' for the men for whom they were painted: they answer back, though in very different ways. The sharp analytical power of Cecilia Gallerani, for example, where dynamism is suggested both by the turn of the head and by the writhing ferret, is very different from the calm, serious gaze of Ginevra de' Benci or the gentle irony of the Mona Lisa. What the portrait does here is to suggest a presence, to suggest the possibility of a dialogue. Leonardo has accomplished what he set out to do, namely to describe 'the motions of the mind'; he has 'visualised the sitter's interiority'. On the other hand, when Isabella D'Este wrote to Cecilia asking for her portrait, the latter demurred, saying it looked nothing like her. This may have been modest self-deprecation; it may have been an excuse not to send the portrait; but then again, perhaps Leonardo did not paint a likeness after all.
72 The picture may have been suggested by a political debate in Bertin's salon. Not everyone approved. Bertin's daughter thought that Ingres had turned her father from 'a great lord into a fat farmer'! (G. Tinterow and P. Conisbee, *Portraits by Ingres: Image of an Epoch*, New York: Metropolitan Museum of Art, 1999, p. 303). On the other side of the Channel an equally celebrated and forceful figure was Thomas Carlyle. His biographer, James Froude, described Millais' 1877 painting of Carlyle as 'a miracle'. 'The passionate vehement face of middle life had long disappeared. Something of the Annandale peasant had stolen back over the proud air of conscious intellectual power . . . the old Carlyle stood again upon the canvas as I had not seen him for thirty years. The inner secret of the features had been evidently caught. There was a likeness which no sculptor, no photographer, had yet equalled or approached. Afterwards, I knew not how, it seemed to fade away. Millais grew dissatisfied with his work and, I believe, never completed it' (cited in Paul Barlow, 'Facing the past and present: the National Portrait Gallery and the search for "authentic" portraiture', in Woodall, *Portraiture*, pp. 219–38). This story has led one commentator to describe portrait painting as a 'sacramental act', an act of grace, in which the painter gets behind the scorn and pride of old age to a tenderness and truth which had been there and which

constituted Carlyle's inner reality. This identity, as Millais discovers it, is found precisely in and through the body.

73 Berger, *Selected Essays*, p. 45.

74 Berger, *Selected Essays*, p. 36. Similarly, Brilliant comments that Francis Bacon's portraits of popes, friends and patrons look as if he was seeking to express himself through their contorted images (*Portraiture*, p. 156).

75 Cited in Brilliant, *Portraiture*, p. 82.

76 Alistair Smith in Norbert Lynton et al., *Looking into Paintings*, London: Faber and Faber, 1985, p. 170. Earlier, Klimt had painted highly illusionistic portraits, like the picture of the young girl in the Leopold Gallery, Vienna, dated 1889.

77 Richardson, *An Essay*, pp. 21–2.

78 Richardson, *An Essay*, p. 79.

79 Richard Wendorf, *The Elements of Life: Biography and Portrait Painting in Stuart and Georgian England*, Oxford: Clarendon, 1990, p. 240.

80 Berger, *Selected Essays*, p. 38.

81 Francis Bacon in Sylvester, *Brutality of Fact*, p. 81.

82 On some accounts Velázquez's successor, Goya, managed to do something very similar with his formal court portrait in 1800, with its nod to *Las Meninas*. Only the children are given any spark of intelligence. Otherwise Goya has managed to depict, in this formal guise, a fatuous and empty-headed group, as blank as the huge canvas behind them. The Queen, who stands at the centre of the portrait, approved, but it is hard today to view it as anything but satirical. Robert Hughes disagrees, reading the painting as 'an excited defense of kingship . . . its glamour, its ability to bedazzle the commoner and the subject' (*Goya*, London: Harvill, 2003, p. 229). Did the artist who painted *Los Caprichos* really think that?

83 Cited in Berger, *Ways of Seeing*, p. 16.

84 Berger, *Ways of Seeing*, pp. 13–16.

85 Cited in Pommier, *Théories*, p. 133.

86 The picture, *The Servant at the Window*, is now in Stockholm.

87 Schneider thinks that the book may be intended to satirise scholarly pretensions. He speaks of the 'pathos and humane understanding' of Velázquez's portraits of dwarves, and points out that at bull fights and shows he, as painter to the king, sat in the same fourth row as they did (Norbert Schneider, *The Art of The Portrait*, Cologne: Taschen, 2002, p. 167).

88 F. Antal, cited in Anne French, 'Servants as artists' models' in G. Waterfield and A. French with M. Craske, *Below Stairs: 400 Years of Servants' Portraits*, London: National Portrait Gallery, 2003 p. 109.

89 Waterfield, 'Servants in institutions' in Waterfield and French with Craske, *Below Stairs*, pp. 79–80.

90 Sylvester, *Brutality of Fact*, p. 28.
91 Sylvester, *Brutality of Fact*, p. 43.
92 Hugh Davies and Sally Yard, *Francis Bacon*, London: Abbeville, 1986, p. 39.
93 Michael Peppiat, *Francis Bacon: Anatomy of an Enigma*, London: Orion, 1996, p. 209.
94 Alan Ecclestone, *Yes to God*, London: Darton, Longman and Todd, 1975, pp. 53–4.
95 John Berger, *New Society*, 6 January 1972.
96 Williams, *Grace and Necessity*, p. 120; it might also be said of Bacon what Williams says of Flannery O'Connor, that 'A "humanism" that denied the facts of mental and physical suffering and above all of the capacity of the human mind for untruth would be ultimately murderous' (p. 118).
97 Kochan, *Beyond the Graven Image*, p. 96.
98 Simon Schama writes: 'For Rembrandt imperfections are the norm for humanity. Which is why he will always speak across the centuries to those for whom art might be something other than a quest for ideal forms; to the unnumbered legions of damaged humanity who recognize, instinctively and with gratitude, Rembrandt's vision of our fallen race, with all its flaws and infirmities squarely on view, as a proper subject for picturing and, more important, as worthy of love, of saving grace' (*Rembrandt's Eyes*, Harmondsworth: Penguin, 1999, p. 699).
99 John Brophy remarks that the faces of Rembrandt's sitters 'have no more distinctive form than a suet pudding turned out of the boiling cloth to sag and spread on a dish' (*The Face in Western Art*, London: Harrap, 1963, p. 47). For Tillich, on the other hand, Rembrandt's faces 'carry the marks of their unique histories in every line of their faces, expressing the ideals of personality of a humanistic Protestantism' (*On Art and Architecture*, p. 62).
100 Schama, *Rembrandt's Eyes*, p. 620. Alistair Smith speaks of Rembrandt's portraits as allusive, suggesting various expressions, and thus, of course, capturing some of the complexity of the human soul (Lynton et al., *Looking into Paintings*, p. 170).
101 John Drury, *Painting the Word: Christian Pictures and their Meanings*, New Haven and London: Yale University Press, 1999, p. 36
102 Merleau-Ponty, *Sense*, p. 18.

NATURE

1 Thomas Browne, *Religio Medici*, London: Dent, 1969, p. 18.
2 Browne, *Religio Medici*, p. 19. Browne defines nature as 'that straight and regular line, that settled and constant course the Wisdom of God hath

ordained the actions of His creatures, according to their several kinds . . . Now
this course of Nature God seldom alters or perverts, but, like an excellent
artist, hath so contrived His work, that, with the self same instrument, without
a new Creation, he may effect his obscurest designs . . . And thus I call the
effects of Nature the works of God, Whose hand and instrument she only is;
and therefore to ascribe his actions unto her, is to devolve the honour of the
principal agent upon the instrument' (p. 18).

3 Aristotle, *Metaphysics*, 1032.11.

4 Aristotle, *Physics*, 199a15: 'generally art in some cases completes what nature
cannot bring to a finish, and in others imitates nature'.

5 Martin Kemp (ed.), *Leonardo on Painting*, New Haven and London: Yale Uni-
versity Press, 1989, p. 13.

6 Louis Dupré, *Passage to Modernity: An Essay in the Hermeneutics of Nature
and Culture*, New Haven and London: Yale University Press, 1993, p. 44.

7 Philo had already spoken of 'Nature' as behaving like Wisdom and teaching
human beings and this view was reiterated in Christian teaching (G. Harder
in C. Brown (ed.), *Dictionary of New Testament Theology*, Exeter: Paternos-
ter, vol. 2, 1980, p. 658). Augustine spoke of the 'great book, the very appear-
ance of created things'. 'Look above you; look below you! Note it; read it!
God, whom you wish to find, never wrote that book with ink. Instead, He
set before your eyes the things he had made' (Sermon 68.6). Hugh of St Victor
spoke of the book of nature, which ran parallel to the book of grace in Scrip-
ture in which 'each particular creature is somewhat like a figure, not invented
by human decision but instituted by the divine will to manifest the invisible
things of God's wisdom' (*Didascalia*, 7.4).

8 The Pelagian controversy generated a negative view of nature which was
opposed to grace, a doctrine resolutely opposed by Aquinas. It is often argued
that the rise of nominalism in the fourteenth century meant that a wedge was
driven between God and creation, emptying the latter of meaning. The medieval
image of Nature as a Wisdom-like figure mediating between God and the
created world gave place to a picture of nature devoid of intelligence and of
life. A respectful attitude was replaced by one which amounted to justifying the
rape of Nature (Carolyn Merchant, *The Death of Nature: Women, Ecology and
the Scientific Revolution*, San Francisco: Harper, 1983, p. 41). This thesis is
challenged by Katherine Park, 'Nature in person: medieval and Renaissance alle-
gories and emblems' in Lorraine Daston and Fernando Vidal (eds), *The Moral
Authority of Nature*, Chicago: University of Chicago Press, 2004, pp. 50–73;
here p. 73. Park argues that the medieval construal of nature was androgynous,
that the emphasis was not on the maternal or the feminine but on the artisanal,
and that the elements of violence in Bacon's argument are overstated. The new

Renaissance figuration of nature did authorise a more exploitative attitude towards the natural world but the dominant metaphor was consumption (of nature's milk or bounty) rather than inquisition, dissection or rape.

9 Jones, 'Federico Borromeo', p. 265.

10 Cited in Basil Willey, *The Eighteenth Century Background*, Harmondsworth: Penguin, 1962, p. 67.

11 G. Tanzella-Nitti, 'The two books prior to the scientific revolution', *Annales theologici*, no. 18, 2004, pp. 51–83. Raymond Sebond was the culprit, whose book, translated by Montaigne, was put on the Index in 1559 where it remained until 1896.

12 Hughes, *Shock of the New*, p. 125.

13 Berger, 'The moment of cubism', in *White Bird*, p. 160.

14 'Dialogue on the New Plastic', in Charles Harrison and Paul Wood (eds), *Art in Theory 1900–1990: An Anthology of Changing Ideas*, Oxford: Blackwell, 1992, pp. 282–7.

15 W. J. T. Mitchell (ed.), *Landscape and Power*, Chicago: Chicago University Press, 1994, p. 20.

16 M. Andrews, *Landscape and Western Art*, Oxford: Oxford University Press, 1999, p. 213.

5 THE WORLD MADE STRANGE

1 R. B. Beckett (ed.), *John Constable's Discourses*, Ipswich: Suffolk Records Society, 1970, pp. 72–3. Kenneth Clark famously suggested that, with the exception of love, there is perhaps nothing else by which people of all kinds are more united than by their pleasure in a good view (*Landscape*, p. 147). Malcolm Andrews cites the eighteenth-century German critic Karl Ludwig Fernow who believed that 'Viewing . . . nature's scenery assuages from the soul all passions, frees it from all tensions, brings together its scattered powers, invites it to calm contemplation, and strengthens, enlivens and refreshes it' (*Landscape and Western Art*, p. 53). He also points out that some anthropologists have suggested that this pleasure in a view mirrors thousands of years of hunter-gatherer experience where prospects and refuges satisfy ancient survival needs (p. 19). There are numerous expressions of delight in the landscape from early modern people, including Alberti, Pope Pius II and Bishop Paolo Giovio writing in 1527 (Clark, *Landscape*, p. 44; Christopher S. Wood, *Albrecht Altdorfer and the Origins of Landscape*, London: Reaktion, 1993, p. 55).

2 David Solkin, *Richard Wilson*, London: Tate Gallery, 1983, p. 86. See the examples in Keith Thomas, *Man and the Natural World*, Harmondsworth:

Penguin, 1984, p. 258, which include Dr Johnson's complaint about the 'hopeless sterility' of the Highlands of Scotland.

3 Pliny writes, 'It is a great pleasure to look down on the countryside from the mountain, for the view seems to be a painted scene of unusual beauty, rather than a real landscape' (Pliny the Younger, ep. 5.6, in *Letters and Panegyrics*, trans. Betty Radice, Cambridge, Mass.: Harvard University Press, vol. 1, 1969, pp. 339–41).

4 Pächt, 'Early Italian nature studies', p. 32. Pächt argues that landscape emerges first in thirteenth-century *Tacuinum sanitatis* (Tables of Health) illustrating the seasons, and then in calendar landscapes, and is found in Italy earlier than in the North.

5 Pächt, 'Early Italian nature studies', p. 46. He also writes, 'Landscape could not have been conceived and represented as an object of disinterested aesthetic pleasure had not Italian craftsmen, aiming at scientific illustration, first become interested in it as part of the physical world' (p. 46).

6 Wood argues that the rise of landscape in the West was a symptom of modern loss, of the fact that our primal relationship with nature was lost, disrupted by urbanism, commerce and technology (Wood, *Altdorfer*, p. 25). He was already preceded by Hugh Blair in the eighteenth century (Thomas, *Natural World*, p. 250). But was that true for Pliny? And when exactly was 'the primal relationship with nature' lost? Surely not in the sixteenth century.

7 Pliny's view cited in Note 3 already anticipates Gilpin by nearly two thousand years.

8 Both the Ruisdael and the Constable exhibitions in London in 2006 drew large crowds.

9 Jonathan Jones in the *Guardian*, 28 February 2009.

10 Clark, *Landscape*, p. 59.

11 Piles' book categorised artists on an eighteen-point scale, placing Raphael and Rubens at the summit of art. Bellini and Caravaggio did miserably badly, and Rembrandt did not appear.

12 Sr Wendy Beckett, *Story of Painting*, p. 30.

13 John Ruskin, *Modern Painters*, London: Allen, vol. 1, 1906, p. xxvi.

14 Ruskin, *Modern Painters*, vol. 1, p. xlix.

15 Cited in Andrew Wilton (ed.), *Constable's 'English Landscape Scenery'*, London: British Museum, 1979, p. 102.

16 Bouret, *Barbizon School*, p. 16. This is close to Karl Ludwig Fernow's celebrated contention that the goal of landscape painting is 'to bring about an aesthetic mood or state of harmony through the representation of ideal natural scenes'. Fuseli probably knew these lectures 'On Landscape Painting' (Harrison, Wood and Gaiger, *Art in Theory 1648–1815*, p. 1068).

17 Hegel, *Lectures on Fine Art*, vol. 2, p. 831.
18 Hegel, *Lectures on Fine Art*, vol. 2, p. 832.
19 The point made by Gombrich, *Art and Illusion*.
20 Turner wrote of Claude: 'A beauty is not a beauty until defin'd or science until revealed, we must consider how he could have attained such powers but by continual study of parts of nature. Parts, for, had he not so studied, we should have found him sooner pleased with simple subjects of nature, and would not have as we now have, pictures made up of bits, but pictures of bits. Thus may be traced his mode of composition, namely, all he could bring in that appear'd beautifully dispos'd to suit either the side scene or the large trees in the centre kind of composition' (Sam Smiles, 'Turner in the West Country: from topography to idealisation' in J. C. Eade (ed.), *Projecting the Landscape*, Canberra: Australian National University, Humanities Research Centre, monograph 4, 1987, p. 42).
21 Seymour Slive, *Jacob van Ruisdael: Master of Landscape*, London: Royal Academy, 2005, p. 39.
22 Clark, *Landscape*, p. 64. Also, on the influence of Ruisdael on Constable, p. 147.
23 For example, in his picture of Bentheim Castle.
24 Slive, *Jacob van Ruisdael*, p. 124.
25 Cited in E. John Walford, *Jacob van Ruisdael and the Perception of Landscape*, New Haven and London: Yale University Press, 1991, p. 20.
26 Slive comments, 'In view of this visual and literary tradition, it is not hard to imagine that some of Ruisdael's contemporaries found a symbolic meaning in [the picture]. The extent to which the artist wanted his masterwork to convey this level of meaning has not yet been measured' (*Jacob van Ruisdael*, p. 124). Patricia Emison distinguishes between the full-blown *paysage moralisé* proposed by Panofsky and what she calls its 'less restrictive cousin', the idea of concealed symbolism. The distinction may be difficult to sustain, but she is surely right that the present matter-of-fact and anti-allegorical vogue of interpretation owes much to the present *zeitgeist* and leaves much to explain (Patricia Emison, 'The paysage moralisé', *Artibus et historiae*, vol. 16, no. 31, 1995, pp. 125–37).
27 Clark, *Landscape*, p. 53.
28 Walford, *Jacob van Ruisdael*, p. 20.
29 Walford, *Jacob van Ruisdael*, p. 20.
30 Walford, *Jacob van Ruisdael*, p. 26.
31 Walford, *Jacob van Ruisdael*, p. 23.
32 Walford, *Jacob van Ruisdael*, p. 21.
33 Walford, *Jacob van Ruisdael*, p. 21.

34 R. B. Beckett, *Constable's Discourses*, p. 64.
35 Walford, *Jacob van Ruisdael*, p. 21.
36 Barth, *CD*, vol. 3, pt 1, p. 362.
37 Tillich, *On Art and Architecture*, p. 20.
38 Williams, *Grace and Necessity*, p. 53.
39 Cited in Solkin, *Richard Wilson*, p. 70.
40 Cited in Harrison, Wood and Gaiger, *Art in Theory 1648–1815*, p. 840. Significantly Goethe, in a review in 1772, poured scorn on these ideas, already invoking a nature red in tooth and claw, which hardens rather than educates in this sentimental way.
41 Brueghel's harvest scene, in the Kunsthistorisches Museum in Vienna, likewise shows the scene threatened by storm clouds, but it is unlikely Constable knew of this.
42 Cited in Gombrich, *Art and Illusion*, p. 325.
43 John Barrell, *The Dark Side of the Landscape: The Rural Poor in English Painting*, Cambridge: Cambridge University Press, 1980, p. 158.
44 Barrell, *Dark Side*, p. 163.
45 Barrell, *Dark Side*, p. 141.
46 Barrell, *Dark Side*, p. 162.
47 Ann Bermingham, *Landscape and Ideology: The English Rustic Tradition 1740–1860*, London: Thames and Hudson, 1987, p. 139.
48 Bermingham, *Landscape and Ideology*, p. 142. Ronald Paulson argues that the arcadian fantasy did not function solely for the rich. To be sure it was they who purchased the pictures but Arcadia could equally be a fantasy of the ruled, who look back or forward to a situation in which they will no longer have to work (Paulson, *Literary Landscape*, p. 52).
49 Michael Rosenthal, *Constable the Painter and his Landscape*, New Haven and London: Yale University Press, 1983, p. 26.
50 R. B. Beckett, *Constable's Discourses*, p. 71.
51 R. B. Beckett, *Constable's Discourses*, p. 71.
52 R. B. Beckett, *Constable's Discourses*, p. 5.
53 By Kenneth Clark, for example. John Barrell comments that this pairing is usually too ambitious and ignores the different possibilities of language and paint, and differences in their social attitudes (*Dark Side*, p. 141).
54 Letter to Fisher on 23 October 1821.
55 Rosenthal, *Constable*, p. 137.
56 Paulson, *Literary Landscape*, p. 119.
57 Rosenthal, *Constable*, p. 26.
58 Theocritus had already extolled the virtues of the simple life in the third century BC, and both Virgil and Horace continued the tradition in literature

which taught the European Middle Ages and Renaissance. The vogue for arcadian literature led Dürer to be asked to illustrate an edition of Theocritus in 1487. That pastoral is an ancient genre seems to me to make it unlikely that the re-birth of landscape is to be understood as an attempt to overcome the alienation brought about by growing cities and by industrialisation.

59 Shakespeare, *As You Like It*, act 2, sc. 1. Andrews, *Landscape*, p. 66.

60 R. B. Beckett, *Constable's Discourses*, p. 61. Constable uses the term 'chiaroscuro of nature' to describe 'the dews, breezes, bloom and freshness, not one of which has yet been perfected on the canvas of any painter in the world', and the use of light and shade in pictures (Clark, *Landscape*, p. 148).

61 All Rubens' landscapes have this edenic quality, even his winter scene (*Winter*, 1681, in the Royal Collection, Holyrood). They raise the question of the origins of romanticism, which they certainly anticipate. As in all romanticism the realities of poverty and hard labour are glossed over. People may feel the cold, as in Rubens' winter scene, but they do not suffer. It is the world seen through the classical arcadian literature.

62 'Emanating from an area of the sky just above the horizon, so that the spectator is looking directly or almost directly into it, the light in his paintings spreads forwards and outwards through the composition, filling the whole landscape with its radiance, and linking foreground and background in a continuous spatial unity' (Michael Kitson, 'The relationship between Claude and Poussin in landscape', *Zeitschrift für Kunstgeschichte*, 24 BD, H.2, 1961, p. 157).

63 Helen Langdon, *Claude Lorrain*, Oxford: Phaidon, 1989, p. 64.

64 Rosenthal, *Constable*, p. 35.

65 Smiles, 'Turner in the West Country', p. 42.

66 Plutarch, *Life of Phocion, in The Age of Alexander*, trans. I Scott-Kilvert, Harmondsworth: Penguin, 1973. p. 221.

67 Antony Blunt, *Nicolas Poussin*, 2 vols, Oxford: Phaidon, vol 1, 1967, p. 295.

68 Blunt, *Poussin*, vol. 1, p. 295.

69 Comparing the *Gathering of the Ashes of Phocion* with Claude's *Marriage of Isaac and Rebecca*, painted in the same year, Michael Kitson remarks, 'In the painting by Poussin the foliage is hard and its forms compact, so that the light, coming from the left and from slightly above, strikes the foliage only to be immediately reflected from its surface. It is light treated largely in terms of highlights, modelling the forms, not penetrating them. With Claude the opposite is the case. The light, coming from behind and from slightly below, infiltrates among the foliage, modulating the forms . . . A slight haze covers the surface, diffusing the light; at the same time we are able to see a certain way into the foliage, beneath the surface . . . Poussin keeps light and

form severely distinct from one another, and gives almost no sensation of atmosphere. Claude, on the other hand, creates a very palpable "atmosphere"; and this, irradiated by light, tends to merge with the forms' (Kitson, 'The relationship between Claude and Poussin in landscape', p. 143). Different ideologies, or theologies, are implicit in these two approaches to light.

70 R. B. Beckett, *Constable's Discourses*, p. 5.

71 Cited in Clark, *Landscape*, p. 131.

72 Blunt writes, 'A composition is to be studied figure by figure, and each one will express its role in the story exactly, as does an actor on the stage, without the use of words but with an equally effective means of expression, the alphabet of gesture' (Blunt, *Poussin*, vol. 1, p. 223).

73 'The imitation of nature must be taken in a generalized sense, and not to mean an imitation of everything to be seen in the outside world' (Blunt, *Poussin*, vol. 1, p. 220).

74 Walter Friedländer, *Nicolas Poussin: A New Approach*, New York: Abrams, 1964, p. 38.

75 Barrell, *Dark Side*, p. 55.

76 Andrews, *Landscape*, p. 92.

77 Andrews, *Landscape*, p. 151.

78 Solkin, *Richard Wilson*, p. 26.

79 Clark, *Landscape*, p. 160.

80 House, *Landscapes*, p. 52.

81 Mitchell, *Landscape and Power*, p. 7.

82 Mitchell, *Landscape and Power*, p. 20.

83 Ernst Bloch, *The Principle of Hope*, Oxford: Blackwell, vol. 1, 1986, pp. 389, 391.

84 Wood, *Altdorfer*, p. 180.

85 *Ad Sepulum diddaemonem* cited in Wood, *Altdorfer*, p. 177.

86 Andrews, *Landscape*, p. 143.

87 J. L. Koerner, *Caspar David Friedrich and the Subject of Landscape*, London: Reaktion, 1990, p. 26.

88 Koerner, *Caspar David Friedrich*, p. 49.

89 Werner Hofmann, *Caspar David Friedrich*, London: Thames and Hudson, 2000, p. 102.

90 Koerner, *Caspar David Friedrich*, p. 100.

91 Koerner rightly notes this affinity: 'Focusing on the figure of Christ, yet mediating his reality not as objective history or theological doctrine but as a feeling elicited in the viewer by an emotionally charged landscape, Friedrich's canvas fits well into the "theology of the heart" of the Moravian brotherhood' (Koerner, *Caspar David Friedrich*, p. 50).

92 Cited in Hofmann, *Caspar David Friedrich*, p. 26.

93 Hofmann, *Caspar David Friedrich*, p. 51.

94 Robert Cumming in Lynton et al., *Looking into Paintings*, p. 212.

95 Cited in John House, *Monet: Nature into Art*, New Haven and London: Yale University Press, 1986, p. 218.

96 Cited in Virginia Spate, *The Colour of Time: Claude Monet*, London: Thames and Hudson, 1992, p. 169.

97 Spate, *Colour*, p. 201.

98 Spate, *Colour*, p. 216.

99 Clark, *Landscape*, pp. 229–30.

100 Clark, *Landscape*, pp. 178–9.

101 Spate, *Colour*, p. 201.

102 Berger, *Selected Essays*, p. 75.

103 F. Cachin et al., *Cézanne*, Philadelphia: Philadelphia Museum of Art, 1996, p. 21.

104 Max Raphael, *The Demands of Art*, London: Routledge, 1968, p. 41.

105 Raphael, *Demands*, p. 11.

106 Cachin et al., *Cézanne*, p. 17.

107 Cachin et al., *Cézanne*, p. 37.

108 'Cézanne's doubt', in Merleau-Ponty, *Sense*, p. 17.

109 John Rewald, *Cézanne: A Biography*, New York: Abrams, 1986, p. 100.

110 Lionel Venturi wrote that 'the new trend of Cézanne was towards abstraction, but his order was essentially different from everything that had been done before, because he did not impose his order in his sensations. In other words he did not close his colours and lights within a preconceived term, but extracted a new form from his masses of colours, thus letting order and sensation coincide' (Cachin et al., *Cézanne*, p. 263).

111 Cited in Raphael, *Demands*, p. 18.

112 Cited in Cachin et al., *Cézanne*, p. 416.

113 Cited in Raphael, *Demands*, p. 42.

114 Merleau-Ponty, *Sense*, p. 16.

115 Merleau-Ponty, *Sense*, p. 18.

116 The Ramblers Society, for example, had a strong working-class appeal in the 1930s.

117 Robert Cumming comments, 'Landscape painting of the highest quality should increase our understanding of art and send us back to nature with fresh eyes and increased awareness' (in Lynton et al., *Looking into Paintings*, p. 219).

118 Williams, *Grace and Necessity*, p. 37.

119 Martin Warnke, *Political Landscape: The Art History of Landscape*, London: Reaktion, 1994, p. 146.

120 See for example the DVD *Rivers and Tides: Andy Goldsworthy Working with Time*, Artificial Eye, 2006.

6 CELEBRATING CREATION

1 Socrates, *Phaedo*, 65c.
2 Peter Brown, *The Body and Society*, London: Faber and Faber, 1989, p. 394.
3 Augustine, *Confessions*, 10.6. I use the translation of Henry Chadwick, Oxford: World's Classics, 1992.
4 Charles Sterling, *Still Life Painting*, New York: Universe, 1959, p. 16.
5 Sterling, *Still Life Painting*, p. 11.
6 Especially in Herbals, where accurate depiction of plants was essential (Pächt, 'Early Italian nature studies', pp. 27ff).
7 Pächt, 'Early Italian nature studies', pp. 31, 32.
8 On the back of the Ghent altarpiece there is a basin and ewer in a niche with a towel, a sign of the Virgin's purity and piety. Joos van Cleve painted a Holy Family with a still small life in the foreground. On the balustrade are set out in a row a covered beaker of wine, a medlar, a knife, half a walnut and a pewter plate which holds grapes, cherries, an apple, a pear and a pomegranate. The apple stands for original sin; the walnut the *lignum crucis* and the divine nature of Christ; the 'mystic grape' for Christ's human nature; the beaker of wine for the blood poured out by him; and a few cherries, the fruit of heaven (Bergström, *Dutch Still Life*, pp. 4, 10).
9 Sterling, *Still Life Painting*, p. 30.
10 Sullivan, 'Aertsen's kitchen and market scenes', p. 240.
11 Bryson, *Looking at the Overlooked*, p. 154.
12 Jones, 'Federico Borromeo', pp. 269–70.
13 In the National Gallery of Scotland.
14 Margit Rowell, *Objects of Desire: The Modern Still Life*, New York: Museum of Modern Art, 1997, p. 16.
15 Rowell, *Objects of Desire*, p. 11.
16 Williams, *Grace and Necessity*, p. 82.
17 Sterling, *Still Life Painting*, p. 71.
18 Jordan and Cherry, *Spanish Still Life*, p. 27.
19 Filippo de Pisis, cited in Rowell, *Objects of Desire*, p. 87.
20 Sterling, *Still Life Painting*, p. 71.
21 Bryson, *Looking at the Overlooked*, p. 66.
22 Bryson, *Looking at the Overlooked*, p. 88.
23 Bryson, *Looking at the Overlooked*, p. 70.
24 Jordan and Cherry, *Spanish Still Life*, p. 20.

25 Jordan and Cherry, *Spanish Still Life*, p. 103. The latter remark quotes Roberto Longhi.

26 Sterling, *Still Life Painting*, p. 72.

27 So Bryson, *Looking at the Overlooked*, p. 71.

28 Bryson, *Looking at the Overlooked*, p. 64.

29 Bryson, *Looking at the Overlooked*, p. 87.

30 Bryson, *Looking at the Overlooked*, p. 138.

31 N. MacGregor, in Jordan and Cherry, *Spanish Still Life*, p. 9.

32 Bergström, *Dutch Still Life*, p. 1.

33 Cited in Bryson, *Looking at the Overlooked*, p. 175.

34 Bryson, *Looking at the Overlooked*, p. 63.

35 Bryson, *Looking at the Overlooked*, p. 178.

36 Sterling, *Still Life Painting*, p. 72.

37 Jordan and Cherry, *Spanish Still Life*, p. 9.

38 Picasso's *Still Life with Guitar and Glass*, for example, which has been compared with Chardin, is sombre, even violent, with harsh dark colours. The space we are occupying is abstract, the space of 'modernity', in which neither music nor wine count for anything. In *Le Jour* (1929), Picasso's cubist running mate George Braque's suggests a kitchen, but the pipe, guitar and newspaper all suggest a bachelor space, and the knife is positively threatening. Gerald Murphy's *Razor* (1924) is almost entirely masculine and puts the world of the everyday into the context of designed or advertising space. Margit Rowell comments that the metaphysical painting of de Chirico and Carlo Carra is also based on 'the direct vision of mystery, contained in the most common and insignificant objects' (*Objects of Desire*, p. 87).

39 Bryson, *Looking at the Overlooked*, p. 91.

40 Bryson, *Looking at the Overlooked*, p. 91.

41 Cited in Herbert Furst, *Chardin*, London: Methuen, 1911, p. 52.

42 Etienne Jollet, *Chardin: la vie silencieuse*, Paris: Herscher, 1995, p. 20.

43 Cited on the notes accompanying the painting at the Louvre.

44 Sterling, *Still Life Painting*, p. 88.

45 Bryson, *Looking at the Overlooked*, p. 161.

46 Bryson, *Looking at the Overlooked*, p. 167.

47 Bryson, *Looking at the Overlooked*, p. 168.

48 Rowell, *Objects of Desire*, p. 47.

49 Bryson, *Looking at the Overlooked*, p. 120.

50 *Still Life with Skull, Leeks and Pitcher*, Fine Arts Museums of San Francisco.

51 Andy Warhol, *Skull* (1976) and Gerhard Richter, *Skull with Candle* (1983) both illustrated in Rowell, *Objects of Desire*, pp. 198–9.

52 Bryson, *Looking at the Overlooked*, p. 128.

53 Cited by Williams, *Grace and Necessity*, p. 120. His extraordinary reflections on Flannery O'Connor have helped me to see that still lifes like these may, in fact, be expressions of grace though in Luther's terms they represent an *opus alienum* rather than an *opus proprium*.

54 Jordan and Cherry, *Spanish Still Life*, p. 184.

55 Sterling, *Still Life Painting*, p. 113.

56 Rowell, *Objects of Desire*, p. 19.

57 Sterling, *Still Life Painting*, p. 134.

58 Using the language of 2 Corinthians Bryson writes, 'In the routine spaces still life normally explores, habit makes one see through a glass darkly; but when the object is revealed face to face, the departure from the habitual blurs and entropies of vision can be so drastic that the objects seem unreal, unfamiliar, un-creatural' (*Looking at the Overlooked*, p. 87). Similarly Sterling writes of the way some still life aspires 'to reveal a poetry of unreality in objects that have become all too familiar to the eye and mind. Something of the freshness and appetite of childhood comes back to us across the years' (*Still Life Painting*, p. 90).

59 Bergström, *Dutch Still Life*, p. 285.

60 Sterling, *Still Life Painting*, p. 51.

61 Hegel, *Lectures on Fine Art*, vol. 1, p. 163.

62 Cited in Cachin et al., *Cézanne*, p. 57.

63 Kandinsky, *Spiritual in Art*, p. 17.

64 Sterling, *Still Life Painting*, p. 102.

65 Cited in Rewald, *Cézanne*, p. 226.

66 Merleau-Ponty, *Sense*, p. 15.

67 Rowell, *Objects of Desire*, p. 25.

68 K. Ruhrberg and M. Schneckenburger, *Art of the Twentieth Century*, Cologne: Taschen, 2000, p. 20. Collingwood writes of Cézanne's still lifes that they are like 'groups of things that have been groped over with the hands; he uses colour not to reproduce what he sees in looking at them but to express almost in a kind of algebraic notation what in this groping he has felt' (R. G. Collingwood, *The Principles of Art*, Oxford: Oxford University Press, 1958, p. 144).

69 Weil, *Waiting on God*, pp. 56, 106.

7 BEYOND THE APPEARANCES

1 Cited in Hans Jaffé, 'Geometrical abstraction: its origin, principles and evolution' in Werner Haftmann (ed.), *Abstract Art Since 1945*, London: Thames and Hudson, 1971, p. 163.

2 Albert Gleizes and Jean Metzinger, 'Cubism' in Robert L. Herbert (ed.) *Modern Artists on Art*, New York: Dover, 2000, p. 2.

3 Wilhelm Worringer, *Abstraction and Empathy*, Chicago: Elephant, 1997, p. 3.
4 Worringer, *Abstraction and Empathy*, p. 20.
5 Worringer, *Abstraction and Empathy*, p. 133.
6 Berger situates this moment in terms both of politics and of technology: 'An interlocking world system of imperialism; opposed to it, a socialist international; the founding of modern physics, physiology and sociology; the increasing use of electricity, the invention of radio and the cinema; the beginnings of mass production; the publishing of mass-circulation newspapers; the new structural possibilities offered by the availability of steel and aluminium; the rapid development of chemical industries and the production of synthetic materials; the appearance of the motor car and the aeroplane' (Berger, 'The moment of cubism', in *White Bird*, p. 162).
7 Berger describes the cubists as 'the last optimists in Western art. They sensed at the turn of this century the promise of the new means of production with all its world implications. They expressed their consequent enthusiasm for the future in terms which are justified by modern science. And they did this in the one decade in recent history when it was possible to possess such enthusiasm and yet ignore, without deliberate evasion, the political complexities and terrors involved' (Berger, *The Success and Failure of Picasso*, Harmondsworth: Penguin, 1965, p. 71).
8 K. Malevich, 'From cubism and futurism to suprematism: the new realism in painting', in Harrison and Wood, *Art in Theory 1900–1990*, p. 170.
9 Kandinsky, 'Reminiscences', in Herbert, *Modern Artists*, p. 31.
10 Hans Jaffé, *Piet Mondrian*, London: Thames and Hudson, 1970, p. 69.
11 Kandinsky, 'Reminiscences', in Herbert, *Modern Artists*, p. 38.
12 Kandinsky, *Spiritual in Art*, p. 57.
13 Kandinsky, 'Reminiscences', in Herbert, *Modern Artists*, p. 27.
14 Kandinsky, 'Reminiscences', in Herbert, *Modern Artists*, p. 36.
15 Nevertheless three years later, in the Cologne lecture he said (in Harrison and Wood, *Art in Theory 1900–1990*, p. 98):

> I do not want to paint music
> I do not want to paint states of mind
> I do not want to paint colouristically or uncolouristically
> I do not want to alter, contest, or overthrow any single point in the harmony of the masterpieces of the past
> I do not want to show the future its true path.

16 Kandinsky, *Spiritual in Art*, p. 19.
17 Kandinsky, *Spiritual in Art*, p. 25.
18 Kandinsky, *Spiritual in Art*, p. 38.

19 Shulamith Behr, 'Kandinsky, Münter and creative partnership' in Hartwig Fischer and Sean Rainbird (eds), *Kandinsky: The Path to Abstraction*, London: Tate Publishing, 2006, p. 98.

20 Reinhard Zimmerman speaks of Kandinsky's abstract style as 'an aesthetic realisation and representation of the "world of fine matter"'. 'It is as though he were dealing with a "second level" of reality that is not visible to the normal eye but that can be perceived by those with a heightened sensibility. It is by nature ethereal and manifests itself above all in auras and thought forms – coloured filigree forms with the consistency of cloud or mist, sometimes clearly outlined, sometimes with no distinct delineation and flowing into the surroundings, superimposed or even mingling' ('Early imprints and influences', in Fischer and Rainbird, *Kandinsky*, p. 40).

21 Kandinsky, 'Reminiscences', in Herbert, *Modern Artists*, p. 34.

22 John Golding, *Paths to the Absolute*, London: Thames and Hudson, 2000, p. 106.

23 Donald Kuspit, 'Abstract expressionism: the social contract' in Shapiro, David, and Cecile Shapiro (eds), *Abstract Expressionism: A Critical Record*, Cambridge: Cambridge University Press, 1990, pp. 182–94; here p. 190.

24 Mark Rothko, *The Artist's Reality: Philosophies of Art*, New Haven and London: Yale University Press, 2004, p. 32.

25 Rothko, *Artist's Reality*, p. 28.

26 Jaffé, *Mondrian*, p. 54.

27 C. Harrison, Francis Frascina and Gill Perry, *Primitivism, Cubism, Abstraction: The Early Twentieth Century*, New Haven and London, Yale University Press, 1993, p. 252.

28 Quoted in Michel Seuphor, *Abstract Painting: Fifty Years of Accomplishment, from Kandinsky to the Present*, London: Prentice Hall, 1962, p. 107

29 Dupré, *Passage to Modernity*, p. 34.

30 Mondrian, 'Dialogue on the New Plastic', in Harrison and Wood, *Art in Theory 1900–1990*, p. 282.

31 Jaffé, *Mondrian*, p. 42.

32 Jaffé, *Mondrian*, p. 54.

33 Mondrian, 'Neo-Plasticism: the general principle of plastic equivalence', in Harrison and Wood, *Art in Theory 1900–1990*, pp. 287–90.

34 *De Stijl*, 1, 105.

35 Jaffé, *Mondrian*, p. 55.

36 Plato, *Philebus*, 51.c.

37 Kandinsky, *Spiritual in Art*, p. 29.

38 Kandinsky, *Spiritual in Art*, p. 32.

39 Herbert Read, *The Meaning of Art*, Harmondsworth: Penguin, 1949, p. 33.

40 In Robert Kudielka, *Paul Klee: The Nature of Creation Works 1914–1940*, London: Hayward Gallery, 2002, p. 15.

41 Cited in Shulamith Behr, in Fischer and Rainbird, *Kandinsky*, p. 91.

42 Kochan, *Beyond the Graven Image*, p. 132.

43 Jaffé, *Mondrian*, pp. 41–2.

44 In Harrison and Wood, *Art in Theory 1900–1990*, p. 76.

45 Michael McNay, *Patrick Heron*, London: Tate Publishing, 2002, p. 52.

46 For Worringer, already aware of Matisse's experiments, it is in ornament that the artistic volition of a people finds its purest and most unobscured expression (Worringer, *Abstraction and Empathy*, p. 51).

47 Karen Stone, *Image and Spirit*, p. 40. David Sylvester comments that Matisse wanted the audience to be concerned not with the agonised face of the artist but with the radiant face of the work. 'For art was good, and was good because of its beauty, not because of whatever heroism went into making it' (David Sylvester, *About Modern Art: Critical Essays 1948–1996*, London: Chatto & Windus, 1996, p. 148).

48 Christopher Alexander, *The Phenomenon of Life*, Berkeley: Centre for Environmental Structure, 2001, p. 312.

49 Alexander develops a complex account of the structure of life which involves the interrelationship of 'centres'. He begins from empirical tests, asking people which of two images makes them feel more alive, more whole etc. and believes that it is possible to arrive at an objective aesthetic which goes beyond the bounds of 'taste'.

50 Harold Rosenberg, 'The mythic act', in Shapiro and Shapiro, *Abstract Expressionism*, pp. 375–81; here p 378.

51 Sylvester, *About Modern Art*, p. 62.

52 Werner Haftmann, *Painting in the Twentieth Century*, London: Lund Humphries, 1965, p. 349.

53 Francis O'Connor, *Jackson Pollock*, New York: Museum of Modern Art, 1967, p. 40. See Francis Bacon: 'When I was trying in despair . . . to paint that head of a specific person, I used a very big brush and a great deal of paint and I put it on very, very freely, and I simply didn't know in the end what I was doing, and suddenly this thing clicked, and became exactly like this image I was trying to record' (Sylvester, *Brutality of Fact*, p. 17).

54 Golding, *Paths to the Absolute*, p. 134.

55 'To interpret or not to interpret Jackson Pollock', in Shapiro and Shapiro, *Abstract Expressionism*, pp. 382–91; here p. 391.

56 O'Connor, *Jackson Pollock*, p. 57.

57 O'Connor, *Jackson Pollock*, p. 76

58 In Shapiro and Shapiro, *Abstract Expressionism*, p. 370.

59 Sylvester, *Brutality of Fact*, p. 59. Bacon said he would hate his painting to look like 'chancy abstract expressionist painting' because art should be highly disciplined (p. 92). He disliked Matisse because he felt he lacked 'the brutality of fact' and was merely decorative (p. 182).

60 Diane Waldman, *Mark Rothko*, London: Thames and Hudson, 1978, p. 39.

61 Marion, *In Excess*, p. 150.

62 Haftmann, *Painting in the Twentieth Century*, p. 365. Maritain apparently felt the same. Summarising his view Williams writes, 'the artist struggling for perfect abstract expression is trying to imitate God's self sufficiency' (*Grace and Necessity*, p. 18).

63 Barth, *CD*, vol. 1, pt 2, p. 319.

64 Waldman, *Mark Rothko*, p. 54. This is more true for the first two: Still's agenda was different. His canvases are more violent, less contemplative, and much more concerned with an existentialist agenda. The use of the language of mysticism probably follows the twentieth-century practice of identifying this with experience. Denys Turner's important argument, that what is called 'mysticism' is just one movement, the critical or deconstructive, in any proper theology or spirituality, would equally apply to these painters. Their paintings could be read as a critique of the false abundance of a consumer society (Denys Turner, *The Darkness of God*, Cambridge: Cambridge University Press, 1995).

65 Marion, *In Excess*, p. 73.

66 Waldman, *Mark Rothko*, p. 61.

67 Cited in Marion, *In Excess*, p. 74.

68 Cited in Marion, *In Excess*, p. 74.

69 Stone, *Image and Spirit*, p. 16.

70 Waldman, *Mark Rothko*, p. 69.

71 Hughes, *Shock of the New*, p. 323.

72 McNay, *Patrick Heron*, p. 48.

73 Cited in Golding, *Paths to the Absolute*, p. 201.

74 Cited in Golding, *Paths to the Absolute*, p. 202.

75 Hughes, *Shock of the New*, p. 318.

76 Hughes, *Shock of the New*, p. 323.

77 Horst Schwebel, cited in Gesa Thiessen, *Theology and Modern Irish Art*, Dublin: Columba Press, 1999, p. 202.

78 'Re-evaluating abstract expressionism', in Shapiro and Shapiro, *Abstract Expressionism*, p. 155.

79 Cited in Harrison and Wood, *Art in Theory 1900–1990*, p. 220. Bacon seems to have agreed, describing abstract art as anodyne and a flight from the cruelty of the world (Sylvester, *Brutality of Fact*, p. 200).

80 Paul Evdokimov, *The Art of the Icon: A Theology of Beauty*, Calif.: Oakwood, 1990, p. 88.
81 Barth, *CD*, vol. 1, pt 2, p. 322.
82 Ernst Gombrich, 'The vogue of abstract art', in *Meditations on a Hobby Horse*, Oxford: Phaidon, 1963, p. 150.
83 Hart, *Beauty of the Infinite*, p. 278.

PICTURES AS PARABLE

1 Thiessen, *Theology and Modern Irish Art*, p. 260. The method of correspondence which Tillich proposes has an obvious attraction and can be easily applied. I have argued that thinking of art as parable respects the divine freedom in revelation to a much greater degree.
2 Collingwood, *Principles of Art*, p. 284.
3 In opposition to Peter Fuller 'The best we can hope for is that aesthetic surrogate for salvation: redemption through form' (*Images of God: The Consolations of Lost Illusions*, London: Hogarth, 1990, p. xiv).

BIBLIOGRAPHY

Alazard, Jean, *The Florentine Portrait*, New York: Schocken, 1968

Alberti, Leon Battista, *On Painting*, New Haven and London: Yale University Press, 1966

Alexander, Christopher, *The Phenomenon of Life*, Berkeley: Centre for Environmental Structure, 2001

Alpers, Svetlana, 'Bruegel's festive peasants', *Simiolus*, vol. 6, nos 3–4, 1972–3, pp. 163–76

Alpers, Svetlana, 'Realism as a comic mode: low life painting seen through Bredero's eyes', *Simiolus*, vol. 8, no. 3, 1975–6, pp. 115–39

Alpers, Svetlana, *The Art of Describing: Dutch Art in the Seventeenth Century*, Harmondsworth: Penguin, 1989

Andrews, M., *The Search for the Picturesque: Landscape Aesthetics and Tourism in Britain*, Stanford: Stanford University Press, 1989

Andrews, M., *Landscape and Western Art*, Oxford: Oxford University Press, 1999

Arnason, H. H., *A History of Modern Art*, London: Thames and Hudson, 1969

Aston, Margaret, 'God's saints and reformers: portraiture and Protestant England' in Lucy Gent (ed.), *Albion's Classicism: The Visual Arts in Britain 1550–1660*, New Haven and London: Yale University Press, 1995, pp. 181–220

Auerbach, Erich, *Mimesis: The Representation of Reality in Western Literature*, Princeton: Princeton University Press, 1968

Austin, Michael, *Explorations in Art, Theology and Imagination*, London: Equinox, 2005

Badt, Kurt, *The Art of Cézanne*, London: Faber and Faber, 1965

Bailey, Colin (ed.), *The Age of Watteau, Chardin and Fragonard: Masterpieces of French Genre Painting*, New Haven and London: Yale University Press, 2003

Barrell, John, *The Dark Side of the Landscape: The Rural Poor in English Painting*, Cambridge: Cambridge University Press, 1980

Barth, Karl, *Church Dogmatics*, Edinburgh: T. & T. Clark, vol. 3, pt 1, 1958

Barth, Karl, *Church Dogmatics*, Edinburgh: T. & T. Clark, vol. 4, pt 3, 1961

Barth, Karl, *Ethics*, Edinburgh: T. & T. Clark, 1981

Barth, Karl, *Wolfgang Amadeus Mozart*, Grand Rapids: Eerdmans, 1986

Bätschmann, Oscar, and Pascal Griener, *Hans Holbein*, London: Reaktion, 1997

Bazin, Germaine, *Fra Angelico*, London: Heinemann, 1949

Beckett, R. B. (ed.), *John Constable's Discourses*, Ipswich: Suffolk Records Society, 1970

Beckett, Sr Wendy, *The Story of Painting*, London: Dorling Kindersley, 1994

Benjamin, Walter, *Illuminations*, London: Fontana, 1973

Bentley-Cranch, Dana, *The Renaissance Portrait in France and England: A Comparative Study*, Paris: Champion, 2004

Berenson, Bernard, *Aesthetics and History in the Visual Arts*, London: Constable, 1950

Berger, John, *The Success and Failure of Picasso*, Harmondsworth: Penguin, 1965

Berger, John, *Selected Essays and Articles*, Harmondsworth: Penguin, 1971

Berger, John, *Ways of Seeing*, Harmondsworth: Penguin, 1972

Berger, John, *The White Bird*, London: Hogarth, 1988

Bergström, Ingvar, *Dutch Still Life Painting in the Seventeenth Century*, London: Faber and Faber, 1956

Bermingham, Ann, *Landscape and Ideology: The English Rustic Tradition 1740–1860*, London: Thames and Hudson, 1987

Blanchard, Marc Eli, 'On still life', *Yale French Studies*, no. 61, 1981, pp. 276–98

Blankert, Albert, *Vermeer of Delft*, Oxford: Phaidon, 1978

Bloch, Ernst, *The Principle of Hope*, 3 vols, Oxford: Blackwell, 1986

Blunt, Antony, *Nicolas Poussin: A Critical Catalogue*, 2 vols, Oxford: Phaidon, 1967

Bouret, Jean, *The Barbizon School and Nineteenth-Century French Landscape Painting*, London: Thames and Hudson, 1973

Bowness, Alan, Marie-Thérèse de Forges and Hélène Toussaint, *Gustave Courbet 1819–1877*, London: Royal Academy of Art, 1978

Brilliant, Richard, *Portraiture*, London: Reaktion, 1991

Brophy, John, *The Face in Western Art*, London: Harrap, 1963

Brown, David, *Tradition and Imagination: Revelation and Change*, Oxford: Oxford University Press, 1999

Brown, David, *Discipleship and Imagination: Christian Tradition and Truth*, Oxford: Oxford University Press, 2000

Brown, David, *God and Enchantment of Place*, Oxford: Oxford University Press, 2004

Brown, Jonathan, *Velázquez: Painter and Courtier*, New Haven and London: Yale University Press, 1986

Browne, Thomas, *Religio Medici*, London: Dent, 1969

Bryson, Norman, *Looking at the Overlooked: Four Essays on Still Life Painting*, London: Reaktion, 1990

Buchthal, Hugo, *Historia Troiana: Studies in the History of Medieval Secular Illustration*, London: Warburg Institute, 1978

Burckhardt, J., *The Civilization of the Renaissance in Italy*, London: Phaidon, 1965

Burnett, Mark, *Servants: Masters and Servants in English Renaissance Drama and Culture*, London: Macmillan, 1997

Butler, C. V., *Domestic Service*, London: G. Bell, 1916

Cachin, F., I. Cahn, W. Feilchenfeldt, H. Loyrette and J. Rishel, *Cézanne*, Philadelphia: Philadelphia Museum of Art, 1996

Calvin, J., *Institutes of the Christian Religion*, trans. H. Beveridge, Grand Rapids: Eerdmans, 1975

Campbell, Lorne, *Renaissance Portraits: European Portrait Painting in the Fourteenth, Fifteenth and Sixteenth Centuries*, New Haven and London: Yale University Press, 1990

Campbell, Lorne, 'Beuckelaer's *The Four Elements*: four masterpieces by a neglected genius', *Apollo*, February 2002, pp. 40–5

Cartwright, Julia, *Jean François Millet*, 2nd edn, London: Swan Sonnenschein, 1902

Cassirer, E., P. O. Kristeller and J. H. Randall (eds), *The Renaissance Philosophy of Man*, Chicago: University of Chicago Press, 1948

Chapman, H. Perry, *Rembrandt's Self-Portraits: A Study in Seventeenth-Century Identity*, Princeton: Princeton University Press, 1999

Chastel, André, *Marseile Ficin et l'art*, Geneva: Droz, 1996

Clark, Kenneth, *Landscape into Art*, 2nd edn, London: John Murray, 1976

Clark, Kenneth, *The Nude*, Harmondsworth: Penguin, 1985

Clark, T. J., *Image of the People: Gustave Courbet and the 1848 Revolution*, London: Thames and Hudson, 1973

Clark, T. J., *Farewell to an Idea: Episodes from a History of Modernism*, New Haven and London: Yale University Press, 1999

Collingwood, R. G., *The Principles of Art*, Oxford: Oxford University Press, 1958

Conisbee, P., *Chardin*, Oxford: Phaidon, 1986

Coulton, C. G., *Art and the Reformation*, Oxford: Blackwell, 1928

Cowling, Elizabeth, *Picasso: Style and Meaning*, London: Phaidon, 2002

Craig, Kenneth M., 'Pieter Aertsen and *The Meat Stall*', *Oud Holland*, vol. 96, no. 1, 1982, pp. 1–15

Craig, Kenneth M., 'Pars ergo Marthae transit: Pieter Aertsen's "inverted" paintings of Christ in the house of Martha and Mary', *Oud Holland*, vol. 97, 1983, pp. 25–39

D'Ancona, Mirella Levi (ed.), *Botticelli's Primavera*, Florence: Olschke, 1983

Daniels, Stephen, *Fields of Vision: Landscape Imagery and National Identity in England and the United States*, Cambridge: Polity, 1993

Davies, Hugh, and Sally Yard, *Francis Bacon*, London: Abbeville, 1986

De Gruchy, John, *Christianity, Art and Transformation*, Cambridge: Cambridge University Press, 2001

De la Bruyère, Jean, *Characters*, trans. Jean Stewart, Harmondsworth: Penguin, 1970

Della Mirandola, Pico, *On the Dignity of Man*, New York: Macmillan, 1985

Dempsey, Charles, 'Mercurius Ver: the sources of Botticelli's *Primavera*', *Journal of the Warburg and Courtauld Institutes*, vol. 31, 1968, pp. 251–73

Dempsey, Charles, *The Portrayal of Love: Botticelli's 'Primavera' and Humanist Culture at the Time of Lorenzo the Magnificent*, Princeton: Princeton University Press, 1992

Düchting, Hajo, *Paul Klee: Painting Music*, London: Prestel, 1997

Dupré, Louis, *Passage to Modernity: An Essay in the Hermeneutics of Nature and Culture*, New Haven and London: Yale University Press, 1993

Dyrness, W., *Reformed Theology and Visual Culture: The Protestant Imagination from Calvin to Edwards*, Cambridge: Cambridge University Press, 2004

Eade, J. C. (ed.), *Projecting the Landscape*, Canberra: Australian National University, Humanities Research Centre, monograph 4, 1987

Eagleton, Terry, *The Idea of Culture*, Oxford: Blackwell, 2000

Eco, Umberto, *The Aesthetics of Thomas Aquinas*, London: Radius, 1988

Emison, Patricia, 'The paysage moralisé', *Artibus et historiae*, vol. 16, no. 31, 1995, pp. 125–37

Evdokimov, Paul, *The Art of the Icon: A Theology of Beauty*, Calif.: Oakwood, 1990

Fer, Briony, *On Abstract Art*, New Haven and London: Yale University Press, 1997

Fermor, Sharon, 'Botticelli and the Medici' in F. Ames-Lewis (ed.), *The Early Medici and their Artists*, London: Birkbeck, 1995, pp. 169–85

Ficino, Marsilio, *The Letters of Marsilio Ficino*, 7 vols, London: Shepheard-Walwyn, 1975–2003

Ficino, Marsilio, *Commentary on the Symposium*, trans. S. Jayne, Woodstock, Conn.: Spring Publications, 1985

Ficino, Marsilio, *Platonic Theology*, ed. James Hankins, trans. Michael J. B. Allen, 6 vols, Cambridge, Mass.: Harvard University Press, 2001–6

Fischer, Ernst, *The Necessity of Art*, Harmondsworth: Penguin, 1963

Fischer, Hartwig, and Sean Rainbird (eds), *Kandinsky: The Path to Abstraction*, London: Tate Publishing, 2006

Foister, Susan, Ashok Roy and Martin Wyld, *Holbein's Ambassadors*, London: National Gallery, 1997

Ford, David, *Self and Salvation: Being Transformed*, Cambridge: Cambridge University Press, 1999

Forsyth, P. T., *Christ on Parnassus*, London: Independent Press, 1959

Franits, Wayne, *Dutch Seventeenth-Century Genre Painting*, New Haven and London: Yale University Press, 2004

Freedman, Paul, *Images of the Medieval Peasant*, Stanford: Stanford University Press, 1999

Fried, Michael, *Courbet's Realism*, Chicago: University of Chicago Press, 1990

Furst, Herbert, *Chardin*, London: Methuen, 1911

Gage, John, *J. M. W. Turner: A Wonderful Range of Mind*, New Haven and London: Yale University Press, 1991

Gallati, B., 'An alchemical interpretation of the marriage between Mercury and Venus', in Mirella Levi D'Ancona (ed.), *Botticelli's Primavera*, Florence: Olschke, 1983, pp. 99–121

Geffroy, Gustave, and Arsene Alexandre, *Corot and Millet*, London: The Studio, 1902

Gent, Lucy (ed.), *Albion's Classicism: The Visual Arts in Britain 1550–1660*, New Haven and London: Yale University Press, 1995

Gibson, W. S., *Pieter Bruegel the Elder: Two Studies*, Kansas: University of Kansas Press, 1991

Gilson, Etienne, *Painting and Reality*, New York: Meridian, 1959

Gilson, Etienne, *Elements in Christian Philosophy*, New York: Mentor, 1960

Golding, John, *Paths to the Absolute*, London: Thames and Hudson, 2000

Gombrich, E. H., *Meditations on a Hobby Horse*, Oxford: Phaidon, 1963

Gombrich, E. H., *Norm and Form: Studies in the Art of the Renaissance*, Oxford: Phaidon, 1966

Gombrich, E. H., *Symbolic Images: Studies in the Art of the Renaissance*, Oxford: Phaidon, 1972

Gombrich, E. H., *Art and Illusion*, Oxford: Phaidon, 1986

Gorringe, T. J., 'Figuring the Resurrection: Botticelli as a teacher of the church', *Theology Today*, vol. 55, no. 4, 1999, pp. 571–7

Greenblatt, Stephen, 'Murdering peasants: status, genre and the representation of rebellion', *Representation*, vol. 1, no. 1, February 1983, pp. 1–29

Gudiol, José, *Velázquez*, London: Secker and Warburg, 1974

Gutierrez, Gustavo, *The Power of the Poor in History*, London: SCM, 1983

Haftmann, Werner, *Painting in the Twentieth Century*, London: Lund Humphries, 1965

Haftmann, Werner (ed.), *Abstract Art Since 1945*, London: Thames and Hudson, 1971

Harris, Enriqueta, *Velázquez*, Oxford: Phaidon, 1982

Harrison, C., Francis Frascina and Gill Perry, *Primitivism, Cubism, Abstraction: The Early Twentieth Century*, New Haven and London, Yale University Press, 1993

Harrison, C., and P. Wood (eds), *Art in Theory 1900–1990: An Anthology of Changing Ideas*, Oxford: Blackwell, 1992

Harrison, C., P. Wood and J. Gaiger (eds), *Art in Theory 1648–1815: An Anthology of Changing Ideas*, Oxford: Blackwell, 2000

Hart, David Bentley, *The Beauty of the Infinite*, Grand Rapids: Eerdmans, 2004.

Hatfield, Rab, 'Botticelli's *Mystic Nativity*, Savonarola and the millennium', *Journal of the Warburg and Courtauld Institutes*, vol. 58, 1995, pp. 89–114

Hauser, A., *The Social History of Art*, London: Routledge, 1951

Hearn, Karen, *Nathaniel Bacon: Artist Gentleman and Gardner*, London: Tate Publishing, 2005

Hegel, G. W. F., *Hegel's Aesthetics: Lectures on Fine Art*, 2 vols, trans. T. M. Knox, Oxford: Oxford University Press, 1975

Herbert, Robert L., *Jean François Millet*, London: Arts Council of Great Britain, 1976

Herbert, Robert L. (ed.), *Modern Artists on Art*, New York: Dover, 2000

Hill, Bridget, *Servants: English Domestics in the Eighteenth Century*, Oxford: Clarendon, 1996

Hofmann, Werner, *Caspar David Friedrich*, London: Thames and Hudson, 2000

Horne, Herbert, *Botticelli*, Princeton: Princeton University Press, 1980 (1908)

House, John, *Monet: Nature into Art*, New Haven and London: Yale University Press, 1986

House, John, *Landscapes of France: Impressionism and its Rivals*, London: Hayward Gallery, 1995

Hughes, Robert, *The Shock of the New*, 2nd edn, London: Thames and Hudson, 1991

Huizinga, J., *The Waning of the Middle Ages*, Harmondsworth: Penguin, 1965

Hunsinger, George, *How to Read Karl Barth: The Shape of his Theology*, Oxford: Oxford University Press, 1991

Irmscher, Günther, 'Ministrae voluptatum: stoicizing ethics in the market and kitchen scenes of Pieter Aertsen and Joachim Beuckelaer', *Simiolus*, vol. 16, no. 4, 1986, pp. 219–32

Jaffé, Hans, *Piet Mondrian*, London: Thames and Hudson, 1970

James, Merlin, *Engaging Images: 'Practical Criticism' and Visual Art*, London: Menard, 1992

Jenks, Chris, *Culture*, London: Routledge, 1993

Jollet, Etienne, *Chardin: la vie silencieuse*, Paris: Herscher, 1995

Jones, Pamela, 'Federico Borromeo as a patron of landscapes and still lifes: Christian optimism in Italy ca 1600', *Art Bulletin*, June 1988, vol. 70, no. 2, pp. 261–72

Jordan, William, and Peter Cherry, *Spanish Still Life from Velázquez to Goya*, London: National Gallery, 1995

Kandinsky, Wassily, *Concerning the Spiritual in Art*, New York: Dover, 1977

Kearney, Richard, *The Wake of Imagination: Toward a Postmodern Culture*, London: Routledge, 1994

Kettering, Alison, *The Dutch Arcadia: Pastoral Art and its Audience in the Golden Age*, Montclair, N.J.: Allanheld & Schram, 1983

Kitson, Michael, 'The relationship between Claude and Poussin in landscape', *Zeitschrift für Kunstgeschichte*, 24 BD, H.2, 1961, pp. 142–62

Kochan, Lionel, *Beyond the Graven Image, A Jewish View*, Basingstoke: Macmillan, 1997

Koerner, J. L., *Caspar David Friedrich and the Subject of Landscape*, London: Reaktion, 1990

Kraye, Jill, 'Ficino in the firing line: a Renaissance Neoplatonist and his critics'

in M. Allen and V. Rees (eds), *Marsilio Ficino: His Theology, His Philosophy, His Legacy*, Leiden: Brill, 2002, pp. 377–98

Kraye, Jill (ed.), *The Cambridge Companion to Renaissance Humanism*, Cambridge: Cambridge University Press, 1996

Kristeller, O. R., *Studies in Renaissance Thought and Letters*, Rome: Edizione di Storia e Letteratura, 1956

Kroeber, K., *Romantic Landscape Vision: Constable and Wordsworth*, Wisconsin: University of Wisconsin Press, 1975

Kudielka, Robert, *Paul Klee: The Nature of Creation Works 1914–1940*, London: Hayward Gallery, 2002

Kussmaul, Ann, *Servants in Husbandry in Early Modern England*, New Haven and London: Yale University Press, 1981

Landau, Ellen, *Jackson Pollock*, London: Thames and Hudson, 1989

Langdon, Helen, *Claude Lorrain*, Oxford: Phaidon, 1989

Levinas, Emmanuel, *Totality and Infinity*, The Hague: Nijhoff, 1979

Lightbown, Ronald, *Sandro Botticelli*, 2 vols, London: Elek, 1978

Lindsay, Jack, *J. M. W. Turner: A Critical Biography*, Greenwich, Conn.: New York Graphic Society, 1966

Lindsay, Jack, *Gustave Courbet: His Life and Art*, Bath: Adams & Dart, 1973

López-Rey, José, *Velázquez's Work and World*, London: Faber and Faber, 1968

Luibheid, Colm (ed.), *Pseudo-Dionysius*, Mahwah, N.J.: Paulist, 1987

Lyles, Anne (ed.), *Constable: The Great Landscapes*, London: Tate Gallery, 2006

Lynton, N., A. Smith, R. Cumming and D. Collinson, *Looking into Paintings*, London: Faber and Faber, 1985

McNay, Michael, *Patrick Heron*, London: Tate Publishing, 2002

Marion, Jean-Luc, *In Excess: Studies of Saturated Phenomena*, New York: Fordham, 2002

Merleau-Ponty, Maurice, *Sense and Non-Sense Studies in Phenomenology and Existential Philosophy*, Evanston, Ill.: Northwestern University Press, 1964

Metzger, Paul, *The Word of Christ and the Word of Culture*, Grand Rapids: Eerdmans, 2003

Michel, Marianne, *Chardin*, Paris: Hazan, 1994

Miedema, Hessel, 'Realism and comic mode: the peasant', *Simiolus*, vol. 9, no. 4, 1977, pp. 205–19

Milner, John, *Mondrian*, London: Phaidon, 1992

Mitchell, W. J. T. (ed.), *Landscape and Power*, Chicago: Chicago University Press, 1994

Moxey, Keith, *Pieter Aertsen, Joachim Beuckelaer and the Rise of Secular Painting in the Context of the Reformation*, London: Garland, 1977

Moxey, Keith, 'Sebald Beham's church anniversary holidays: festive peasants as instruments of repressive humour', *Simiolus*, vol. 12, 1981–2, pp. 107–30

Moxey, Keith, *Peasants, Warriors and Wives: Popular Imagery in the Reformation*, Chicago: University of Chicago Press, 1989

Murdoch, Iris, *The Sovereignty of Good*, London: Ark, 1970

Nichols, Aidan, *The Art of God Incarnate*, London: Darton, Longman and Todd, 1980

O'Connor, Francis, *Jackson Pollock*, New York: Museum of Modern Art, 1967

Pächt, Otto, 'Early Italian nature studies and the early calendar landscape', *Journal of the Warburg and Courtauld Institutes*, vol. 13, nos 1/2, 1950, pp. 13–47

Panofsky, Erwin, *Renaissance and Renascences in Western Art*, New York: Harper and Row, 1969

Panofsky, Erwin, *Early Netherlandish Painting*, New York: Harper and Row, 1971

Parsons, Christopher, and Neil McWilliam, '"Le paysan de Paris": Alfred Sensier and the myth of rural France', *Oxford Art Journal*, vol. 6, no. 2, 1983, pp. 38–58

Pascal, Blaise, *Penseés*, Paris: Editions du Seuil, 1963

Pattison, George, *Art, Modernity and Faith*, 2nd edn, London: SCM, 1998

Paulson, Ronald, *Literary Landscape: Turner and Constable*, New Haven and London: Yale University Press, 1982

Peppiat, Michael, *Francis Bacon: Anatomy of an Enigma*, London: Orion, 1996

Pickstone, Charles, 'Much strife to be striven: the visual theology of Vincent Van Gogh', *Theology*, July/August 1990, pp. 283–91

Pointon, Marcia, *Hanging the Head: Portraiture and Social Formation in Eighteenth-Century England*, New Haven and London: Yale University Press, 1993

Polizzotto, Lorenzo, *The Elect Nation: The Savonarolan Movement in Florence 1494–1545*, Oxford: Clarendon, 1994

Pommier, Édouard, *Théories du portrait de la Renaissance aux lumières*, Paris: Gallimard, 1998

Pope-Hennessy, John, *The Portrait in the Renaissance*, London: Phaidon, 1966

Raphael, Max, *The Demands of Art*, London: Routledge, 1968

Rewald, John, *Cézanne: A Biography*, New York: Abrams, 1986

Reyce, Robert, *Suffolk in the Seventeenth Century*, ed. Lord Francis Hervey, London, 1902

Richardson, Jonathan, *An Essay on the Theory of Painting*, Menston: Scolar Press, 1971

Ricoeur, Paul, *The Conflict of Interpretations*, Evanston, Ill.: Northwestern University Press, 1974

Ridolfi, Roberto, *The Life of Girolamo Savonarola*, London: Routledge & Kegan Paul, 1959

Robb, Nesca, *Neoplatonism of the Italian Renaissance*, London: Allen & Unwin, 1935

Roethlisberger, M., *Claude Lorrain: The Paintings*, 2 vols, Berkeley and Los Angeles: University of California Press, 1968

Rosenthal, Michael, *Constable the Painter and his Landscape*, New Haven and London: Yale University Press, 1983

Rothko, Mark, *The Artist's Reality: Philosophies of Art*, New Haven and London: Yale University Press, 2004

Rowell, Margit, *Objects of Desire: The Modern Still Life*, New York: Museum of Modern Art, 1997

Rowland, Christopher, *Revelation*, London: Epworth, 1993

Rubinstein, Nicolai, 'Youth and spring in Botticelli's *Primavera*', *Journal of the Warburg and Courtauld Institutes* , vol. 60, 1997, pp. 248–51

Ruskin, John, *Modern Painters*, 6 vols, London: Allen, 1906

Sanneh, Lamin, *Encountering the West: Christianity and the Global Cultural Process: The African Dimension*, London: Marshall Pickering, 1993

Schama, Simon, *Rembrandt's Eyes*, Harmondsworth: Penguin, 1999

Schneider, Norbert, *The Art of the Portrait*, Cologne: Taschen, 2002

Schwartz, Gary, *Rembrandt: His Life, His Paintings*, Harmondsworth: Penguin, 1985

Serota, Nicholas, et al., *Mark Rothko: 1903–1970*, New York: Stewart, Tabori and Chang, 1987

Shapiro, David, and Cecile Shapiro (eds), *Abstract Expressionism: A Critical Record*, Cambridge: Cambridge University Press, 1990

Slive, Seymour, *Jacob van Ruisdael: Master of Landscape*, London: Royal Academy, 2005

Smiles, Sam, 'Turner in the West Country: from topography to idealisation' in J. C. Eade (ed.), *Projecting the Landscape*, Canberra: Australian National University, Humanities Research Centre, monograph 4, 1987

Solkin, David, *Richard Wilson*, London: Tate Gallery, 1983

Spate, Virginia, *The Colour of Time: Claude Monet*, London: Thames and Hudson, 1992

Stechow, Wolfgang, *Dutch Landscape Painting of the Seventeenth Century*, Oxford: Phaidon, 1966

Sterling, Charles, *Still Life Painting*, New York: Universe, 1959

245

Sterling, Charles, *La nature morte*, Paris: Macula, 1985

Stone, Karen, *Image and Spirit: Finding Meaning in Visual Art*, London: Darton, Longman and Todd, 2003

Sullivan, Margaret, *Bruegel's Peasants: Art and Audience in the Northern Renaissance*, Cambridge: Cambridge University Press, 1994

Sullivan, Margaret, 'Aertsen's kitchen and market scenes: audience and innovation in northern art', *Art Bulletin*, vol. 81, no. 2, June 1999, pp. 236–66

Sylvester, David, *The Brutality of Fact: Interviews with Francis Bacon*, London: Thames and Hudson, 1987

Sylvester, David, *About Modern Art: Critical Essays 1948–1996*, London: Chatto & Windus, 1996

Tanzella-Nitti, G., 'The two books prior to the scientific revolution', *Annales theologici*, no. 18, 2004, pp. 51–83

Thiessen, Gesa, *Theology and Modern Irish Art*, Dublin: Columba Press, 1999

Thomas, Keith, *Man and the Natural World*, Harmondsworth: Penguin, 1984

Thomson, Richard, *Camille Pissarro: Impressionism, Landscape and Rural Labour*, London: South Bank Centre, 1990

Tillich, Paul, *On Art and Architecture*, New York: Crossroad, 1989

Tinterow, G., and P. Conisbee, *Portraits by Ingres: Image of an Epoch*, New York: Metropolitan Museum of Art, 1999

Turner, Denys, *The Darkness of God*, Cambridge: Cambridge University Press, 1995

Van de Velde, Henry, 'Du paysan en peinture', *L'avenir social*, 1899: August, pp. 281–8; September, pp. 327–34; October, pp. 378–82

Van Gogh, Vincent, *The Complete Letters of Vincent Van Gogh*, 3 vols, London: Thames and Hudson, 1959

Van Mander, Carel, *Dutch and Flemish Painters*, New York: Arno, 1969

Van Marle, Raimonde, *Iconographie de l'art profane au moyen-âge et à la Renaissance*, 2 vols, New York: Hacker, 1971

Viladesau, Richard, *The Triumph of the Cross: The Passion of Christ in Theology and the Arts – from the Renaissance to the Counter Reformation*, Oxford: Oxford University Press, 2008

Villa, Claudia, 'Per una lettura della "primavera": Mercurio "retrograde" e la retorica nella bottega di Botticelli', *Strumenti critici*, vol. 13, no. 1, January 1998, pp. 1–28

Villari, Pasque, *Life and Times of Girolamo Savonarola*, London: Fisher Unwin, vol. 2, 1890

Von Balthasar, Hans Urs, *The Glory of the Lord*, Edinburgh: T. & T. Clark, 1982

Waldman, Diane, *Mark Rothko*, London: Thames and Hudson, 1978

Walford, E. John, *Jacob van Ruisdael and the Perception of Landscape*, New Haven and London: Yale University Press, 1991

Ward, G., 'Sacramental presence or neopaganism?', *Theology*, 1991, pp. 279–83

Warnke, Martin, *Political Landscape: The Art History of Landscape*, London: Reaktion, 1994

Waterfield, G. and A. French with M. Craske, *Below Stairs: 400 Years of Servants' Portraits*, London: National Portrait Gallery, 2003

Weil, Simone, *Waiting on God*, London: Routledge & Kegan Paul, 1951

Weinstein, D., *Savonarola and Florence: Prophecy and Patriotism in the Renaissance*, New Jersey: Princeton University Press, 1970

Wendorf, Richard, *The Elements of Life: Biography and Portrait Painting in Stuart and Georgian England*, Oxford: Clarendon, 1990

West, Shearer, *Portraiture*, Oxford: Oxford University Press, 2004

Widenstein, Georges, *Chardin*, Oxford: Cassirer, 1969

Wilder, Amos, *Jesus' Parables and the War of Myths*, London: SPCK, 1982

Williams, Rowan, *Grace and Necessity*, London: Continuum, 2005

Wilton, Andrew (ed.), *Constable's 'English Landscape Scenery'*, London: British Museum, 1979

Wilton, Andrew, *Turner and the Sublime*, London: British Museum, 1980

Wind, Edgar, *Pagan Mysteries of the Renaissance*, Harmondsworth: Penguin, 1967

Wolterstorff, Nicholas, *Art in Action: Toward a Christian Aesthetic*, Carlisle: Solway, 1997

Wood, Christopher S., *Albrecht Altdorfer and the Origins of Landscape*, London: Reaktion, 1993

Woodall, Joanna (ed.), *Portraiture: Facing the Subject*, Manchester: Manchester University Press, 1997

Woods-Marsden, Joanna, *Renaissance Self-Portraiture*, New Haven and London: Yale University Press, 1998

Worringer, Wilhelm, *Abstraction and Empathy*, Chicago: Elephant, 1997

PHOTOGRAPH CREDITS

INDEX